Published in 1985 by
Galahad Books
149 Madison Avenue
New York, New York 10016
By arrangement with W.S. Konecky Associates, Inc.

Library of Congress Catalog Card Number: 85-080469
ISBN: 0-88365-703-1

PREFACE

Are they too close to us or too far away? It is difficult enough to form a picture of someone who has been gone for a century. How much more difficult then to envision an artistic movement such as Impressionism. To us this word might suggest the image of a swarm of bees or better yet a flight of butterflies scattered by the light of the sun. However, that which appears to us today as a succession of charming images was in its day the cause of great controversy and virulent attacks.

Let us try to place ourselves back in the time when this art, so light and fluid, filled with inspired touches, was first brought to the attention of a generation more concerned with bagatelles and stale academic exercises than with a poetic that was to fundamentally alter our perception of the visible world.

What is Impressionism? We could liken it to an undiscovered territory, always there but waiting for this group of artists to lay claim to it.

Gustave Geffroy, one of the first defenders of the new art, said that it is "a painting which verges on the phenomenal, toward the appearance of signification of the object in space." Theodore Duret, for whom the Japanese were the first and most perfect of Impressionists, proclaimed: "Above all the painting will be clear, once and for all divested of litharge, bitumen, chocolate and charred effects. . . . No more melodramatic touches, no more wild ruins, no more trees whose silhouettes are composed to academic models, no more theatrical effects. All will be bright with the summer sun." Now luminosity will eclipse the shadowy.

It was in fact a revolution when those artists, who along with Manet and Courbet were almost always rejected by the Salon juries, united to form a Cooperative Society of Artist-Painters. They were called rebels, intransigents, the Japanese painters and the actualists. Their first exhibition opened on April 15, 1874, in Paris at 35 Boulevard des Capucines, in rooms recently vacated by the photographer Nadar.

Among the thirty who showed their work there were Boudin, Cezanne, Degas, Guillaumin, Berthe Morisot, Pissarro, Renoir, Sisley, and Claude Monet, who presented a canvas entitled *Impression, Sunrise.* This work provoked the following remarks by Louis Leroy in his humorous journal *Charivari:*

" 'What is this canvas trying to say?'

'Impression, Sunrise.'

"Impression—I was certain of it. I kept telling myself that since I was impressed there had to be some impression in it. What freedom, what ease of workmanship. Wallpaper in its embryonic state is more finished than that painting."

Thus was the new school baptized. We often forget that great things can be born out of derision. Another critic of the period instructed those who would paint in the new school: "Mix three quarts of black and white on canvas, rub yellow all over, add a few touches of red and blue at random, and there you have it. An Impression of springtime."

But even though the Impressionists were seen by their contemporaries as rebels against the established order, they were not without their precursors.

The first of these was Claude Lorrain, who studied the nuanced effects of sunlight on water. He also was the first painter to make use of the light of different hours of the day, to depict morning, noon, evening. Thus he brought the element of time into painting. This illiterate artist lived in nature; his paintings are composed of distant horizons and great trees, ports, and peristyles, whose form in these paintings already defies their fixity in space. He was the painter of embarkments and debarkments, which he painted under the first light of dawn, and the good-byes of twilight. Baudelaire knew the works of this wonderful ingenu:

> I have for a long time inhabited his vast porticoes
> Which the sea's light tinges with a thousand fires.

After Lorrain we must jump to Delacroix to encounter the next major teacher of the future Impressionists. From Delacroix they learned primarily about color. His color was filled with the fever of desire. Already in his journal the painter of the *Massacres at Scio* was writing of the need to consider color in ways not envisioned by the academics of his day.

Among those who came to announce this new movement there was one who had a preponderant influence. Turner, the English visionary, was the direct animator, the alpha of the movement of which Claude Monet in his *Water Lilies* hanging in the Orangerie of the Tuileries is the omega.

In between these two painters all of the Impressionists were linked in their interest in naturalism (this includes Monet before his final period). Turner arrived at making no pretext of painting reality in canvasses of evanescences and objects dissolved in torrents of light and color. After being sidetracked for a short time by his admiration for Lorrain, he found a full embodiment for his vision of a life of turbulent water, earth and sky.

Then there is the Corot of Italy. Gustave Kahn says the Impressionists took from his paintings of the Coliseum a profound understanding of the emotional nature of painting. Finally we arrive at Courbet, whose *Young Girls at the Seaside* opens the door wide to the fresh air and anticipates Manet's *The Picnic.*

Manet was the bridge over which the Impressionists passed with their love of sunlight and clarity and their desire to make their art reflect their own life and time. He was inspired by Baudelaire, who on his side owed much to Manet. A revolutionary in spite of himself,

Manet had to brave the criticisms of society years before Monet for his *Olympia,* about which Paul de Saint-Victor remarked, "The crowd pressed into the exhibition as if going to the morgue."

Also let us not forget one who was only eight years older than Manet and was the preeminent painter of weather conditions. Boudin was a very important influence on Monet. He also had a certain ascendancy over the other young Impressionists and joined with them in showing his work in 1874.

Finally, among those who were advocates of painting in the open air we ought to add Bonington, Paul Huet, Diaz, Dupre, Daubigny, and Guigou.

In literature Impressionism had its proponents in the Goncourt brothers, who created a literary style of rapid notations, of words trapped in flight. Their words corresponded to the fine strokes of these painters, where shadows ceased to be opaque.

The Goncourts realized that one could exhaust a literary as well as an artistic style. The Impressionists signaled the end of an outmoded way of painting, one that considered that art like diplomats should wear kid gloves. They universally opposed that antique litter and Homeric bric-a-brac which was the staple of the academy. They knew instinctively that art could not stop growing, groping its way toward new forms of expression; that it is a succession of steps, of arrivals and departures. For these innovators the artistic impulse expressed itself better as a spontaneous act than as an overelaborated and overworked product.

Targets of general reprobation, the Impressionists lived close to the poverty line, when they did not know actual destitution. But they were aware that the public is always years behind the artist. For some sectors of the population it is only now that their experiments, seen from the vantage of those who were to come after, can be fully apprehended. At the time those who supported the movement demanded an end to the entire French academy system, where modes of painting were supported by the government by medals and direct patronage. It was time to say good-bye to that superficial mixture of mythology, orientalism, history, and archaeology.

No more of that. Impressionism was to rediscover nature and develop an aesthetic based on seizing the momentary, the transient, the immediate.

And as to 1874, the date of the first glorious public manifestation of Impressionism—an event comparable to the arrival of romanticism—how was it celebrated in the Ville-Lumiere, where Marshal MacMahon held the presidency of the Republic?

In fact the event had not the slightest impact. It passed with little fanfare. At this time Flaubert was releasing *The Temptation of St. Anthony* and Barbey d'Aurevilly *The Devils.* The talk of the town were Mezieres who had been accepted at the Academy, and Albert Besnard who received the Prix de Rome for his work *The Death of Timophane.* It was thought that the satiric journals would soon bury the fledgling Impressionist movement. There is something slightly pathetic about these self-assured esthetes, soon to be consigned to obscurity.

The Impressionists were looked down upon until the end of the nineteenth century. They were branded socialists, anarchists, dangerous revolutionaries. They remained targets of an almost total misapprehension. It was only with the greatest difficulty that Roger Marx managed to include them in the Universal Exposition (World's Fair) of 1900. When the President Loubet arrived at the hall he was greeted by a man who barred his entrance, exclaiming, "Don't go in, Mr. President, for there stands the dishonor of France." It was Gerome, a mediocre academic painter, who had stopped him. To him Manet was a scribbler, Monet a fraud. As to Renoir, Pissarro, Sisley, these were actual criminals who were corrupting influences on a generation of young artists.

But the tide was turning. At the same time Andre Perate gave Impressionism excellent reviews: "To fragment rays of light, to seize the very palpitations of the air, to follow its flow around the object and to envelop it in color; here is the enterprise of Impressionism."

At the beginning of their careers the Impressionists did not have much of a choice as to where to work. There were only two studios that were open to them: that of Pere Suisse and that of Charles Gleyre.

Pere Suisse founded his studio before 1830. It had a very liberal reputation, a little artistic republic that was frequented by many young painters. Suisse had longstanding friendships in the artistic community. His studio was located at the corner of the Quai des Orfevres and the Boulevard du Palais (where now stands the Palace of Justice). One took a dirty old wooden stairway of a rather gloomy aspect up into the wide open sunlit room of the studio.

Delacroix worked there as did Bonington. It was there that Cezanne met Claude Monet, Guillaumin and Pissarro.

The other studio, more conservative, was that of Charles Gleyre. He was a little modest man, who wore glasses. Both Bazille and Renoir recognized and appreciated him. He had no desire to be a leader of the Neogrecian school of which Gerome was a guiding light. He was a timid man, most fearful of his wife. "It is in his studio that I learned to paint," said Renoir, which suggests that the man had certain qualities perhaps not readily apparent on the surface. Monet, however, was less appreciative. Gleyre was said to have told him: "When you paint always think of antiquity." Monet would have none of that, and soon persuaded his friends Bazille, Sisley, and Renoir to join him in his workshop in the woods.

The movement was ultimately for each of the major figures an expression of his own personality. Abandoning little by little figure drawing, of which he was a master, to devote himself to nature, Monet arrived finally at his zenith in his floral paintings. Following his earliest inclinations, Renoir became the painter of meetings in Montmartre and above all the glorifier of the female nude. Sisley extended Monet's work with the delicacy of his brush stroke; Pissarro finished by concentrating on the streets of Paris. Before the movement had achieved any great success, but after the death of his wife Camille, Monet was asked if he was still an Impressionist. "I am and I always will want to be," he replied. "But I see little of my comrades, and what was once a little church has become a banal school open to any windbag that comes along."

Already by the end of the century we find the Impressionists scattered in different

directions. Cezanne returned to Aix-en-Provence, Sisley retired to Moret, Monet to Giverny, Pissarro to Eragny, Guillaumin to Crozant, and Renoir to Cagnes in the south of France. Only Degas remained in Paris, continued on his paintings of dancers and his mysterious paintings of women surprised in the bath.

Monet was perhaps the archtypical Impressionist. His work finished with an apotheosis. His career begun in the footsteps of Turner comes full circle with his *Water Lilies*. Here finally reality is dissolved. All is recomposed in shimmering waves of light, like a sound which echoes over water.

It is curious that France was the home of all the major figures in the movement. Perhaps Impressionism is best seen as another phase in a long line of development of a characteristically French art: it reaches back to Delacroix, Corot, Daumier, Millet, Courbet, and Manet. Although strongly represented by Turner (and Bonington, who pursued his career in Paris) England remained isolated. The dissolution of content did not appeal to the German aesthetic tradition, though Libermann's brush strokes approached an impressionistic luminosity. With Cassatt, the United States had a major participant in the original group; others, Whistler, Sargent, Prendergast, were more or less involved. One should also mention the work of the Belgian painter Rik Wouters, though his work was achieved after the first flowering of the movement.

As to Gaugin and Van Gogh, who were the inspiration for the Nabis and Fauvism, they worked in an impressionist mode only in the early part of their careers: Gaugin in his landscapes, which took after those of Pissarro; Van Gogh in his bouquets of flowers and his *July 14th in Paris*. Lautrec, painter along with Degas of the artificial light of the music hall, was represented in the Impressionists and Symbolists exhibition that took place toward the end of the century.

After the first wave of Impressionists had accomplished their revolution a second wave, somewhat more scientific and less expansive, arrives. Here the leader was Georges Seurat. Seurat in the course of his experiments with color and form arrived at replacing the line with a multitude of tiny points. He was the only artist who succeeded in making use of the scientific discoveries of Chevreul on the theory of color. This allowed him to create a considerable body of work, primarily large canvasses. Seurat was the inspiration for Signac, as well as the school that is commonly called Pointillism, but which Seurat named chromo-luminarism, on account of its technique of dividing tone (colors are mixed on the canvas, rather than on the palette).

Finally we come to Vuillard, painter of maternal scenes, and Bonnard, last flowering of Impressionism.

All of these painters are now behind us. Impressionism has become part of our visual vocabulary. To some extent our visual perceptions have been altered by these canvasses. In their own time the Impressionists were viewed as seditious troublemakers, a fact that we have some difficulty fully appreciating given their capital importance for twentieth-century art. But in fact there was good reason for the academics of the time to be frightened of Impressionism. In effect, it announced the subversive power of art, by freeing the artist to pursue his craft fearlessly and by insisting on engagement with the real physical world.

BAZILLE Frederic Jean

Montpelier, 1841 - Beaune-la Rolande, 1870

Despite the advice of his friends he signed up for military service upon the news of France's early defeats. He met an untimely end in battle at the age of twenty-nine. Bazille came from an upper middle class protestant background. At the time of his death he had alrady been recognized as a painter of great talent.

Very tall, thin, blond, with a wispy beard, Frederic Bazille was cultivated, serious, a bit stiff. He was a shy man, who blushed easily.

He was from a well-off protestant family; his father owned a lot of property in the Midi. Bazille began his career with the study of medicine. But early on he was writing to his father: "Could you envision me as a painter, perhaps not a celebrity, but as one who creates beautiful works?"

Soon after he went to study at Gleyre's studio, where he met Renoir, Sisley and Claude Monet. He had a studio on the Rue de Furstenburg, just below that of Delacroix. He went there to see the master's famous painting *Jacob Wrestling with the Angel.* Delacroix's work was a revelation for Bazille, as it was for many of the Impressionists.

In August of 1865 Bazille cared for Claude Monet, who had been struck by a carelessly thrown rock. Bazille painted the artist lying in bed.

Returning to Paris Bazille posed for Monet's *Picnic,* which was an hommage to Manet's groundbreaking work.

With Monet, Bazille would go the Cafe Guerbois, the rendez-vous of the future lights of the Impressionist movement. There he met among others, Emile Zola, who was to create a literary portrait of him as Lucien de Hautecoeur in his novel *The Dream.*

Late in 1866 Monet was forced to destroy almost two hundred of his paintings rather than turn them over to his creditors. Fleeing their pursuit, Monet removed himself to Ville-d'Avray with Camille. Moved by his distress, Bazille bought his largest canvas of this period, *Women in a Garden,* for the very generous amount of 2,500 fr. This he paid to Monet as a monthly stipend of 50 fr.

Bazille spent the summer of 1867 in the Languedoc at his family's estate in Meric. Gabriel Sarraute has described this beautiful spot: "From above one can see transfigured the bell towers and arbors of the town. And then far in the distance one sees the shimmering horizon of the sea." It was there that Bazille painted one of his greatest canvases, *The Family Reunion,* challenging himself with a difficult range of blues and greens. All is composed with the utmost care from the various subjects to the bouquet placed on the ground next to a straw hat and an umbrella.

Three years later, Bazille had just completed his undoubted masterpiece, *The Studio on Rue de la Condamne,* when war was declared on July 15. With the news of the first French defeats, Bazile enlisted in the army, even though he had an exemption from military service. During an assault on the 28th of November he was struck in the chest by two bullets. Lying beside a little brook he died on the field of battle at four in the afternoon. He was only twenty-nine years old.

Bazille loved the outdoors, forms strong and legible and the clarity of the countryside as is surely demonstrated in his wonderful canvas, *Summer Scene.* Here the forms of male bathers spring from a background of greenery. He also painted portraits of Renoir, Sisley & Monet. His reputation and future as a painter were assured when they were cut short by the fortunes of war.

Family Reunion, 1867
(152 x 230 cm)
In this picture, Bozille has painted a portrait of his family on the terrace at Meric. It is one of the first of the new paintings, done outdoors with natural patches of sunlight.

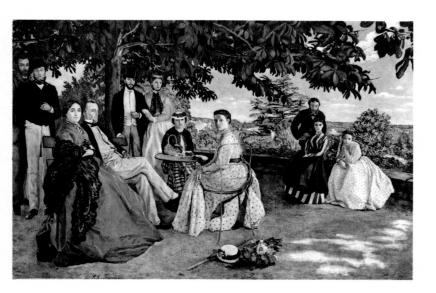

BONNARD Pierre

Fontenay-aux-Roses, 1864 - Le Channer, 1947

Blessed with a remarkable sensitivity, Bonnard arrives as a kind of final flowering of Impressionism, its greatest glory. He was the glorifier of women and after, of nature washed in light.

Bonnard was the son of a bureaucrat at the Ministry of War and an Alsatian mother. After passing his bar exam Bonnard studied at the Academie Julien in company with Vuillard, Serusier and Maurice Denis, with whom he formed the group of Nabis, which was to follow in Gaugin's footsteps.

Bonnard is at one and the same time the last practitioner of Impressionism and one who while preserving a figurative mode, succeeded in painting reality without realism. By filling his figureation with the depth of his emotion, he succeeded in manifesting a kind of visual poetry.

Bonnard spent his childhood in the family house and the garden of the Grand-Lemps at Isere. His love of painting soon distracted him from his law career. He spent his working time in short stints at the School of Fine Arts and long hours at the Academie Julian. It was there that one fine day Paul Serusier brought his astonished friends a marvel of color, improvised on the cover of a box of cigars. They called it the "talisman." It was this sketch that inspired Bonnard and his friends, Maurice Denis, Vuillard, and Vallotton, to form with Serusier the Nabis.

Mirror in the Bathroom, 1908
(120 x 97 cm)
No one has done intimate secrets better. Everything here is done with great delicacy. The idea of letting us see the woman only through her reflection in the mirror is a felicitous touch.

The Seine at Vernon, 1917
(109 x 105 cm)
A charming summer scene painted at Vernon, where Bonnard had a summer house called "Ma Roulatte."

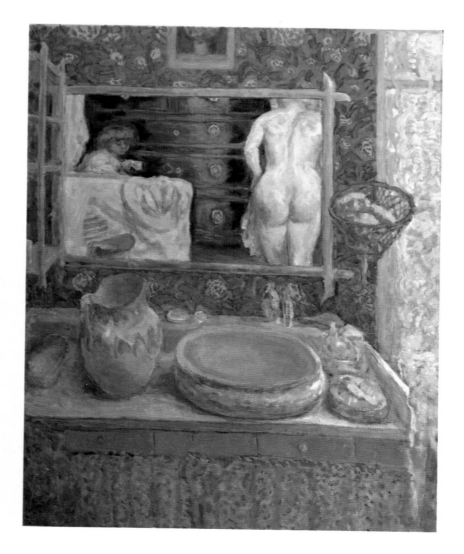

Bonnard's poster, *France-Champagne,* attracted Toulouse-Lautrec's attention (the poster eventually brought 100 francs). Soon came the exhibition at the Salon des Independants and in the gallery Le Barc de Boutteville. Bonnard was at this point ready to do any work that came to hand. He had a studio on the Rue Douai. He illustrated a little music book for his brother-in-law, Claude Terrasse, did scenic design for the Theatre des Pantins, and made a suite of lithographs for Verlaine's *Parallelement* as well as for the classic erotic work, *Daphnis and Chloe.*

Starting in 1910 Bernheim-Jeune became the principle dealers handling the artist's work. Bonnard bought a small house which he called "My Trailer," near Vernon in the Eure, while still keeping his small studio above the cemetary at Montmartre.

After a retrospective at Druet where he showed sixty-seven canvasses, Bonnard moved to a house called "Le Bousque" in the Midi near Cannet. He also installed himself in Paris at 48 Boulevard des Batignolles. In 1932, there was the great exhibition of Bonnard-Vuillard at the Kunsthaus in Zurich. This was followed by exhibits throughout the world (London, Chicago, Stockholm, etc.).

During the Second World War Bonnard returned to Cannet, where he painted *Woman in the Bath.* Growing ill and saddened by the death of his wife, he continued to work. His last painting was *Almond Tree in Flower.*

Bonnard's painting has a troubling element to it. Imprinted with an interior sureness, its balance is constantly threatened by the figure of the woman, which is present throughout the entire body of his work. Tall, erect, hallucinatory, she stands in an open doorway. A light from the city flows down her shoulder over her thigh; supple, light, shivering, she dresses herself in a room where her scattered clothes lie fallen.

Pierre Bonnard was a master at evoking natural scenes and the cafes of Clichy. But above all he was a painter of women. In paintings such as *The Bathroom Mirror* and *Nude against the Light* he translates their magnetism onto canvasses bordering on the visionary.

He is also a painter of color and light, of sunlit days, dark odorous shades, the fragile light of early mornings, a poet of blue greens underneath an enormous incandescent

Mother and Child, 1894
(33 x 42 cm)
In this outdoor scene, Bonnard is able to convey the tenderness of the mother and child by contrasting the light of the background.

sky. He knew well the vibrations, subtleties and powers of color. For him art was enchantment, emotion, discovery. Form was wrought slowly out of torment. What did it matter what shape it was to take, be it a dog, a face or a figure lying on a beach. His art transforms substance.

There was a remarkable collection of Bonnard's work in 1967 at the exhibition of the centenary of his birth at the L'Orangerie des Tuileries.

Twenty years had passed since he had last appeared at the door of his ville at Cannet, followed by the yellow basset hound he had painted so often. I see him standing there wearing pants two sizes too big, glasses clamped onto his nose and saying humbly, "The price they're asking for my paintings, scandalous is it not."

Bonnard was a painter of wonders. The eternal figure of woman gazes at us from his radiant paintings, bearer of some unfathomable but life-affirming secret; she is a magician and escapes our efforts at definition. She is a product of that imaginative landscape that we have glimpsed in the music of Debussy, the writings of Proust, the ideas of Bergson. There also we encounter Bonnard.

Nude Against the Light, 1908
(125 x 109 cm)
In the shimmering light of Paris, Bonnard has placed Marthe, his favorite model, in front of a window next to a tub. She became his wife.

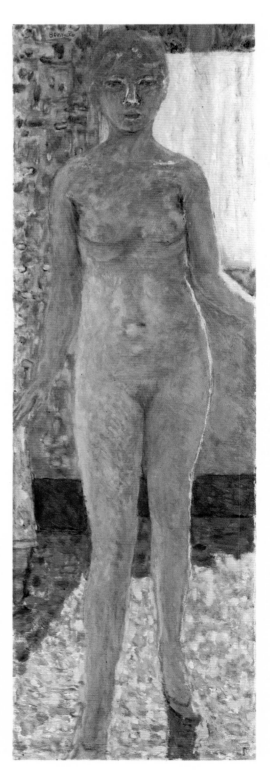

Nude Against the Light, 1908
(122 x 38 cm)
Here we see her standing with mauve and orange highlights which seem to reflect the light. In the detail of the bust of the figure, we can see how the brush of Bonnard has evoked the essence of woman.

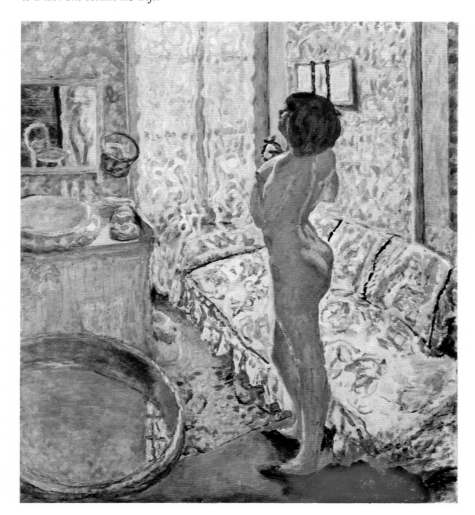

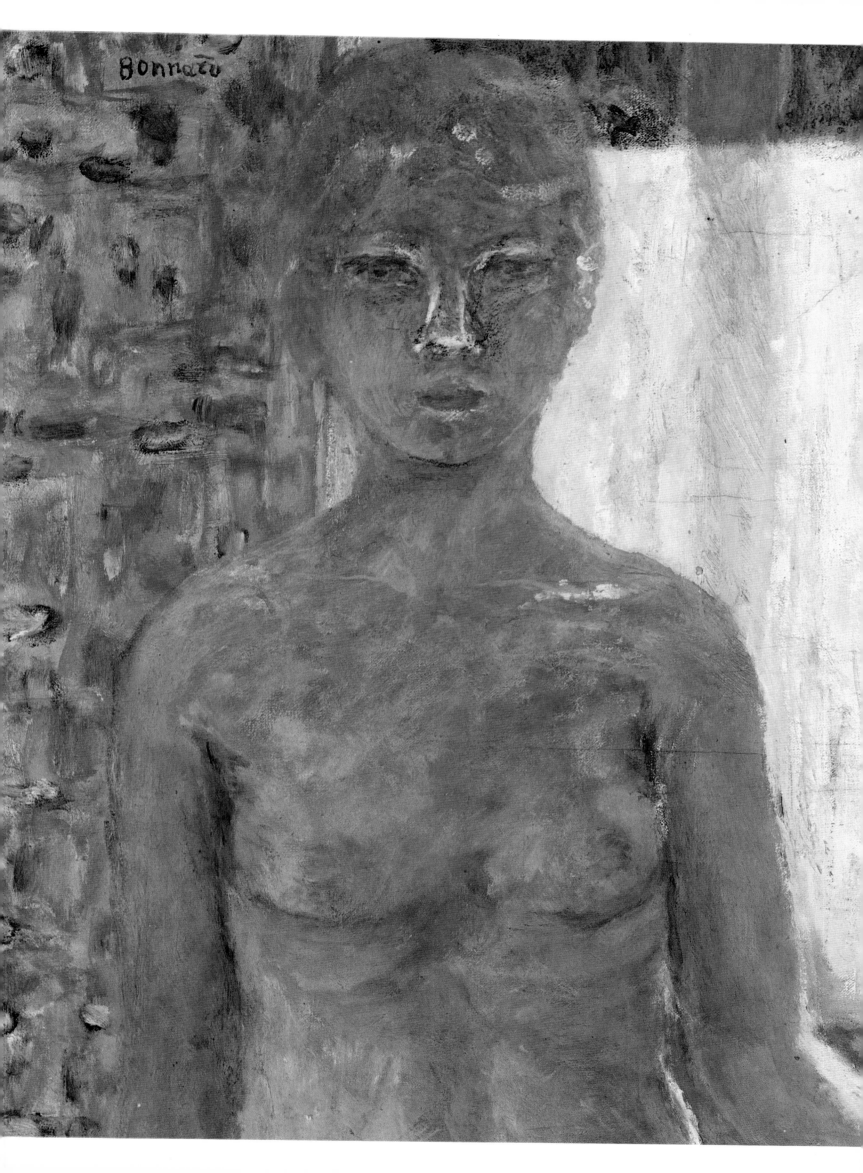

BOUDIN Eugene-Louis

Honfleur, 1824 - Deauville, 1898

After having painted Breton washerwomen and the ports of Normandy, Boudin became an observer and painter of atmospheric conditions on the Normandy beaches peopled by summer vacationers from the Second Empire.

An important precursor of Monet, he was a painter of beaches where among the vacationing crowds are scattered pretty ladies in the crinolines of the Second Empire. Eugene Boudin is an Impressionist before the advent of Impressionism.

Giving up his picture frame shop in le Havre to pursue his love for painting, he concentrated on paintings of sky, sea, and vacationers on the coast of Calvados. He became the definitive depicter of changes in weather, of winds and clouds. "Three brush strokes following nature are worth more than two days work at the easel," he used to say.

We see in his work a light rapid delicacy of touch that anticipates Monet. It clearly exists in his *Twilight on the Basin at le Havre,* which can almost be mistaken for a Monet.

At the Salon of 1859, Baudelaire deplored the lack of imaginative power in the work of the majority of landscape painters. But of Boudin's pastels he wrote that they render that which is "most inconsistent and difficult to apprehend, the prodigious genies of air and water." For the poet Boudin was the creator of "meteorological beauty." In fact Baudelaire was known to have said that one could always tell the season, the hour and the direction of the wind from a Boudin painting. Long before Claude Monet depicted the cathedral at different hours of the day, Boudin had already written on the margin of a sketch "October 8, noon, wind from the northwest."

Going through le Havre in 1860 Courbet saw a show of some of Boudin's paintings. Inquiring as to the painter's address, he visited Boudin at home. "It's incredible," he told him upon seeing a painting of the Channel that Boudin took out to show him. "There is no one who knows the sky as you do."

In Paris, Boudin stayed mainly at his lodgings in Montmartre. Matisse tells us that he visited the artist at Vintimille Square (today Adolphe Max Place). He described it as lit by a bay window which threw a shadow below it. In this shadow was a couch. Something moved in the shadow. It was Boudin, a little man, dressed in gray. "I am bored, I am bored," he muttered. He languished when far from the sea and open sky.

He died in Deauville of cancer, close to his beloved sea.

A Beach at Trouville, no date
(19 x 46 cm)
Boudin had a strong influence on the Impressionists, especially on Claude Monet. In strong, swift strokes, he vividly brought to life the sky and the sea.

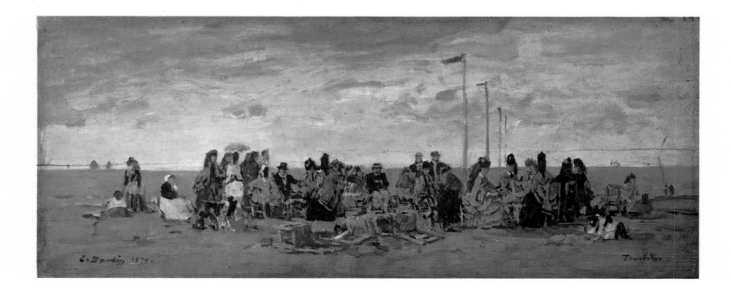

CAILLEBOTTE Gustave

Paris, 1848 - Gennevilliers, 1894

This friend of the Impressionists was both collector and painter. For a long time his importance in the former field overshadowed his reputation in the latter. But of late there has been a favorable reappraisal of his work, in which one can find the marks of a considerable artistic individuality.

From a well-to-do family (his father was a judge) Caillebotte entered the atelier of Bonnat at the first School of Fine Arts in Paris in 1873. He was at one and the same time a painter and a patron of the work of his friends who were at that time struggling to give birth to a new movement of painting. He accumulated one of the most important collections of Impressionist paintings of his time. He was twenty-five when his father died, which left him in the possession of a considerable fortune. Admitted on the suggestion of Renoir, he joined in the second Impressionist showing (1876) and after that became one of the driving forces of the movement.

After working on rather conventional interiors, his painting took a more individual bent. This can be seen in paintings such as *Sailmakers in Argenteuil* (he had a house there where he liked to invite many of his friends in the arts). Caillebotte distinguished himself from his comrades by particularly intimate knowledge of the streets of Paris. It is thus that we have his bird's-eye view of the streets in his *Refuge Boulevard Haussmann,* with its passersbys reflected in the street lamps, and his *A Rainy Day in Paris.*

In his self-portrait Caillebotte has a somewhat contemptuous expression. It is as if he were saying to the artistic establishment, "You, I know you; you confused your contempt for true art with your taste for the conventional." His distaste for the academic school of painting led to a rupture in his family relations. Perhaps the most famous tribute to Caillebotte can be found in Renoir's *Luncheon of the Boating Party.* It is he astride the chair in the foreground.

At his death Caillebotte left his entire collection to the Luxembourg, but on the advice of the French Institute the government rejected the bequest. It was not until Clemenceau's personal appeal the following year that the museum finally decided to accept thirty-eight of the sixty-five paintings of the original legacy. They only accepted Renoir's *Le Moulin de la Galette* because the painter Gervex, an academic of middling talent who had flirted with Impressionism, figured as one of the subjects in the painting.

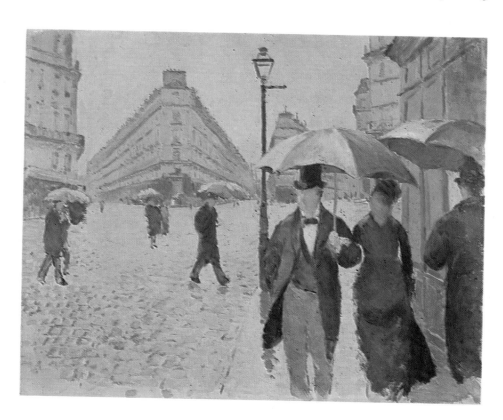

A Street in the Rain, no date
(54 x 65 cm)
This is the first version of this picture. In this canvas one gets a real feel of the gray, wet streets of Paris in the rain.

CASSATT Mary

Allegeny, Pennsylvania, 1845 - Mesnil-Theribus near Beauvais, 1926

Degas called her the "American of Paris." She was a painter primarily of motherhood and a lithographer of universal fame. She was part of the initial wave of Impressionism.

Born of a rich banker from Pittsburg, Mary Cassatt dared to go against the will of her father and pursue her love for painting. At the age of 24 she traveled through Europe and stayed to work in France. She studied first with Chaplin, a portraitist of a certain delicacy but for all that still rather academic. During the course of a visit to the Salon of 1874 she learned that Degas had praised the head of a young dancer that she had painted. She admired along with the work of Courbet, Manet, and Cezanne, that of Degas, the master of the dancing figure. Degas came to see her at her studio in 1877 and it was there that he invited her to participate in a group show of Impressionists, which she did in 1879. She exhibited two canvasses. In one, she painted her sister dressed in white, seated in a long armchair. Her legs are cut off by the frame, in the Japanese style. She had seen with Degas the exhibition of oriental prints at the School of Fine Arts,

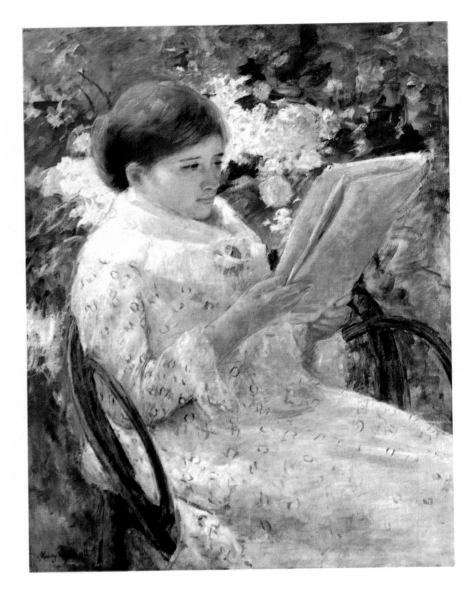

A Reader in the Garden, 1880
(89 x 65 cm)
In bright fresh light, in the middle of a flower garden, a woman sits reading.

The Bath, 1891-1892
(100 x 66 cm)
In a personal and naturalistic way, Cassatt gives this picture of a mother and child a warmth of feeling by placing the basin at the bottom; the balance is quite Japanese.

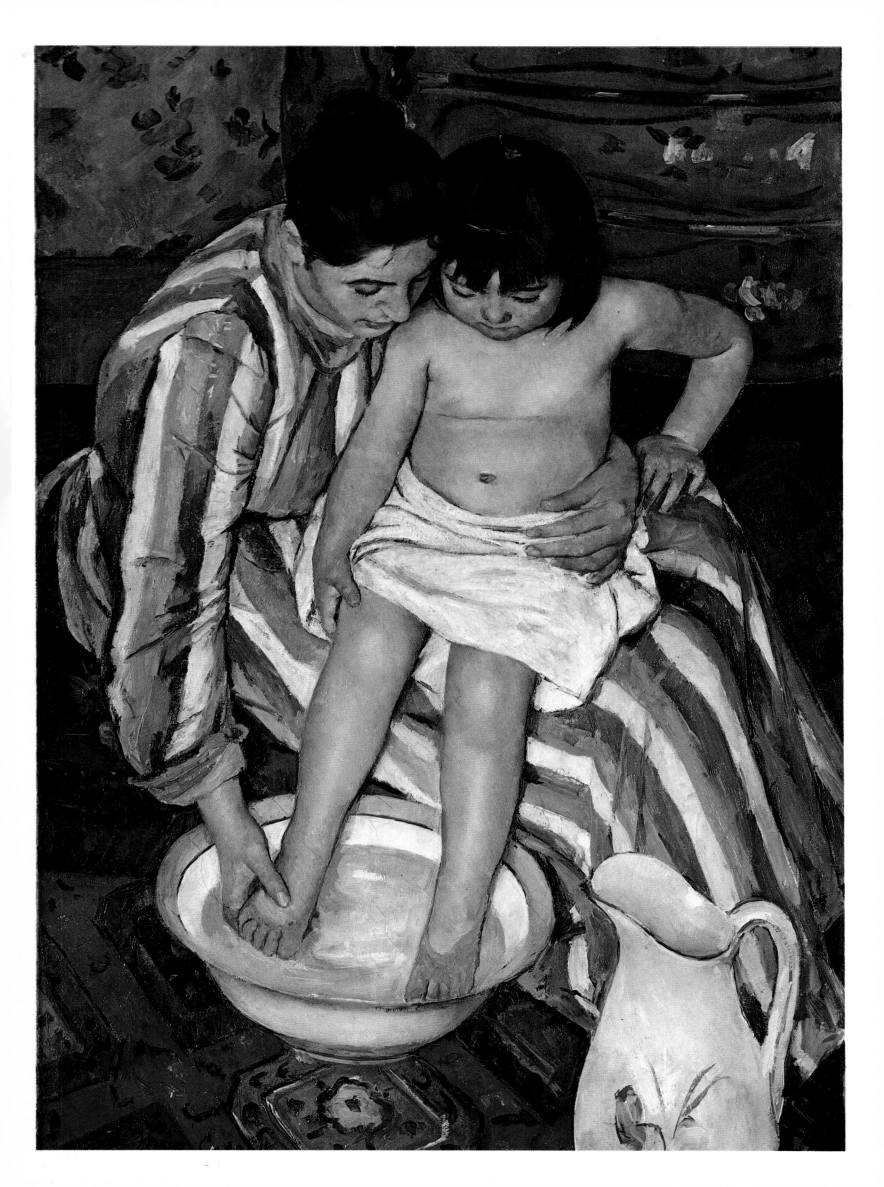

and was greatly taken by it. She admired the flat tones of Hokusai and Utamaro. Her work certainly reflects the influence of these Japanese masters.

Cassatt was never seduced by fame and fortune. She was highly suspicious of fads and the applause of crowds. Had she not had a painting accepted by the Salon of 1876, which they had rejected previously?

Degas painted his protege from the back leaning on an umbrella in a movement totally natural, contemplating an Etruscan tomb at the Louvre.

In 1884 Paul Durand-Ruel, dealer for the Impressionists, was on the verge of bankruptcy. After an exhibition in New York, Cassatt interested her friends, mainly Louisine, wife of the "Sugar King" Henry D. Havemeyer, in making substantial purchases. For this reason the Metropolitan Museum in New York is as rich in the works of Courbet, Manet, Monet and Renoir as the Louvre.

In Paris Cassatt is linked with Montmartre. After having lived on the Rue Trudaine and having had her studio on the Boulevard de Clichy, she settled in 1887 at 10 Rue Marignan. She was accustomed to summer at Louveciennes. Then in 1891 she rented the Chateau of Bachvillers in the Oise. From 1911 on she spent the winter in Grasse (a photograph taken at the Villa Angeletto shows her with a pensive countenance). It is there that, as with her teacher Degas, she finished her days in total blindness.

Critical opinion of Cassatt's work has varied over the years. Perhaps she made excessive use of maternal figures, soft and rounded, who with child in arms, caused Degas to observe: "Here is the baby Jesus with his nurse." This did not stop Gustave Geoffroy from remarking on "the fine way she had of seeing mother and child in the light in the garden, and in rooms where light filters through drawn blinds. Their concord is usually expressed in vibrant breathing flesh tones and their fresh clothing."

Often her evocations of young girls make one think of a rose wrapped in a cornet of white paper. Here she concentrates her feelings for childhood. She had a way of painting that seemed easy without really being so: In her portraits she gives her full attention to the face, but without mannerism.

Cassatt never comes across more clearly than in her *Self-Portrait* painted in gouache with an alert, delicate touch in 1878 (Proskauer collection), where she is wearing a white dress, gloves and a flowered hat. Leaning on her elbows on a sofa, she has the air of waiting for someone or something.

More than that of Degas or Manet, it is the influence of Fantin-Latour that appears in this portrait of herself. The artist shows herself in her every day aspect: resolute, she seems to be criticizing her own painting.

A painting of her sister driving a barouche with reins in hand, touches on the independent nature of American women. Here we have someone who could certainly understand Scarlett O'Hara of *Gone with the Wind*.

Cassatt was the only American to be a part of the Impressionist group. She showed with them in 1879, 1880, 1885, and 1886. She preceded a generation of American artists influenced by Monet, including Sargent, Robinson, Butler, and Hassam.

It was not until her death that Mary Cassatt was seen along with Degas, Pissarro and Bracquemond to be one of the great aquafortists of her time. The whole of her oeuvre lays open the complex nature of motherhood.

Young Woman Sewing, 1886
(92 x 65 cm)
Outdoors, a young girl is sitting on an iron chair in the middle of a planting of geraniums. Behind her is an evocation of the woods. One doesn't know which is more arresting, her serious intent face, or the fine detail of her busy hands.

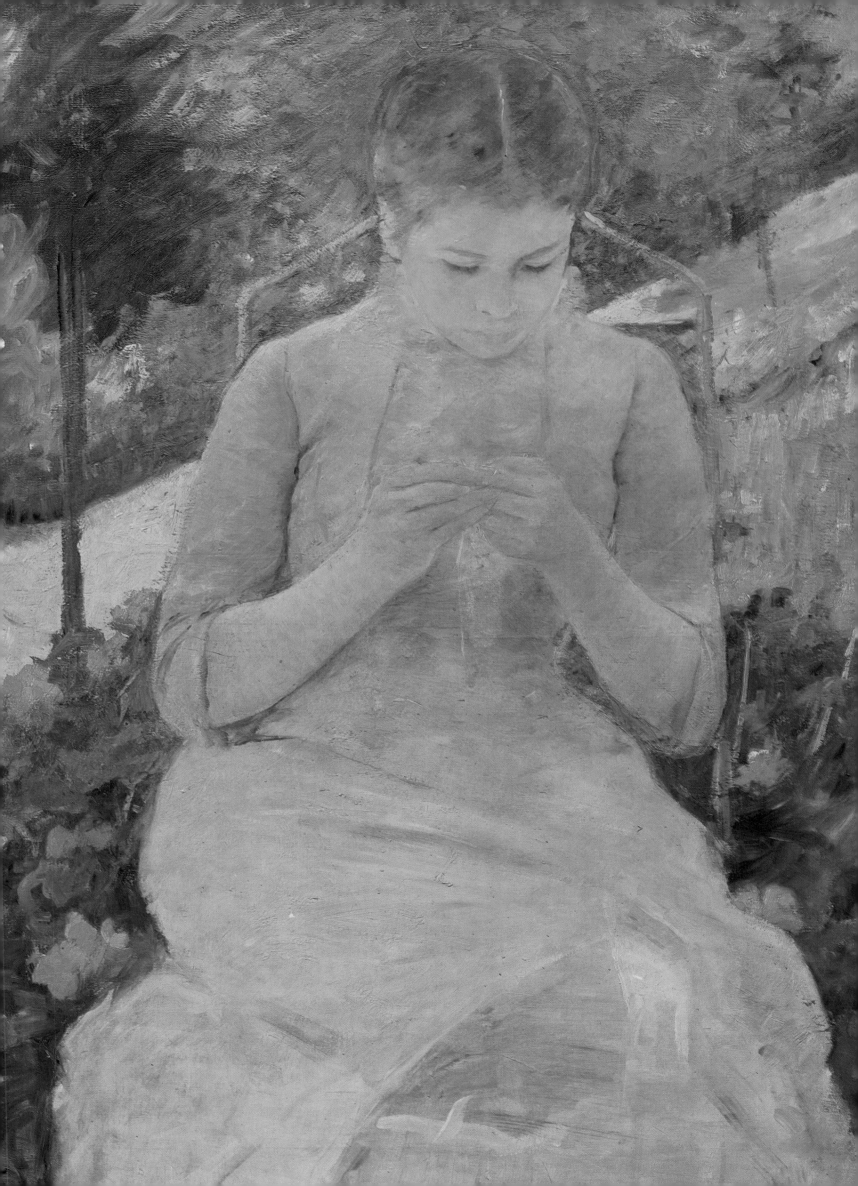

CEZANNE Paul

Aix-en Provence, 1839-1906

Cezanne is singular among his fellow painters in the Impressionist group. His work ranks with the great masters. In concept and in substance Cezanne's influence has extended over the entire first half of the 20th century and continues to be felt today.

The details of Cezanne's life are well-known—his birth in Provence, the relative freedom he enjoyed throughout his life, his arrival in Paris where he met Pissarro, his friendship and subsequent break with Emile Zola after seeing himself caricatured as a failed artist in Zola's novel, *L'Oeuvre*. Cezanne's work didn't fit into the Paris scene. After being there and seeing the early efforts of the Impressionists he returned to the warmer, more hospitable environment of the Midi to live out his life.

A great deal has been written about the difficulty Cezanne had in painting, his meticulous approach to his work, his sincerity, and his artistic sensitivity. A master colorist, he juxtaposed his tones on canvas with painstaking care. According to Renoir, "He couldn't lay one brush stroke next to another unless it was just right." He defiantly disregarded what he considered to be "noble subjects" showing a preference for the familiar. Three apples on a plate, as portrayed by Cezanne, can touch us in a way we never imagined possible. His work has inspired a renewed appreciation of the purity in Chardin's painting, although the techniques they used show striking differences. Chardin's still-lifes focus attention on the relationships of tones, which are called "values." In Cezanne's still-lifes form is created solely through the use of color. In Cezanne's words, "When color is at its richest, form is at its fullest." In his intimate blending of color and light—the light emanating from the quality of color, as in the works of Vermeer—Cezanne is one of the strongest innovators in painting.

All Cezanne's subjects move the viewer: his blue bathers, his fruits in bowls or on rumpled table cloths, his landscapes, and his early works which were inspired by Pissarro. From the early paintings to his sketches in which two crayon strokes become a palpable tree, or lightly applied aquarelles become sky and sea with a floating boat, or nude women lolling on a narrow stretch of land, his work merits its place next to Delacroix at the Louvre. From the various self-portraits he's left us we see him with his egg-shaped head and military beard, and are surprised at the agelessness of his art. His was an art that ignores changing fashion. How did he manage this?

Cezanne didn't fall into the academic formulas of the conventional studio painters of his time. He worked directly from nature composing as he painted, finding harmonies directly suggested by the subject matter and

A Modern Olympia, 1873
(46 x 56 cm)
This oil was exhibited at the first group show in 1874. At the home of Dr. Gachet one day, Cezanne amused himself by doing this caricature of Manet's well-known painting Olympia.

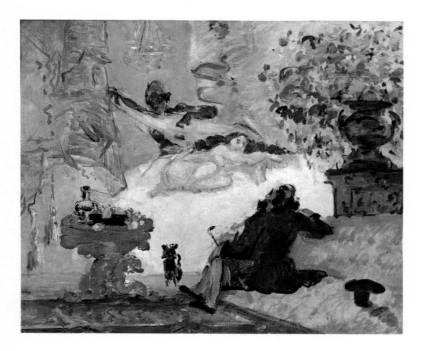

Mme. Cezanne in Her Yellow Arm Chair, 1890-1894
(81 x 65 cm)
One of the many paintings Cezanne did of his wife. In the contrasts of the purplish red of the dress, the mustard yellow of the chair and the blue of the background, one sees the unmistakable pallette of the Master of Aix. Notice also the strong structure of the face and the suppleness of the hands.

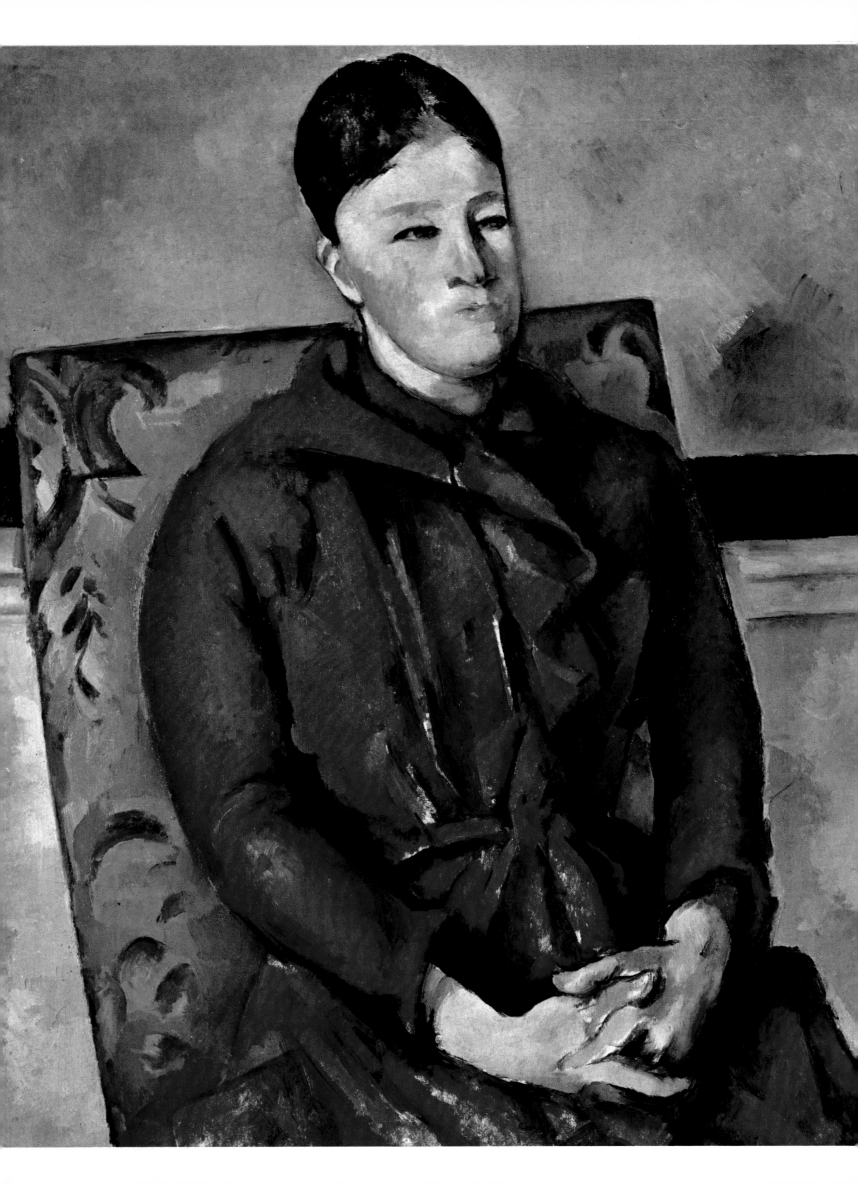

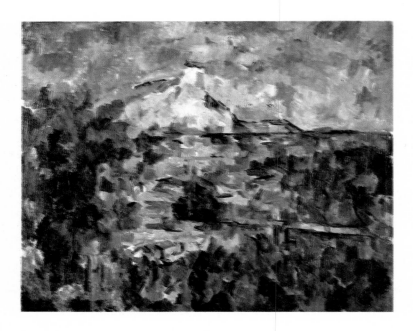

Sainte Victoire Mountain, 1904–1906
(60 x 72 cm)
Cezanne painted many pictures of this mountain. Here he uses it to show the architectural qualities of the peaks, plants and colors.

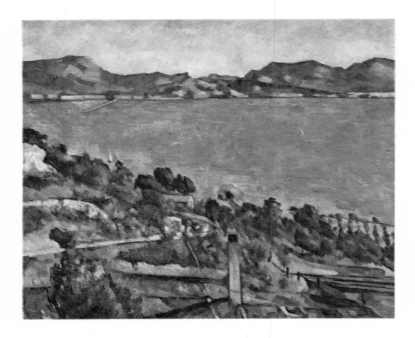

L'Estaque, 1882–1885
(60 x 73 cm)
One of Cezanne's most densely painted oils; between the blues and greens there is an almost tactile sensation. It was here, in the mountains of L'Estaque, that Cezanne hid to escape military service during the war of 1870.

his own contemplation of it. There is no trickery in combining effects or imitating nature in his work. He relied on his own eyes to see the trees, water, and hills before him, and on his mind to unveil their meaning. Poussin only sketched from nature, retaining a strong mental image of what he considered to be most beautiful, often saying that "it's through the observation rather than the copying of nature that a painter develops his skill." Cezanne was no more bound by the observation of nature than was Corot, who would go out every morning to "court the beautiful lady." Cezanne painted in depth. His need to be in nature to paint does not mean that he was a copyist, but rather that he felt impelled to have his chosen subject right there in front of his eyes.

His father was a banker in Aix-en-Provence. Cezanne and Emile Zola were students together at Bourbon High School. Before starting to paint, Cezanne toyed with studying law. His father gave him a modest allowance and Cezanne left home to go to Paris. At the atelier of Suisse, he met Pissarro. During his second stay in Paris Cezanne went to work at the Suisse studio in the company of Bazille and Guillaumin. On May 15, 1863, he showed a canvas at the exhibition of rejected paintings. Zola complimented on it in the publication, *Mon Salon.*

During the time he was repeatedly refused admission to the official Salons, he met a young model named Hortense Fiquet, whom he lived with after the war of 1870. In 1872 Cezanne went to Pontoise with Hortense in order to be with Pissarro. Then they moved to Auvers-sur-Oise where they stayed with Dr. Gachet and made etchings. Gachet purchased Cezanne's *A Modern Olympia* which had already caused quite a stir. The painting was shown again at the first exhibition of the Impressionist group in 1874.

In Paris, he lived on the Rue de Vaugirard and then at 13 Quai d'Anjou, next-door to Guillaumin. He began to quarrel with his father, who reduced his monthly allowance to a mere 20 dollars. At L'Estaque he took care of Renoir when he returned ill from Italy.

During a time when he was suffering from the breakup of a romance, he discovered he was the prototype for Claude Lanier, portrayed as a failed artist in Zola's newly published novel, *L'Oeuvre.* He broke off all ties with his former friend. That same year his father died, and he married Hortense Fiquet. He rented a room at Chateau-Noir which he used as a studio. Having gained the support of the critic Roger Marx, the art collector Choquet, and the author of *A Rebours,* Huysmans, he was able to participate in the Universal Exposition of 1889. While travelling in Switzerland he painted his famous work *The Card Players.* It was during this trip that he felt the first symptoms of diabetes. After *The Card Players* his position in the

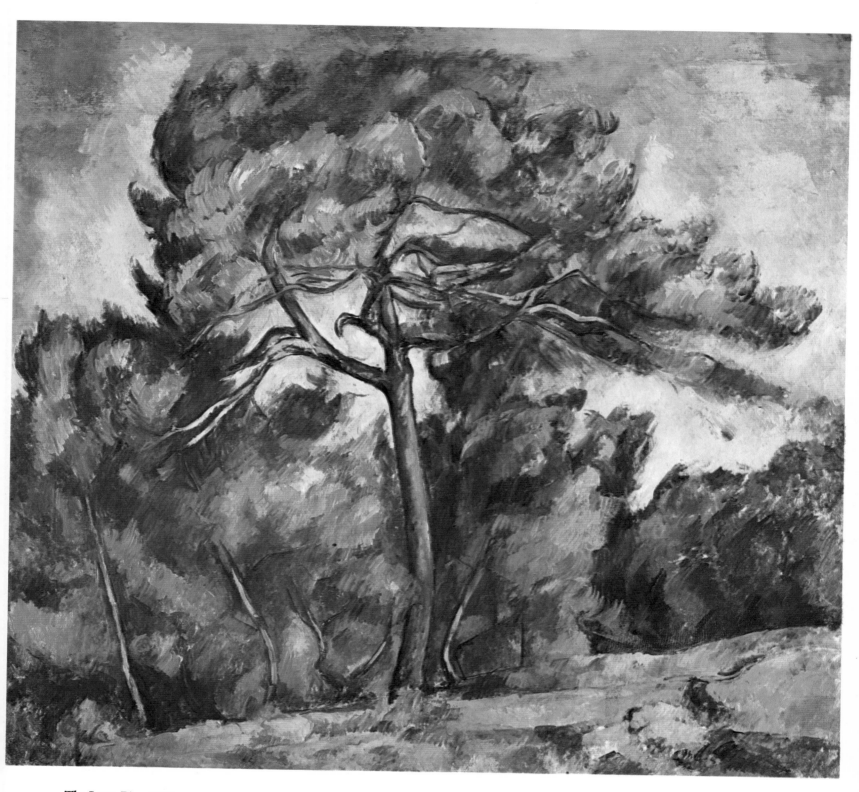

The Large Pine, 1895
(84 x 92 cm)
This oil was painted at Montbriant, during a period of dynamic baroque technique. The trunk of the tree is a strong column, contrasting with the leaves, which are blown by the Mistral.

Large Bathers, 1895 ▷
(127 x 196 cm)
One of many compositions of bathers painted by Cezanne between the years 1894-1905. In spite of its somewhat crude appearance, it has wonderful richness and rhythm. It is also a precursor of Cubism. Cezanne worked on it for ten years.

23

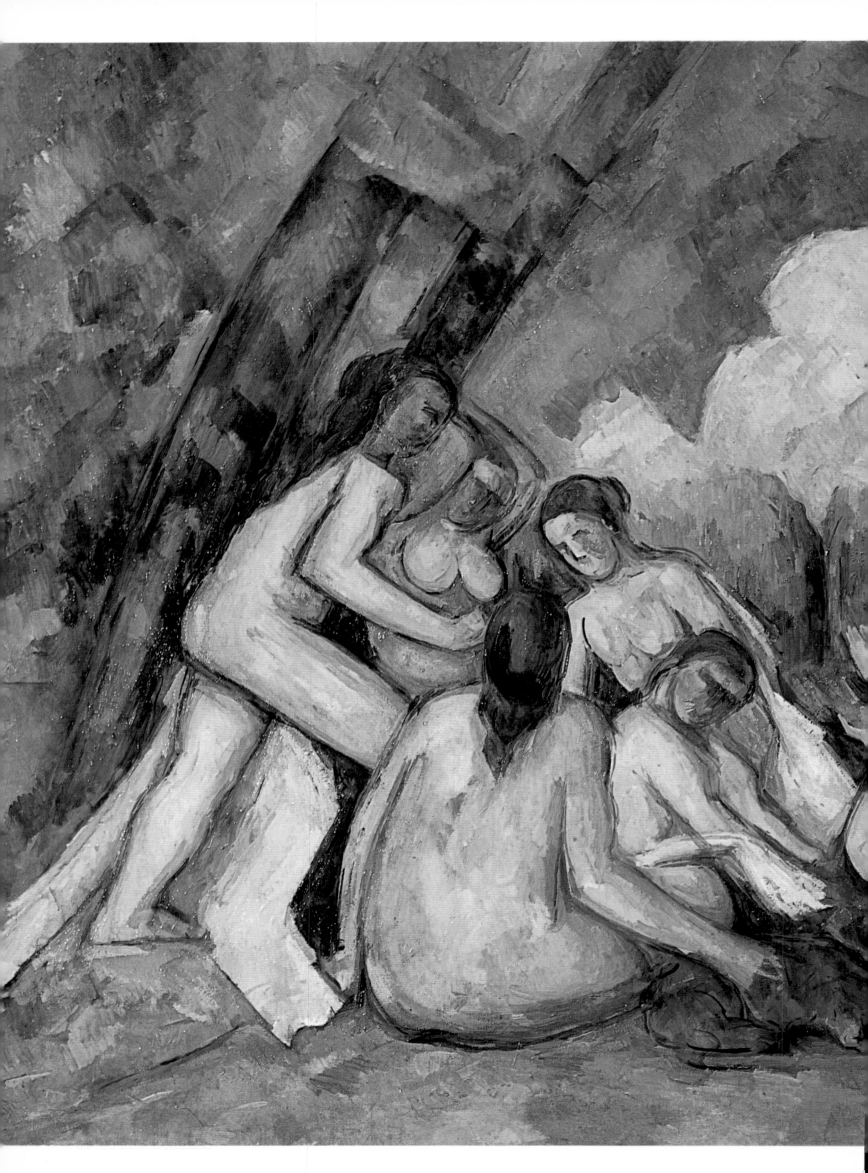

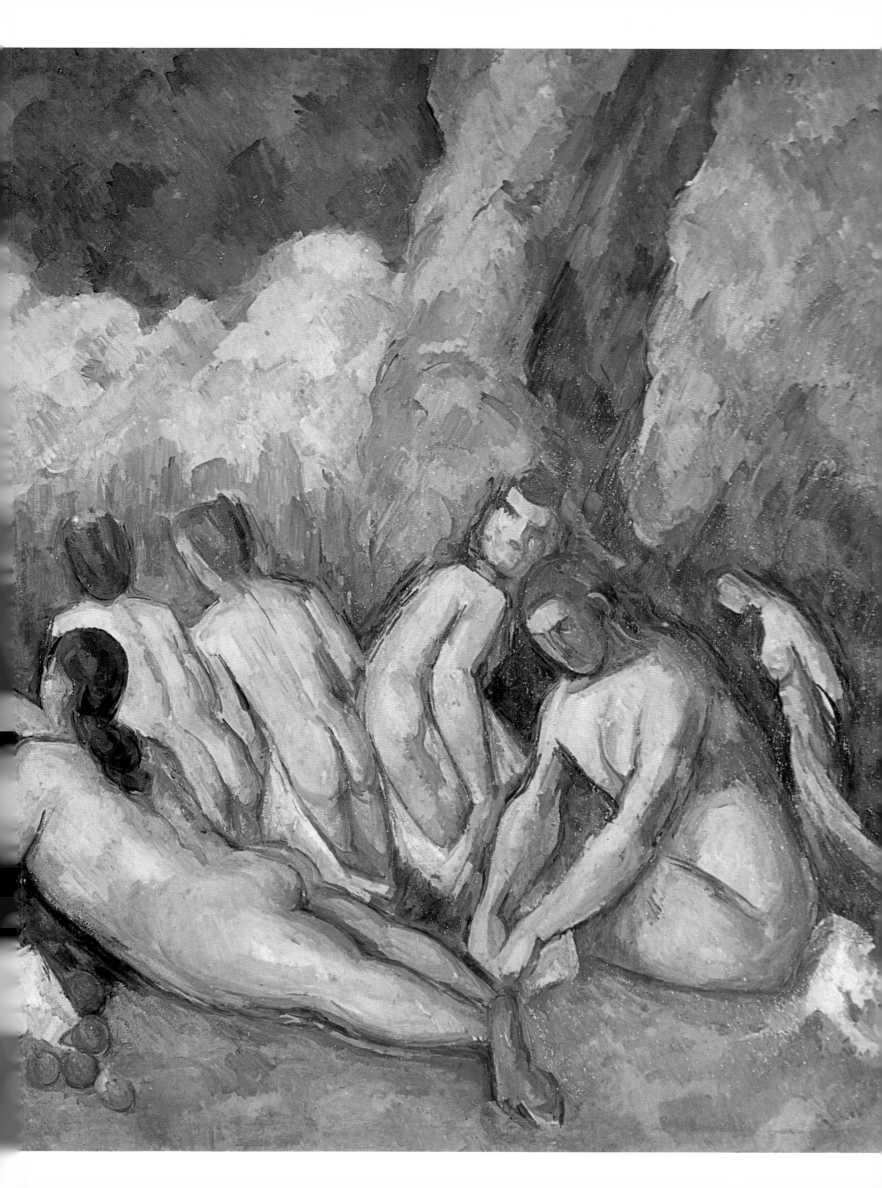

art world improved. He painted a portrait of Gustave Geffroy, who wrote an article about him. He lived for awhile in Giverney at the home of Claude Monet, exhibited with Vollard, the avant-garde dealer, and painted a portrait of Joachim Gasquet, his first biographer. The number of his admirers continued to grow. The Salon d'Automne dedicated an entire room to his work in 1904. He went on painting, up until the *La Montagne Sainte-Victoire* canvases, his last.

There is an element of truth in Cezanne's comment about Monet: "His is only an eye, but there is none other like it." Impressionism has given us tones and shadows of day light that had previously been ignored in painting. It is, above all, visual, caressing, flattering, and enchanting to the eye, but it rarely penetrates to the heart. Cezanne is an exception. His obstinate devotion to work and his acute analysis of nature before recreating it in its essence on canvas, is full of emotion and meticulous probing. He gets to the core of things, and we can feel the painters presence in all he portrays.

Nature was neglected during Cezanne's time, and painters dealt with it through the conventions of the atelier. Cezanne's direct use of nature is therefore significant. The complete presence of the painter in his subject matter is as evident in the still-lifes of Cezanne as it is in an odalisque by Ingres. The painter is saying: "Love these fruits as I have loved them."

Although he worked with Venetian colors and Baroque style, he always chose Dutch subject matter. He did more than the Dutch Masters, however, by adding a different and previously unexplored depth to simple objects. All his greatness lies in his subordination of light to color. He's the first artist to have given such a powerful voice to inanimate objects. His work is filled with emotion.

Cezanne grasped the rolling hills and the earth of Provence with open eyes. He measured their scale to match the beats of his own heart and instinctively made his way to their essence. He used his native Provence to fashion the material he needed to create his own world. Capturing the luminous grey of the Midi, he gave local festivals a universal quality. The elaborate combs worn by the beautiful women of Arles and of Aix when they pose today for postcards became simple combs on the painter's canvas, combs that were painted to hold the hair of all women.

Cezanne started with a reaction, an effect, and went

Bathers, 1890–1894
(22 x 33 cm)
Cezanne, possibly remembering his student days, shows in an exaggerated way human bodies in a pastoral setting. Forms of both humans and plants soar into the air.

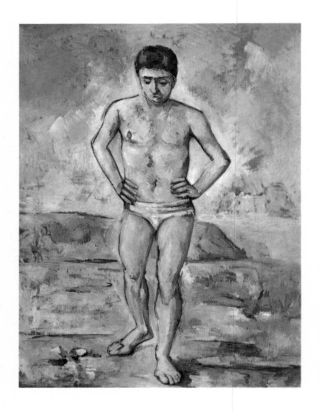

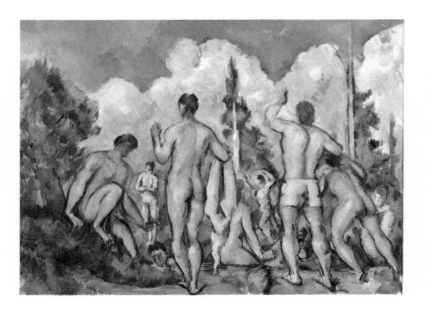

Bather, 1886
(125 x 95 cm)
Cezanne painted both male and female nudes in his series of bathers. Here we have a lone boy in the open air.

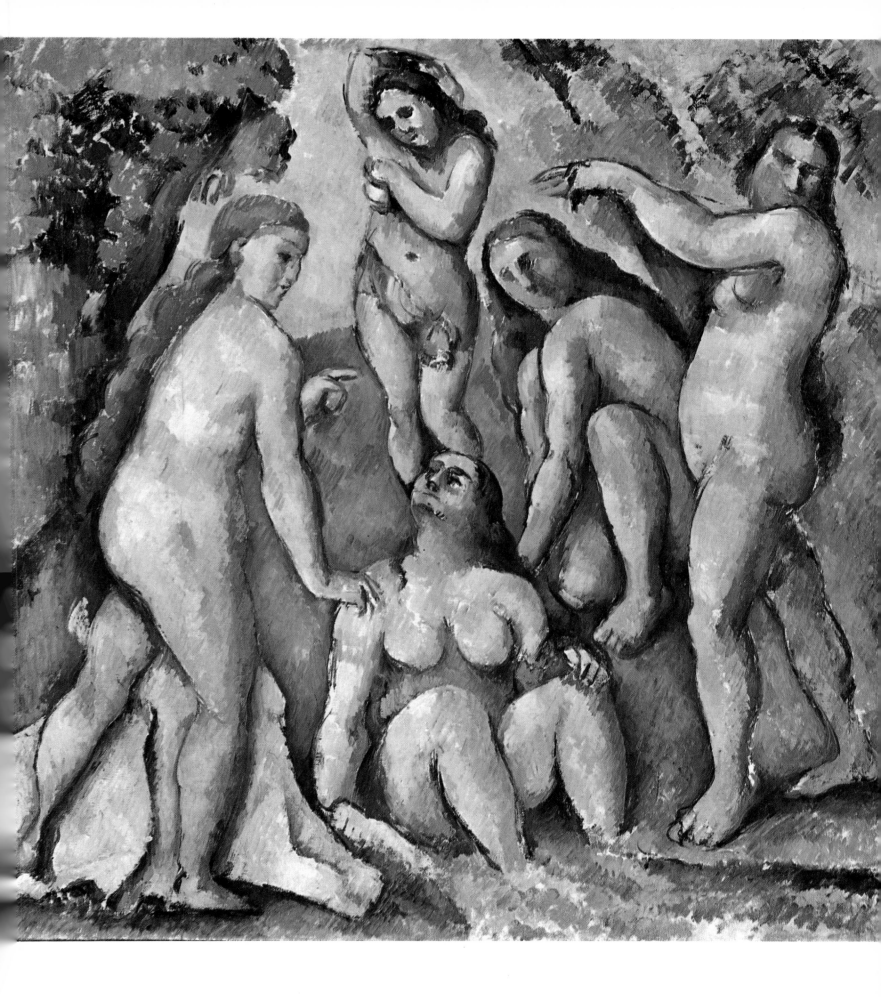

Five Bathers, 1885–1887
(66 x 65 cm)
*This painting of bathers is the most surprising and the
most complete of the series. The painter wanted to "redo
Poussin in nature." It is a majestic synthesis of rhythm
and form, a "concert" of female curves.*

27

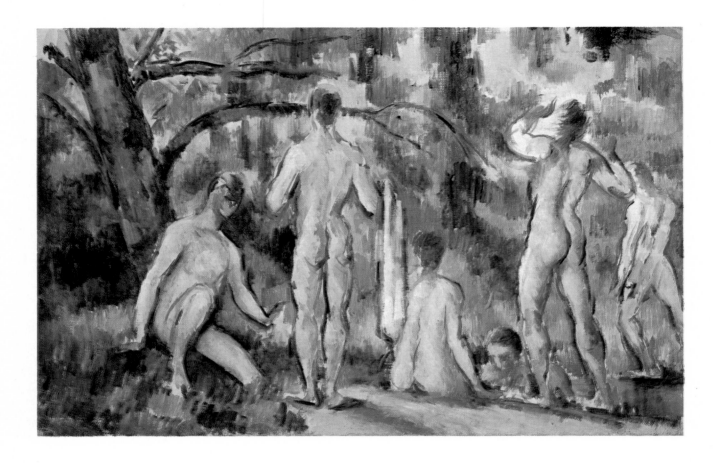

right to the source of it. All distracting elements and all possible detours disappear, as if a divine and invisible hand were guiding the artist's brush strokes. He never thought about the utility of painting. Nor was his work riddled with the selfishness of art for art's sake. His work is a veritable celebration of painting.

In the aftermath of Cezanne's life there's a pungent aroma of rusticity, frankness, and belief. He never adorned his work with the polish and frills that lesser talents so often do. His greatness resides in the unique sensitivity and profound love that emanate from his work. I can imagine him in the solitude he maintained. He was without any trace of bitterness. As a painter he opened his soul to the inscrutable mysteries of nature. He knew how to listen to the sounds in the trees that spoke directly to him. He was as attentive to the earth as a man who turns to the woman who is carrying his child.

Cezanne was somewhat afraid of women. The only women he allowed to pose for him were his wife, or those he referred to as "old pieces of meat." In *The Bathers* he's primarily concerned with the rhythms on his canvas. He's more preoccupied with the modelling of the figures than with the figures themselves. The most successful of these can be seen at the museum in Basle, Switzerland. Cezanne seems to be most sure of himself with villages,

Study for Bathers, 1892-1894
(26 x 40 cm)
A variation on the canvas of "The Bathers" that is in the "Jeu de Paume" museum. This has the addition of a large tree at the left. The next to last figure on the right is a woman.

Old Woman With Cap, 1896
(81 x 66 cm)
I can't see this old woman without thinking of Gustave Flaubert's "Old Servant" with a rosary in her hands, head bowed; she is a personification of resignation and perpetual devotion. The whole has a mysterious mournfulness.

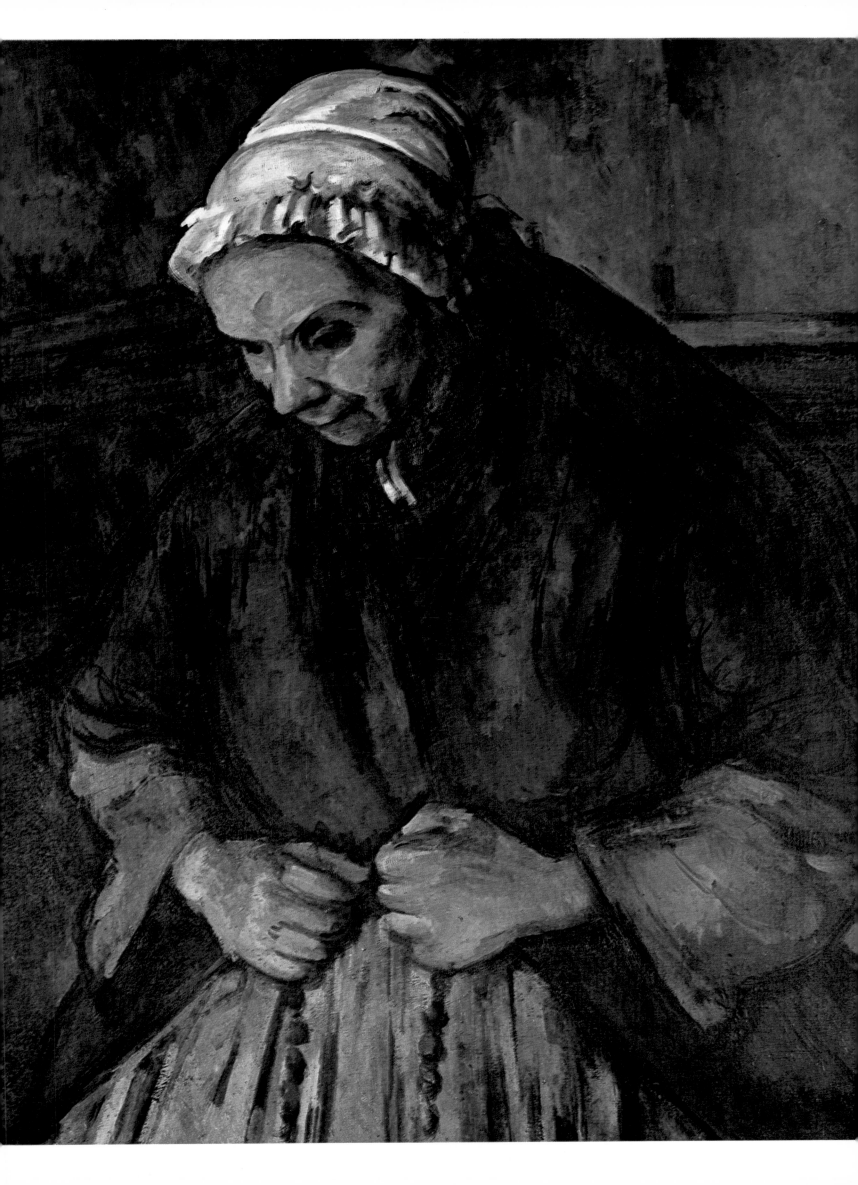

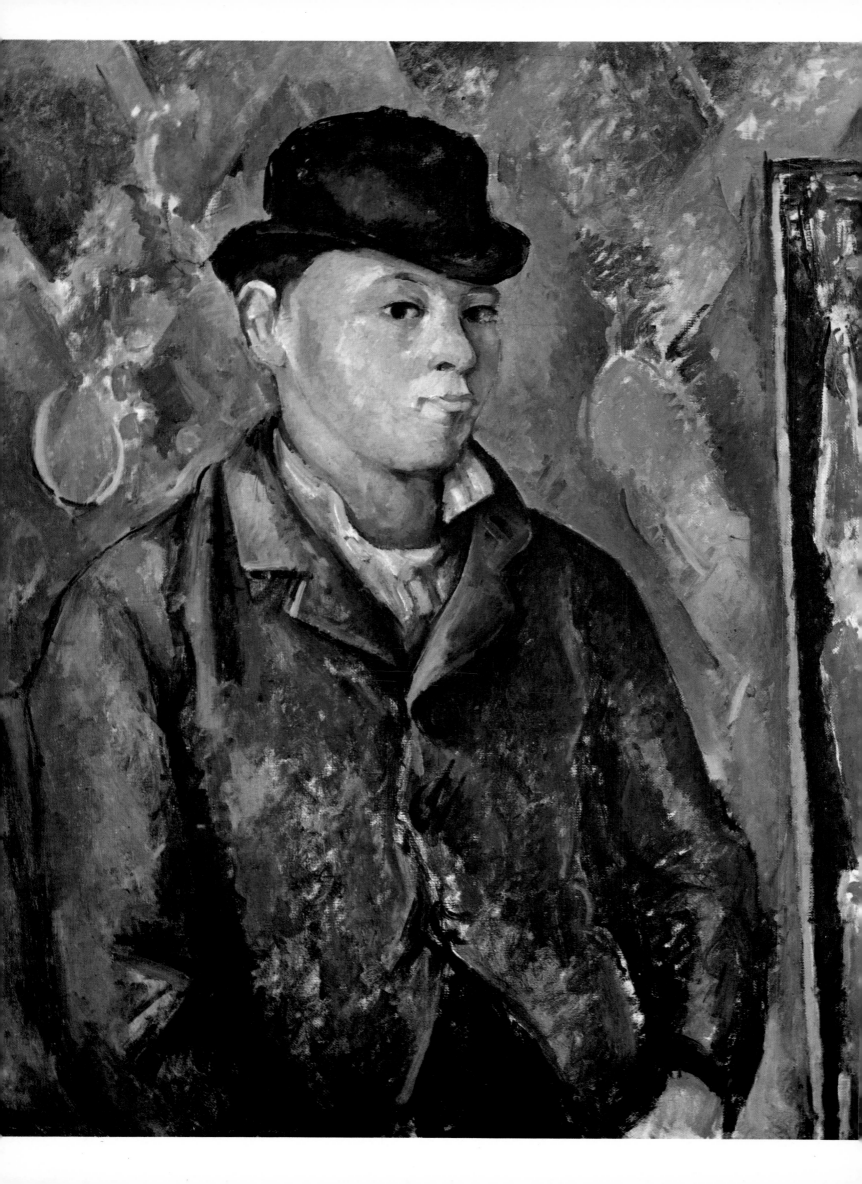

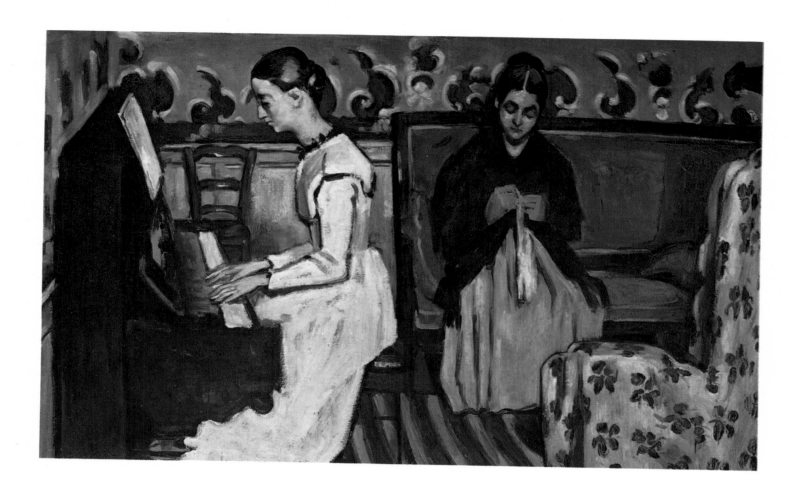

Young Girl at the Piano, 1867-1869
(57 x 92 cm)
This is a work that resembles music. In this canvas, the painter was able to make the sound of the piano seem to echo in the quiet of the room.

Paul, Artist's Son, 1885
(65 x 54 cm)
In this portrait of his son, one can see with what patience Cezanne worked. One could say that every brush stroke was carefully placed, and as always he preferred to leave the final appearance unfinished.

housetops, glimpses of trees or of his wife, all of which inspired him with more readily communicable emotions. The extreme simplicity of these subjects makes them all the more moving. He had the rare ability to transform the simplest things into images of beauty. He infused his feelings into the light on a wall or into the weighty fullness of a piece of fruit.

There's a lesson to be learned from the painter's isolation. Cezanne wasn't very famous during his lifetime nor did he have the satisfaction of foreseeing the reputation his work would enjoy. He had no way of knowing that such an issue would be made about how he lived his secluded life in Aix-en-Provence, spending his days far from the public eye, content to paint the patch of earth and rolling hills that provided him with an image of the world. It appears strange to us to hear of him one day suddenly pounding his fists on the table and announcing to his provincial friends in a holy rage: "Don't you realize that I'm the greatest painter in Europe!"

Cezanne the recluse, deeply-rooted in his native Provence, was very aware of his importance, although he refused to flaunt it. Instead he chose to concentrate on flowers in white vases and fruit on tablecloths. The exhibitionist side of Gauguin annoyed him. Pissarro had endowed him with a passion for work. Guillaumin had

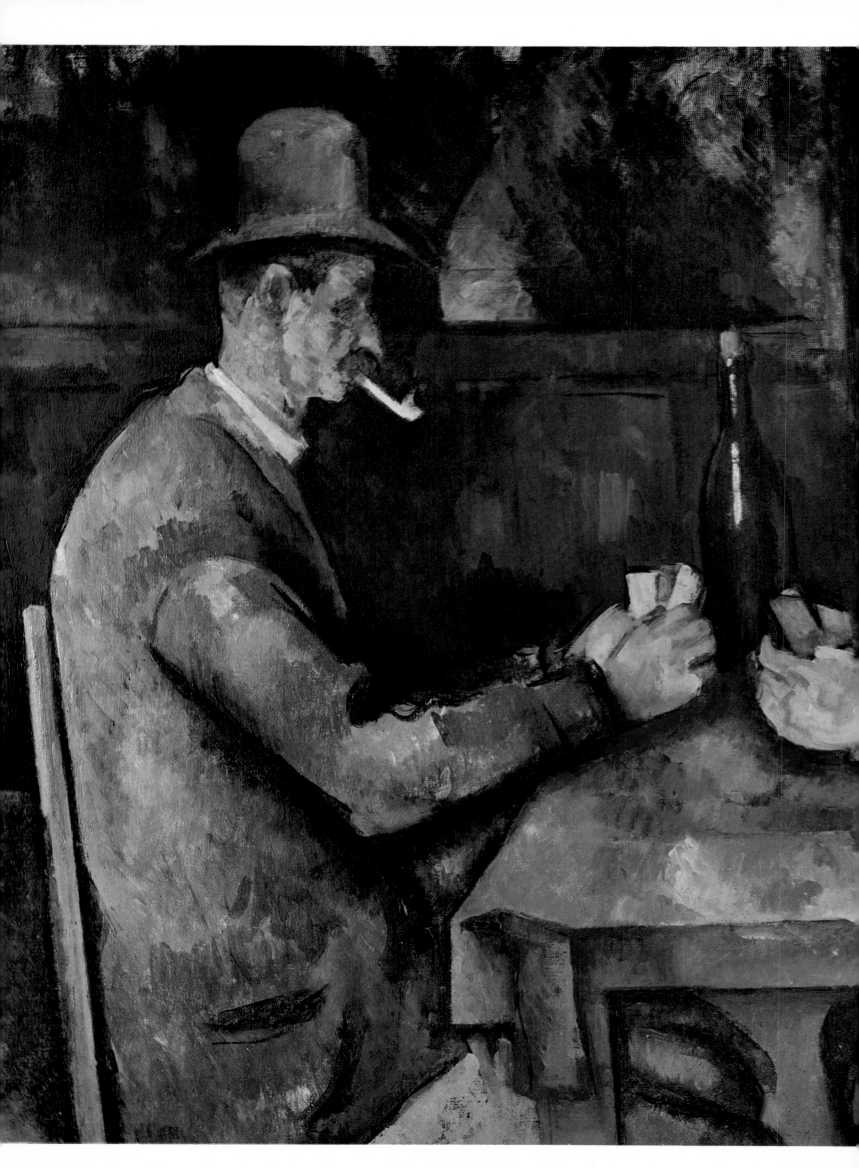

The Card Players, 1885–1890
(48 x 57 cm)
There are five versions of this theme, not counting studies. This one is the most concentrated. The canvas is elaborated with many small, layered planes.

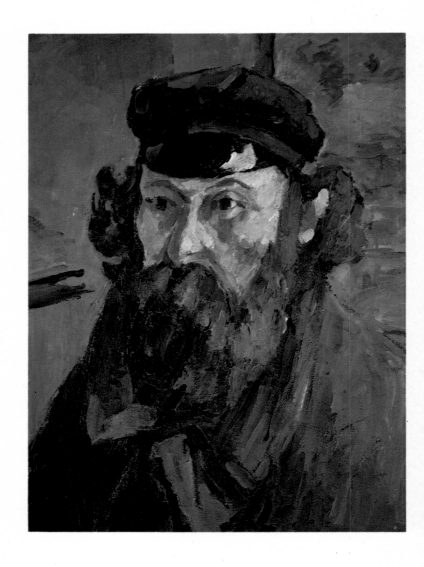

introduced him to engraving. All these friends were deeply disturbed by Cezanne's desire to "remake Poussin true to nature," and "to wed the female curves to hillsides." Poussin had become for Cezanne "a completely developed parcel of French earth."

In his strong desire "to portray nature as a cylinder, a sphere, or a cone, all of which had to be put into perspective, so that each side of an object or an outline moved towards a focal point," Cezanne proved to be a precursor of Cubism. (quoted from a letter of Emile Bernard)

Aside from Cezanne's self-portraits, it's Edmond Jaloux's description of the painter that provides us with the strongest image of the man: "His shoulders were somewhat rounded, and he was sunburnt with a brick-colored complexion. Long white strands of hair fell down over his bare forehead. He had small piercing and prying

Self Portrait, 1870
(53 x 38 cm)
Here is the recluse of Aix determined to paint as he chose. One can see his obstinate desire to paint not just the surface, but also his impression of the feeling of things.

Portrait of Joachim Gasquet, 1900
(66 x 55 cm)
This and the portrait of Gustave Geffroy are the most important of Cezanne's portraits. There is a freshness in the lighting that is startling. Gasquet knew Cezanne intimately, and wrote a biography of the painter. He was a well-known poet who came from Aix. This picture was probably painted in Jas de Bouffant, where Cezanne lived during 1896-1897.

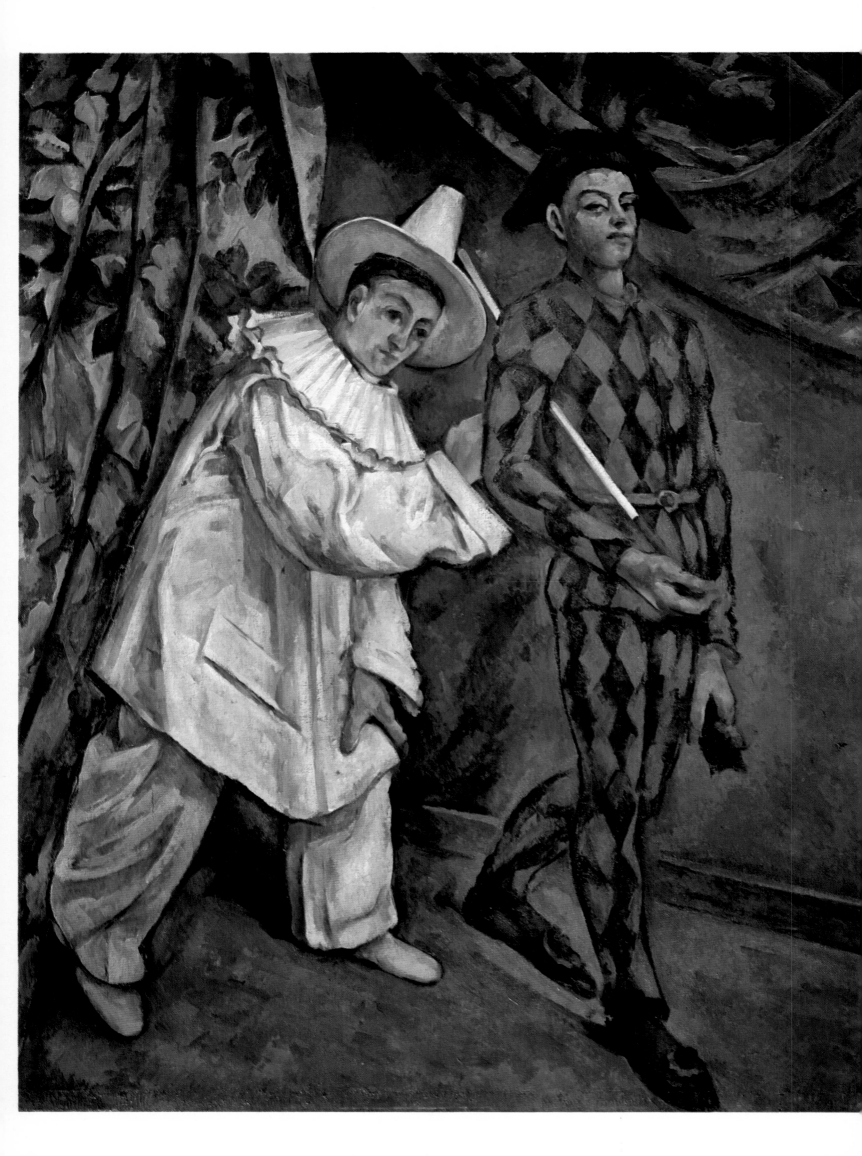

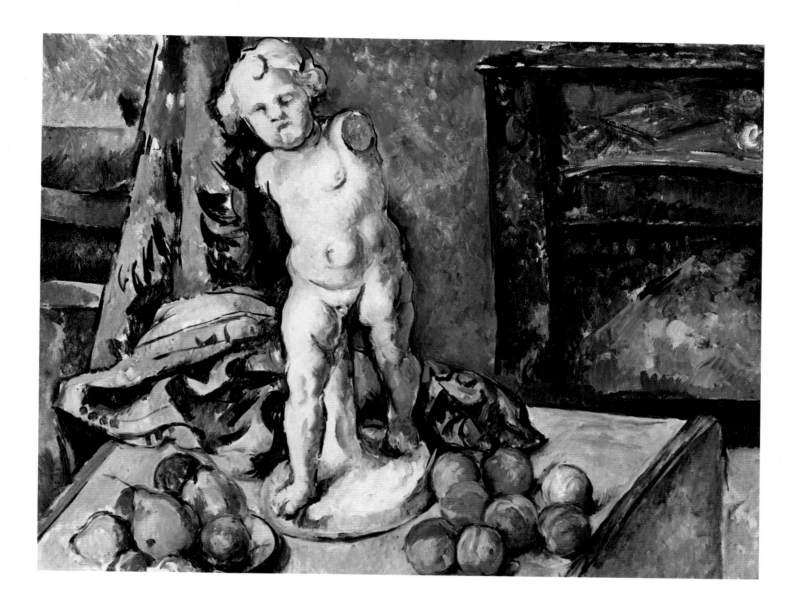

The Plaster Cupid, 1895
(63 x 81 cm)
*The pears and peaches are on a table on which
the plaster cupid stands against a blue curtain
with a gloomy background. A variation in
which the cupid is in profile is in the Courtald
collection in London.*

Pierrot and Harlequin, 1888
(102 x 81 cm)
*The Pierrot is copied from a design by Louis
Guillaume. There is a painting of Harlequin
alone in the Rotschild collection at Cambridge.
In this canvas, the composition is a rhythmic
blend of arms, legs and different postures.*

eyes, a slightly red Bourbon nose with a short mustache,
and a military goatee. He spoke slowly and meticulously
in a nasal tone which had a certain tender and caring
quality about it.

"One day he was having lunch at home, and was
looking at some apricots and peaches piled in a bowl. He
said: 'Look how much the light loves the apricots. It has
penetrated them to their pulp and they are filled with
luminosity. But look how stingy the light is with the
peaches. They are only half luminous.' "

All subsequent painting until Esteve shows the strong
influence of Cezanne's work. Cezanne was an explorer in
art who proceeded according to the most demanding
dictates of the eye. He was the only one of the Impression-
ist group to go beyond mere notation—even in his
sketches and aquarelles. Everything he did was con-
structed, down to the slightest arch of green. When he
couldn't find the right tone, he would leave an empty

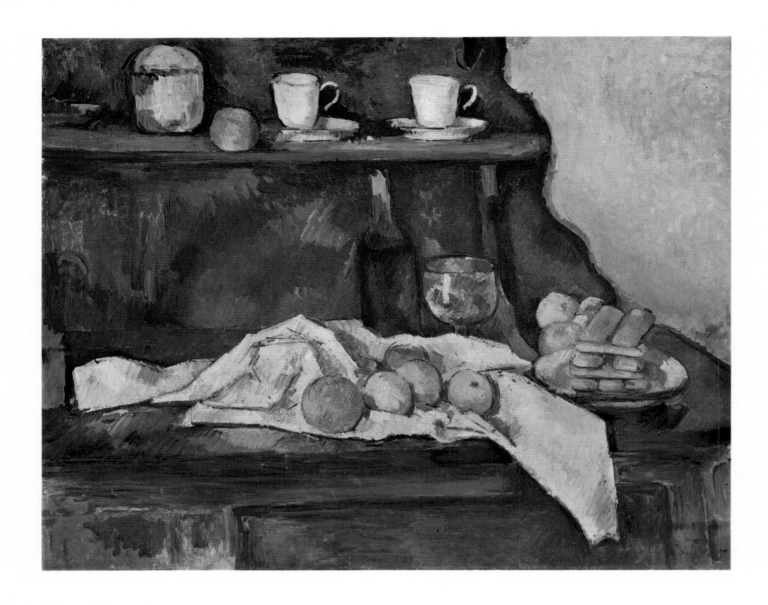

The Sideboard
(65 x 81 cm)
Here Cezanne resumes his study of still life, which allowed him to slowly examine a different approach.

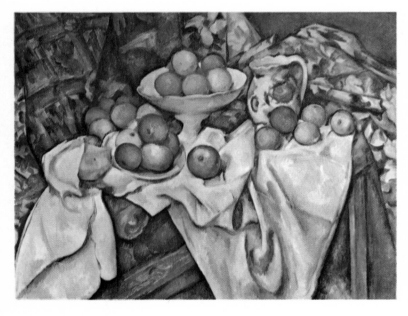

Apples and Oranges, 1895-1900
(74 x 93 cm)
This is an avalanche of fruit on a large, draped white table cloth, thrown on a table in front of a flower-patterned drape. A lovely baroque feeling.

white space on his canvas. The Impressionist method of painting is an inner process with Cezanne. He brings it out through a synthetic simplification of his subject. His reflexive and contemplative process in no way sacrificed either the brilliance of his colors or the feeling of spontaneity.

"I'm not hiding the fact that I was an Impressionist," he used to say. "Pissarro influenced me greatly. But I wanted to make Impressionism something substantial, like the art you see in museums."

Cezanne painted outdoors, but as a reflexive and contemplative outdoorsman. If he was dissatisfied with a painting, he would sometimes leave the canvas lying in the fields. Gasquet found one canvas that he had folded in half to steady a wardrobe chest.

Still Life with Curtain, 1899
(53 x 72)
*In this dynamic still life, the eye is caught by
the pitcher, which gives the whole a tranquil
air.*

Diabetes left Cezanne nervous and irritable toward the
end of his life. Bald with long hair streaming down
around his neck, he suffered from crying spells and would
sleep on and off. Nonetheless, he kept on painting his
favorite themes.

On October 15, 1906, Cezanne was painting outdoors.
There was a sudden storm and a violent downpour. He
caught a cold, took to his bed at his family's house on Rue
Boulegon, and died a week later.

Still Life with Pitcher, c. 1893
(53 x 71 cm)
*One sees how Cezanne constructs his designs:
first the lines that give form to his observation
and ideas—everything revolves around the
pitcher—and then all the other, knowing
curves, each different one from the other.*

COROT Jean-Baptiste-Camille

Paris, 1796 - Paris, 1875

It is primarily the works of his youth that announce the coming of Impressionism. The monuments that he painted in Italy and his Chartres Cathedral *are examples of paintings in which stone takes on the golden color of honey.*

He was the son of Louis-Jacques Corot and Marie-Francoise Oberson, of Swiss origin. His father lived in Paris and was a draper on the Rue de Bac. Against his father's wishes Corot studied painting with the landscapist Bertin and soon made two voyages into Italy. It is there amidst the light of sun on stone that he acquired that limpidity for which his painting is renowned. This articulation of light made him an important precursor of the Impressionists.

His life was a quiet one. His father was sure that he had chosen the wrong path. "You call yourself a painter," he said skeptically. To him Corot was a failure because he could not sell his paintings. He was fifty before his work began to attract admirers.

In his *Bridge of Narni,* which hangs in the Louvre, there is a luminosity and a sureness of touch that anticipates Cezanne. Corot was a painter first and last. On his deathbed he said to the priest come to administer last rites, "Father, I hope that there is painting in your paradise."

Not even in his best moments did Corot think that his work was of classic stature. Nothing in him asked to be admired or even recognized. His work is filled with the freshness of spring foliage, gestures of a delighted innocence, throughout marked by a sweet tenderness. It is born of luminous daylight and the vibrant being of an atmosphere that he knew by a unique insight how to lighten or darken. It is not just time or space but the two together reconciled in supreme golden mellifluousness. All vibrates with equal import: water, earth, sky and rays of the sun.

Given this we are not surprised that Corot loved to paint rock and stone. What elements could better serve the artist to contrast with transparent panels of sky than the ancient stones of the Coliseum, the broken rocks piled up near the cathedral at Chartres, the yellow earth of rock quarries. He studied and mastered their densities. Reflected in the weightiness of the rocks are lights and shadows, the orange intensity of daylight and the mauve envelopment of night.

The Bridge at Narni, 1826
(34 x 48 cm)
This is a study for the painting in the National Gallery in Ottawa. Even more than the final version, this canvas heralds the work of Cezanne in the vigor of its use of sunlight.

COURBET Jean Desire Gustave

Ornans, 1819 - La Tour de Peilz, Switzerland, 1877

The painter of Ornans is an admirable representative of realism. His work is solid and fragrant. In his open air canvasses he suggests the Impressionist movement that was to follow.

Courbet exercised a tremendous influence on the generation of Impressionists that included Cezanne and Renoir. Perhaps only Manet was more important to them. His early days as a painter were spent with Bonvin in the Paris of the Rue Hautefeuille and the Pension Laveur. He was linked from the beginning with Baudelaire and that champion of realism, Champfleury, who was the author of *Burial at Ornans* and *The Artist's Studio*. Courbet's hatred for Napoleon III was extreme. His joy at being liberated under the rule of the Commune led him to accept the presidency of the Commission on the Arts. This resulted in his being held responsible for the destruction of the Vendome column and led to his condemnation.

He fled to Switzerland to avoid his persecutors and took refuge near Vevey in the canton of Vaud, where he died some years later.

Courbet had an innate sense of the weightiness of earth, which nourishes and fattens his canvasses. They remind us of travelers who always dress a bit somberly. He was probably trying to make his canvasses endure, as the French peasant preserves the family overcoat. Courbet was the ancestor of the anti-intellectual movement in painting. He was self taught and grounded in basic things. A worker, but what a worker! Painter of the peasantry, as Chardin was painter of the bourgoisie. He wanted to be a force for socialism, but the earth and its poetry inspired him more than the most vivid pages out of the book of the workingman's life.

Courbet loved the materiality of earth, country roads and bubbling waters. He was, in a way, a geologist among painters. Mountains, waterfalls, windswept seas are as carefully rendered by Courbet as the wide eyes of a woman smiling slightly or lazy nudes stretched out on sheets fresh from the wash.

It was from Courbet that the Impressionists got the idea of painting outdoors. His wonderful painting *Girls on the Shore of the Seine* was the direct precursor of *The Picnic*, Manet's groundbreaking work.

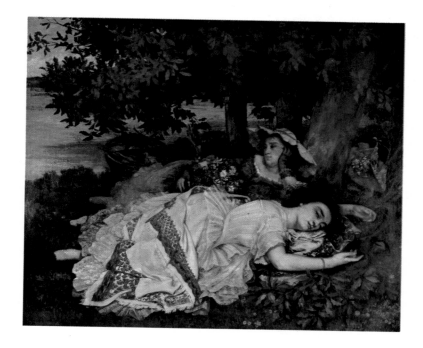

Young Women on the Shore of the Seine,
1856
(173 x 205 cm)
Here Courbet paints two friends stretched out on the ground at the edge of the river.

DEGAS Edgar

Paris, 1834 – Paris, 1917

Often presented as a misogynist, Degas was, on the contrary, a lover of women, whom he painted in the most fluid movements, first as dancers, then in the studio and later in the intimacy of their most private moments. He was also a master of representing cabaret scenes.

At the cafe Guerbois, in 1865, Degas rejoined the young painters rejected by the jury. There among others were Manet, Fantin-Latour, Renoir, Claude Monet, Desboutins and the Irish writer George Moore. After encouraging beginnings, Degas embraced the new form of painting, in which he entered with no fanfare, prizes, official recognition, success or publicity.

Degas was born in Paris to a family of brokers and bankers. He combined the two parts of his name "de Gas" for himself. He was of Neopolitan descent on his father's side. His mother's people were from Louisiana.

Degas took his baccalaureate in arts, had an interest in the print room at the Louvre, spent some time studying the law and some time in the School of Fine Arts. He traveled through Italy, and in Florence began a large canvas of certain of his relatives entitled *The Bellelli Family*. This he finished in 1862 in his studio on the Rue Madame. Then there were the first oils at the race track, and his portraits, and after, he takes us into the anteroom of the dance on the Rue Peletier, where he was to find his most important themes. He painted cafe concerts, girls on the terraces of Montmartre, women in the bath, all of this after having begun a series of laundresses and some tableaus of obsessive realism (vid. *Absinth,* 1876-77). He painted the accessories of the modiste with the same care as that of the face of one of the dancers in the corps de ballet.

The effects which the other impressionists achieved with the sun, its radiance, and luminous strokes glimmering through leafy branches, Degas caught in artificial lighting, on stages of theatres and music halls, with their winding stairways and indirect light, between the rise and fall of the curtain.

Paul Lafond, his old friend, longtime curator of the Musee de Pau has given us the best physical description of the artist: "Rather tall, with powerful features but of a rather mocking aspect and a broad, high forehead, crowned with chestnut hair. His eyes were lively and mischevious, questioning, set beneath pronounced eyebrows in the form of an accent circumflex, his nose was a bit turned up, his mouth fine but half hidden by a beard that he never shaved."

In Front of the Judges, 1879
(46 x 61 cm)
A group of jockeys passes slowly in front of the judges. They make an oblique line that cuts the painting. It is full of clear, bright color, yellow and green and scarlet. In the distance, a horse is seen galloping.

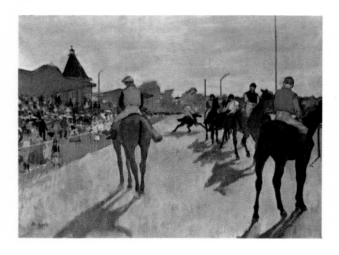

Absinthe Drinker, 1876
(92 x 68)
This is a portrait of Ellen Andre, who modeled for Manet, as well as for Marcellin Desboutins, an eminent engraver and friend of the Impressionists. This wonderful work shocked contemporary Paris with its violent realism.

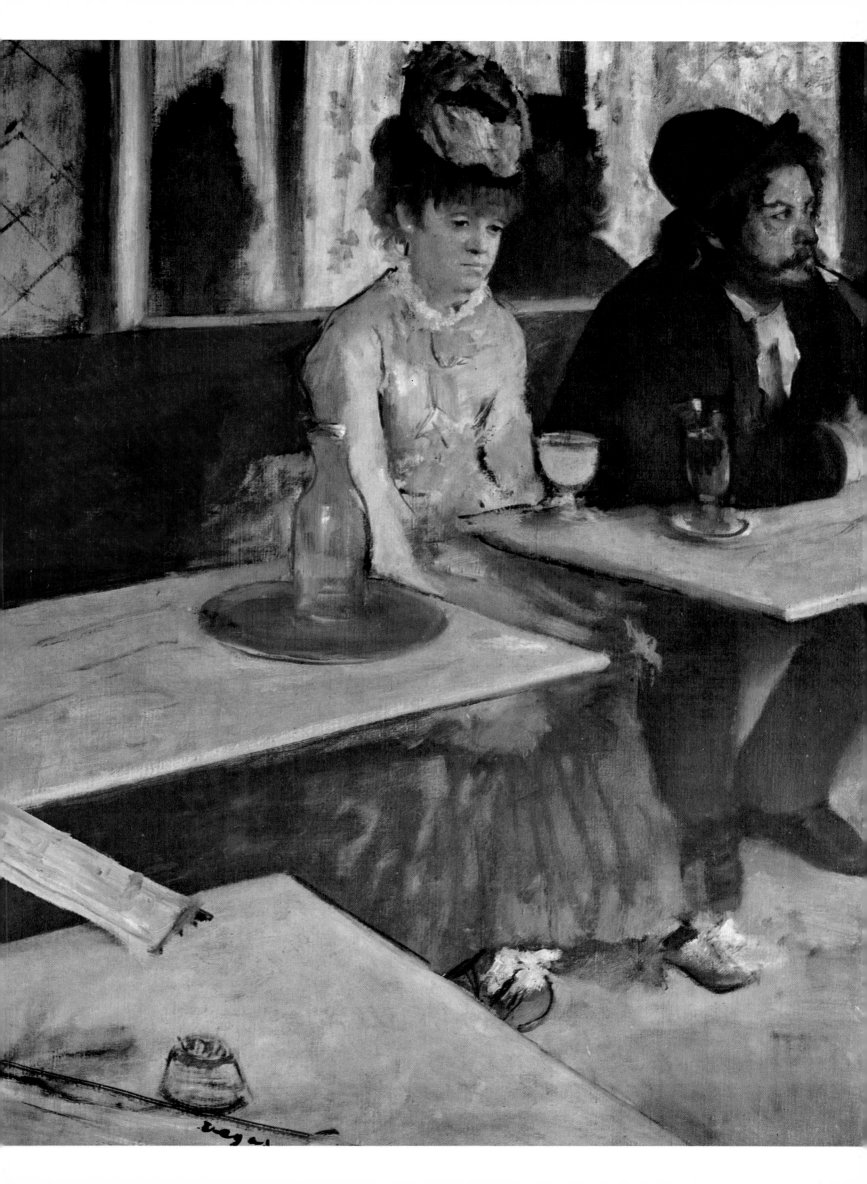

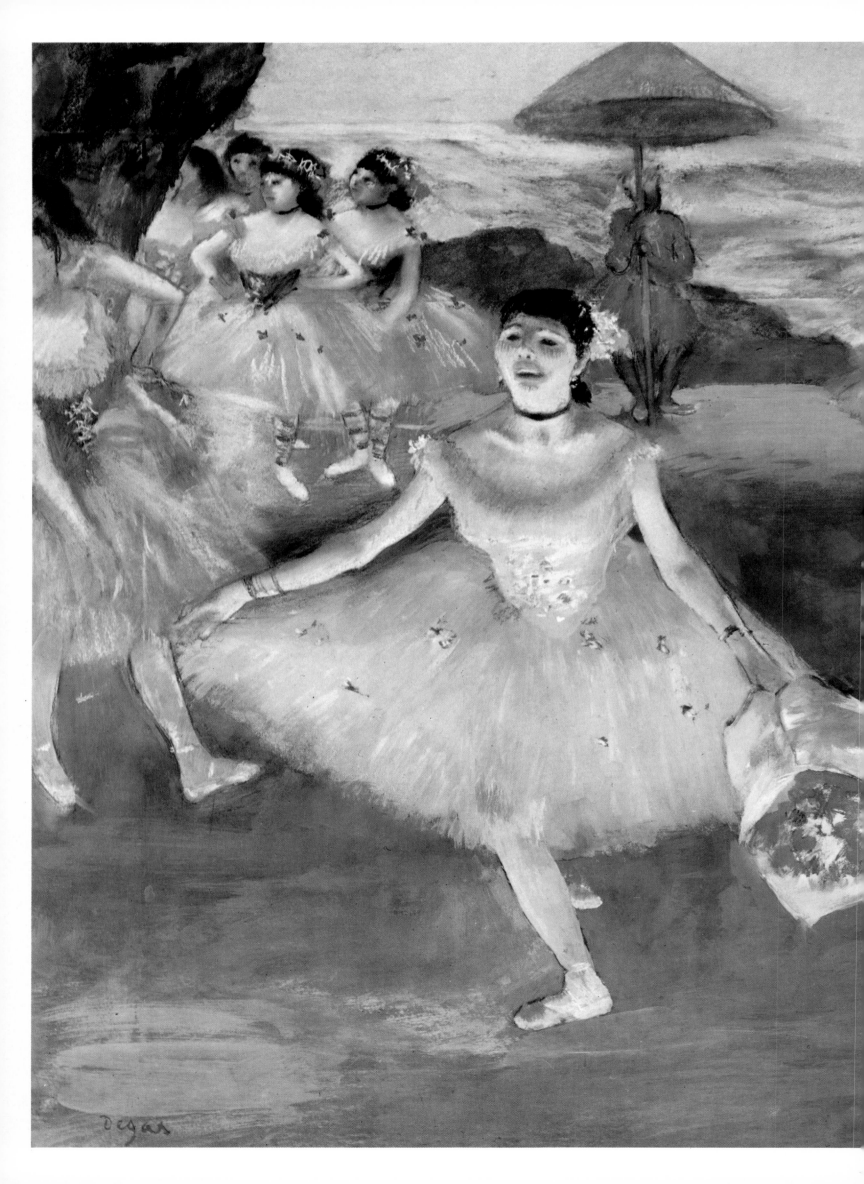

In 1871, in a letter to his English friend, the painter James Tessot, Degas complained of a loss of vision and weakness of the eyes. "This hit me at the seaside in the full light of day while painting a watercolor. I lost three weeks during which time I could not read, work or even go out much. I was in great fear that I would remain in that condition."

After a visit to Degas' studios, Edmond de Goncourt made a journal entry dated February 13, 1874: "A unique young man is Degas, an extremely sensitive being . . . He is the best that I have yet seen at capturing the spirit of modern life."

Degas had a horror of artistic types and pretense in any form (the affectations of Gauguin enraged him.) He ran away from "artistic" types and had no time for art critics. One critic said to him: "Monsieur Degas I'd like to come visit your studio." "Wait 'til night fall." Degas suggested. He expressed his views on the subject of art criticism as follows: "Words explain art without understanding it."

He was sarcastic, at times cynical. "A painting," he said, "is a thing which is as steeped in roguery, malice and vice as any crime. Use artifice, but with a touch of nature."

He did not like the institute, false esthetes or artists who had "arrived." He was scintillating but at times unbearable. Valery tells of a dinner at the home of the Rouarts. "Degas was full of life, terror and gaiety. His conversation danced and struck, his mind went off into flights of fancy, produced maxims, jokes and drew in the most intelligent way the face of injustice."

Dancer with Bouquet, 1877
(72 x 78 cm)
This is one of the most famous of the Impressionists' pastels, employing the artificial light of the theaters and music halls. There is a brilliance of truth in both stance and movement.

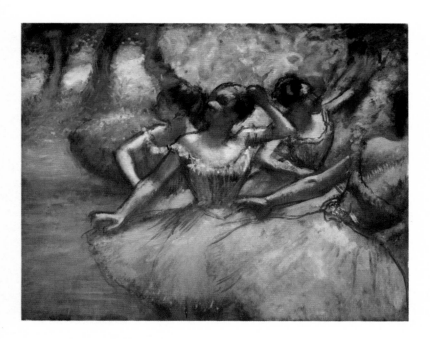

Four Ballerinas on Stage, 1882
(72 x 92 cm)
This is a fairly late work. Degas' style has been invigorated. The colors are strong in pink and blue. It is full of the rhythm of the curving arms.

In short he was a character. There was in him a mixture of bonhommie and mockery. Under his rather calm appearance he preserved a sense of raw reality which is revealed in the etchings he made to illustrate *The Tellier House* and the thirty-three monotypes in black and in color for the *Cardinal Family* of Ludovic Halevy. His tastes ran to the classical. He read Saint-Beuve and Louis Veuillot and was a friend of Mallarme. In appearance, a misogynist, he was in fact a sensualist.

He had an eye for human affectation and a deadly tongue. "His gaze," said Ambroise Vollard, "made the object of it feel like a butterfly stuck with a pin." It was Degas who said of Eugina Carriere during childbirth, "It's wrong to smoke in a sick room." One day upon being congratulated on the large sum obtained by his dealer for the sale of one of his paintings he responded, "I feel like a horse who has just come in first and receives for his trouble a bag of oats."

Many called him wicked, but this was just a cover. "What do I hear," he cried entering one windy night the house of his mistress. "You tell everyone that I'm not a rotter. If you take that away, what will be left for me."

He showed to all a consistent misanthropy. He was called the "grey bear", a characterization he did not find wholly displeasing. In effect, he had a Neopolitan temperament in which was blended a certain maliciousness with a mocking attitude grounded in the minute observation of his fellow creatures.

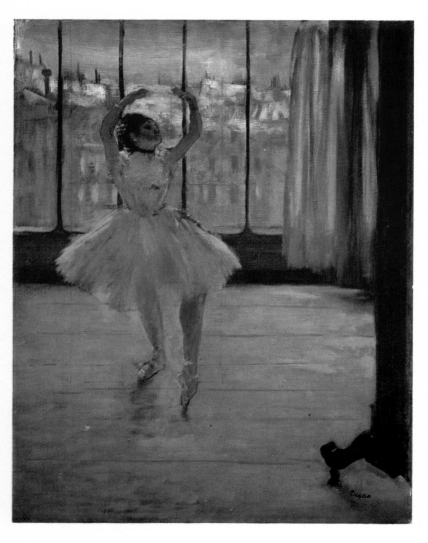

Dancer in Front of a Window,
(65 x 50 cm)
At the end of the afternoon, a dancer rehearses her steps. In the twilight, she and the city behind her are bathed with a blue light. The gauze of her tutu is almost transparent and the floor is iridescent in the reflected shadows.

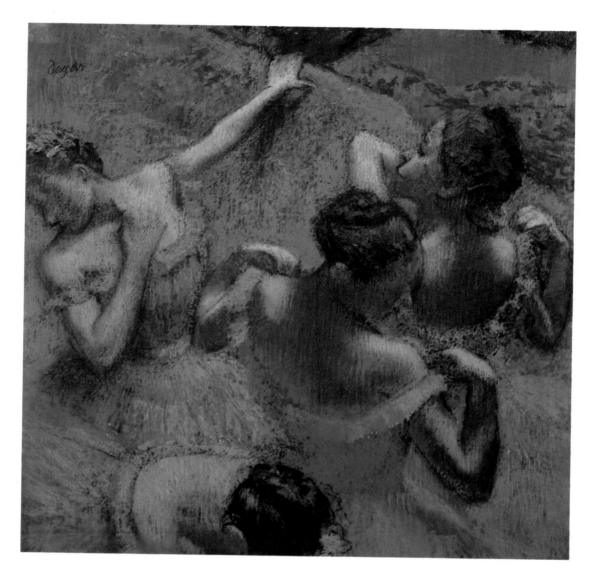

Dancers in Blue, 1899
(64 x 65 cm)
This symphony in blue uses all possible nuances of color to envelop these four ballerinas. Towards the end, Degas became a wonderful colorist.

His niece Jeanne Fevre spoke of the effect of his presence. "His look leapt out and touched you and at the same time saw through you. His gaze was like clear water. Suddenly the things he spoke of were right there in front of you, living and breathing. At times his discourse was so passionate that one lost sight of the teller."

After his racetrack paintings (works such as *The Trainers* and *At the Start of the Race*) and after a number of important portraits Degas embarked on his definitive studies of dancers. His interest was so bound up in this pursuit that a rival was heard to remark: "For him all art can be found in a ballet slipper." In these works Degas often used pastel, which he handled with great dexterity. This allowed him extraordinary freedom in linking line and color. It was at this point that Degas brought Impressionism inside to a world of smoking interiors and artificial light.

Degas spoke of his dancers in the following verses:

Partez sans le secours inutile de beau
Mignonnes, avec ce populacier museau
Sautez effrontement, pretresses de la grace!

He was perhaps at his best in exposing the life of his young subjects of l'Opera, young girls in tutus in empty rehearsal halls. He captures their agility, as they pirouette to the strains of violins; we see them on point by turns graceful and disjointed; and then, when the curtain rises, they fly like spirits of the air, before plunging back into their day to day lives.

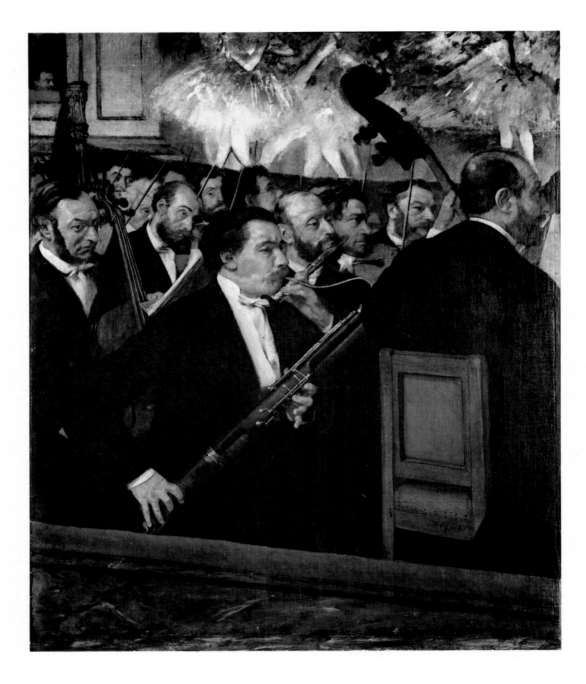

The Musicians of the Orchestra, 1868
(56 x 46 cm)
The musician in front is Desire Dilhau, a friend of Degas who was the bassoonist in the Opera Orchestra. It is one of those rare pictures that seem painted on the spot.

When he wished Degas could be the most brilliant of illusionists. No one knew better how to depict a flower in a woman's hair, or suggest the transparency of a muslin dress, to capture the fleeting expression of a moment in all its subtleties. But he disdained easy effects, the overly pretty, the seductions of mythological nudes.

Look instead at his painting of Miss Lala from Fernando's circus. Balancing under the big top she hangs by her teeth from a trapeze, all in all a painting to inspire dizziness rather than an easy satisfaction.

Degas continued his paintings of dancers until the very end. Toward the end of his life he also began to explore the possibilities of sculptures.

His "priestesses of grace" were painted and sculpted out of love of movement and adoration of the woman. "I am called the painter of dancers," Degas said. "But you don't understand. I only do it because I like to paint pretty clothes and am fascinated by movement." It is to be admitted that inflections of the female body attracted his refined sensuality. He is mistaken for a woman hater, but in fact he was mesmerized by their physical presence. What is forgotten in these liberated days is the shock that Degas' extraordinary realism produced in his contemporaries. He showed himself, before Bonnard, to be the first intimate painter. His work was labeled obscene. Many thought his nudes in the bath or drying themselves, ugly because they did not conform to the conventions of sanitized female beauty as shown in Cabanel or Bougereau's nude goddesses.

Dance Studio at the Opera, 1872
(32 x 46 cm)
In a strictly studied setting, the tutus of the dancers make a garden of variations of white.

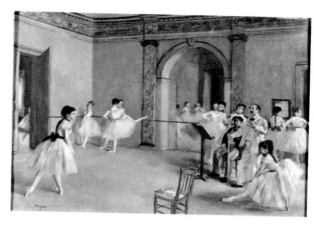

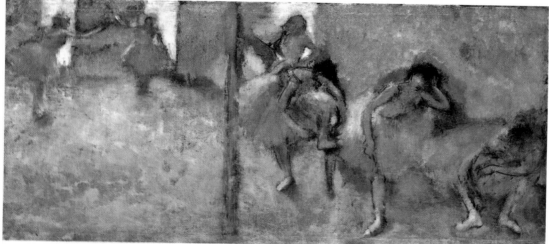

Ballerinas in the Hallway, 1900
Very often, Degas drew dancers rehearsing. Here he is just as attentive to the walls and floor as he is the young dancers in their blue-green tutus.

Russian Dancers,
(62 x 67 cm)
In this painting, the dancers are doing an exotic step. It is a rare Degas drawing, in which one sees something of Russian folklore.

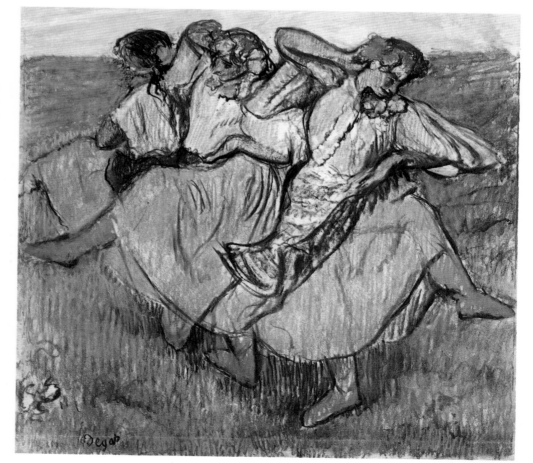

49

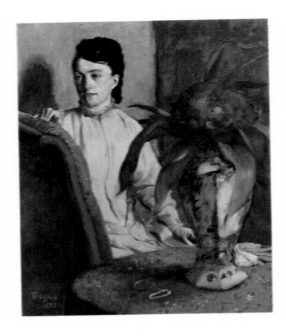

Woman With a Vase, 1872
(65 x 54 cm)
In 1872, Degas rejoined his family in New Orleans, expressly to paint their portraits. Here we have a girl dressed in a clear beige dress behind a bouquet of red flowers, her hand resting on the back of the armchair in an unexpected pose.

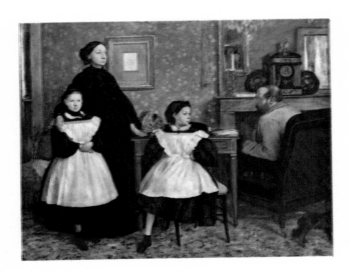

The Belleli Family, 1879
(200 x 250 cm)
When one thinks that this portrait was started in Florence when Degas was only 23, it is possible to comprehend that he alwaye had the ability to paint in a naturalistic manner.

In 1882, taking up the realism already demonstrated in *Absinthe,* Degas painted a nude woman as if surprised by the artist looking through a keyhole. Admittedly there was something of the voyeur about him.

Alice Michel (is this Suzanne Valadon?) published in 1919 her memoirs under the title *Le Mecure de France.* Taking up a position on a platform in his studio on the Rue Victor-Masse, she could at her leisure contemplate the confusion of furniture, boxes and picture frames. She speaks of Degas having her "freeze in the most difficult poses with legs outstretched and every muscle down to the fingertips tensed. The sight of a rounded back or a hand draped nonchalantly would infuriate him."

While working in his studio Degas drank herb teas and whistled airs from Don Giovanni. His eyesight was so bad that he would grope his way toward the canvas and sometimes ask his models to point out colors to him.

Degas was very interested in the relatively young medium of photography, which he sometimes made use of. It was by surprising the most private and intimate secrets of women in the bath that he signaled an end to a false appreciation of them as exalted goddesses. In effect he was the modern Pygmalion bringing back to true life a Galatea who had been stifled by academic conventions. As Geoffroy says, "He wanted to paint women without their knowing he was looking at them." That is to see beyond their posed self-consciousness to the pure movement or gesture of their inner lives.

Portrait of Rose Adelaide, 1868 or 1870
(27 x 22 cm)
Surely one of Degas' most beautiful portraits, the clarity of her look, the wonderful skin tones, all make this work exceptional. Here we see that Degas was able to use traditional technique, with an understanding of modernism.

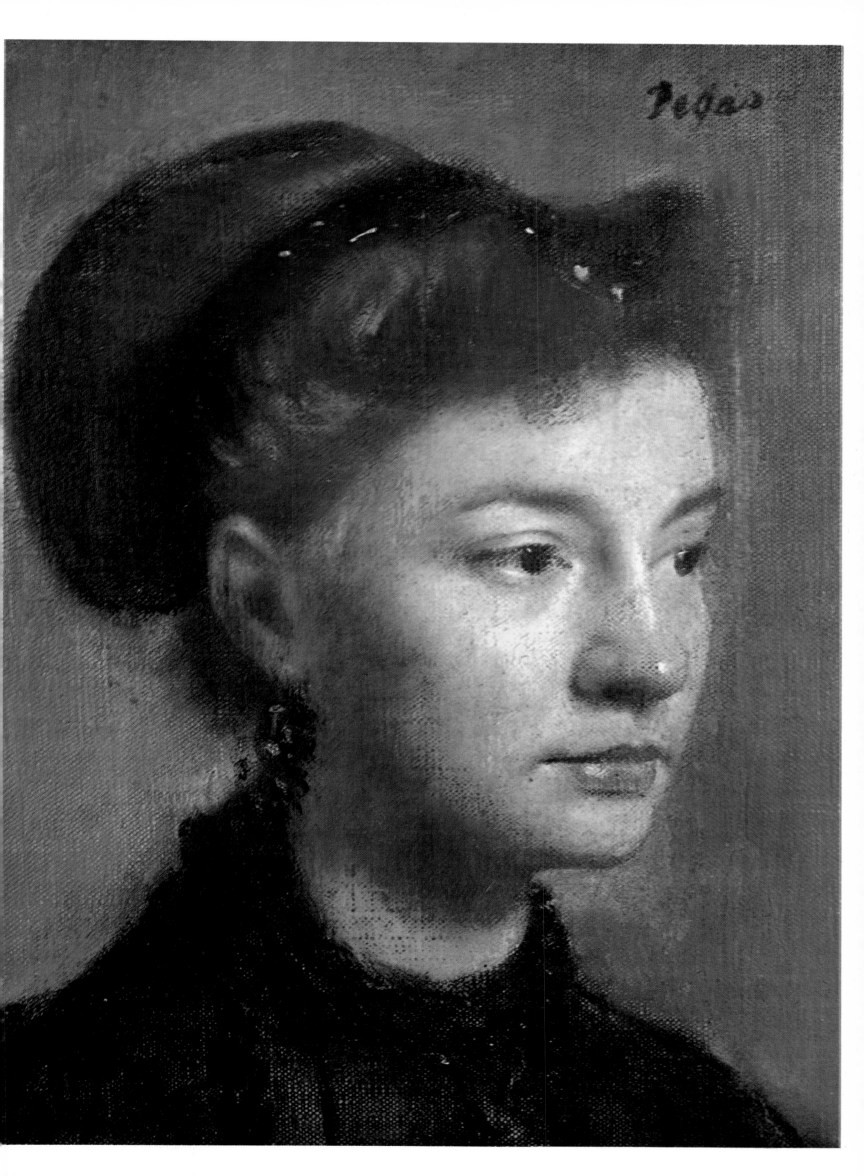

One can understand his final estrangement from Impressionism. His painting was never vulnerable to critics that complained of saffron colored faces, figures scarred by sunlight or above all a mania for the color violet.

Degas had to leave his house on the Rue Victor-Masse where he had lived on the fifth floor for twenty-five years. This was a real blow for him. His friends found him a place at 6 Boulevard de Clichy. Though still in Montmartre, it wasn't the same. Depressed, having totally lost his eyesight, he stumbled around the boulevards of Paris, needing help to cross the street.

The Bath, 1886
(60 x 83 cm)
This pastel on cardboard is admirably precise. One sees how well Degas unerstands a woman's body by the lovely curve of the back.

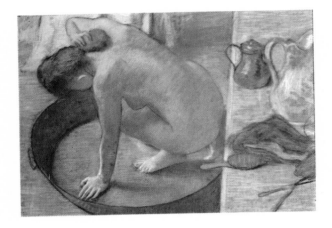

Woman at Dressing Table,
(65 x 78 cm)
This is a variation of a pastel in London. Here, the hair is the most important part of the coloration.

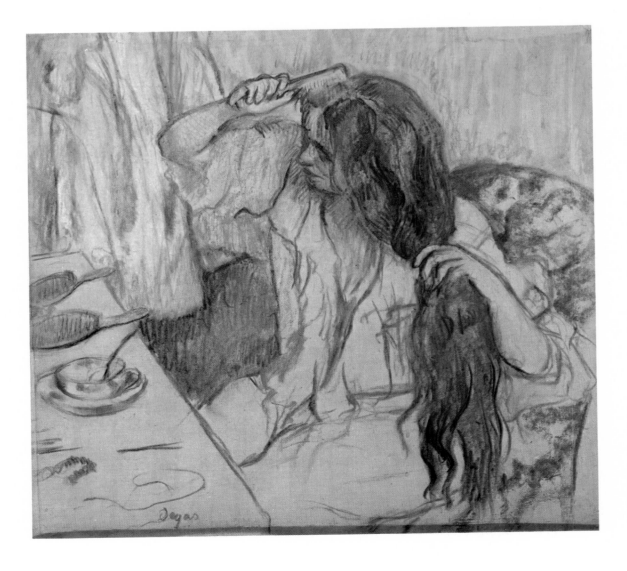

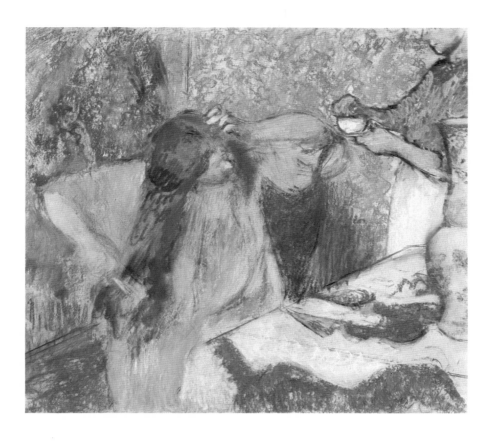

Woman With Her Hairdresser, 1894
(96 x 110 cm)
*In this quick sketch, the woman's gesture
is caught realistically. Behind her, the color
is all nuance, except for the lapis blue.*

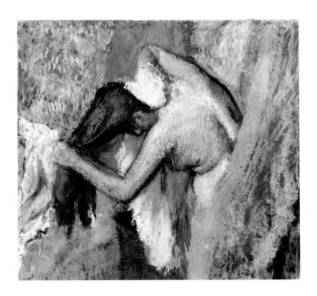

Woman Dressing, 1903
(75 x 73 cm)
*We have now come to the last part of Degas'
works, a series of "women dressing." On this
one, the nude torso swings in opposition to the
yellow curtain.*

"I feel myself heading toward the end," he said. He
was much afraid of death, which he would only speak of
in whispers. We have it from his niece Jeanne Fevre that
the Abbe Closson from Notre Dame heard his final
confession. He died of a cerebral haemorrage.

Unlike Courbet about whom one could say the paint-
ing was greater than the man, Degas (like Delacroix,
whom he deeply admired) lived his life without ever
abandoning his own caustic intelligence. Indifferent to
success, he knew of the changing winds of popularity and
fortune. Finally with the perspective of half a century we
can see that his position is secure beyond shifting fashions.
He knew that to embrace a spurious modernity leads

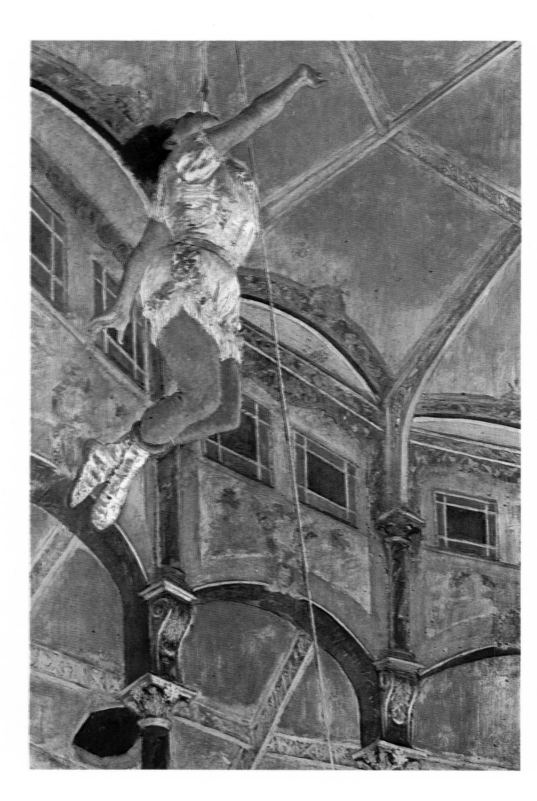

Lala of Fernando's Circus, 1879
(117 x 78 cm)
Degas loved the circus, but rarely drew pictures of it. In this drawing of the acrobatic Mlle. Lala, there is a dizzying feeling of her hanging in space.

often to a quick and final obscurity, that art has a secret life and thus lives on. Thus among his comrades in Impressionism Degas was at once the most classical and the most innovative.

Degas was never interested in painting nature. Although his work gives the impression of spontaneity, it was the product of long hours of work. This same attitude led him into daring technical explorations. But there is an indefinable quality which is the central mystery of his work. It beckons the viewer toward a culminating apprehension of form and movement that assures us that his work will continue to speak to generations yet to come.

DELACROIX Ferdinand–Victor–Eugene

Charentoi-Saint Maurice, 1798 - Paris, 1863

Magician of color, transmitter of "feverish intensity," Delacroix was a precursor of Impressionism on account of the attention he paid to reflections and to the juxtaposition of tones. His work as a painter touched upon every domain and genre. All of his work is filled with the profound visual poetry that was to him the breath of life. His art is a visionary's response to human passion.

Delacroix was an amalgam of three generations, each of which profoundly influenced him but also did battle within him. He was of the Revolution in the person of his father Charles; a defender of the Empire through his two brothers, both soldiers of Napoleon; and in his own work a hero of romanticism. Politically he was a conservative, putting little trust in the dubious allure of progress, but nonetheless he rejoiced in Les Trois Glorieuses, the heady days of the revolution of July 1830. In fact, Delacroix's painting of that time, *Liberty Leading the People,* ranks with David's *The Assassination of Marat* and Gericault's *The Raft of Medusa* as one of the few great topical expressions in painting.

View of the Sea from the Heights of Dieppe, c. 1852
(35 x 51 cm)
In this canvas of sky and water, we see in the foreground only the sea. It is a touch that will be used by Monet, twenty five years later.

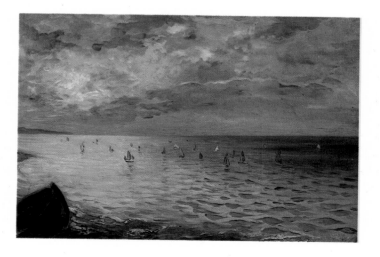

As an artist Delacroix was a most outspoken adversary of the academic school of painting, a staunch defender of individualism. He was a habitue of dinners, political and philosophical discussions and the salons, where he demonstrated his passionate interest in music. He was a friend of George Sand and Chopin, whom he visited at Nohant. Beneath all of his mannered politeness his imagination was fired with dark passions.

He was a man of incredible diversity. Approaching him one thinks of the many facets of his work. First and most immediate is Delacroix the impetuous colorist, sorcerer of things in motion. Then there is Delacroix the journalist, reader of Racine and Dante, Shakespeare and Goethe, admirer of Mozart. Then we have the Delacroix of his *Self-Portrait,* the man in the green waistcoat in the Louvre, who faithfully each year had a reunion of his friends at Saint Sylvestre. Then the Delacroix of the portraits of Nadar; the lion, with a beauty mark under his lip. Finally the painter of the Orient, the sickly Delacroix described by Theophile Silvestre.

Dreamer and logician, passionate and timid, a savage and sophisticate, Delacroix was one of those rare souls who seem to combine and reconcile antimonies. Although a true conservative, his *Liberty Leading the People* struck a blow for revolutionary ideals. At work he was both spontaneous and reflective. He was at one and the same time a romantic figure and an apostle of tradition. An admirer of classic work, he experimented daringly with bloody evocations, battles of horses and tigers, massacres. Poet of blood, he liked mineral waters, slippers and a corner by the fire.

But the true Delacroix lived only for art, seeing only the mixture of color, of reds and blues. He lived within himself, in a shadow whence speaks the journal of his life, with its disturbing strain of questioning introspection. "A volcanic crater, artfully hidden by bouquets of flowers." Thus did Baudelaire describe him.

Illustrator of Shakespeare and Goethe, Delacroix was the only Frenchman whose art scaled the summits of romanticism. Do we not find in him that same coursing of blood that runs through the dreams of Clement Bretano, the need to explore, to fly toward the unknown? He alone was gripped by the fever of imagined lovers and the temptation to possess the universe that haunted the great German poets. His moral disposition was played out in rooms where odalisques watched squatting on mats; in

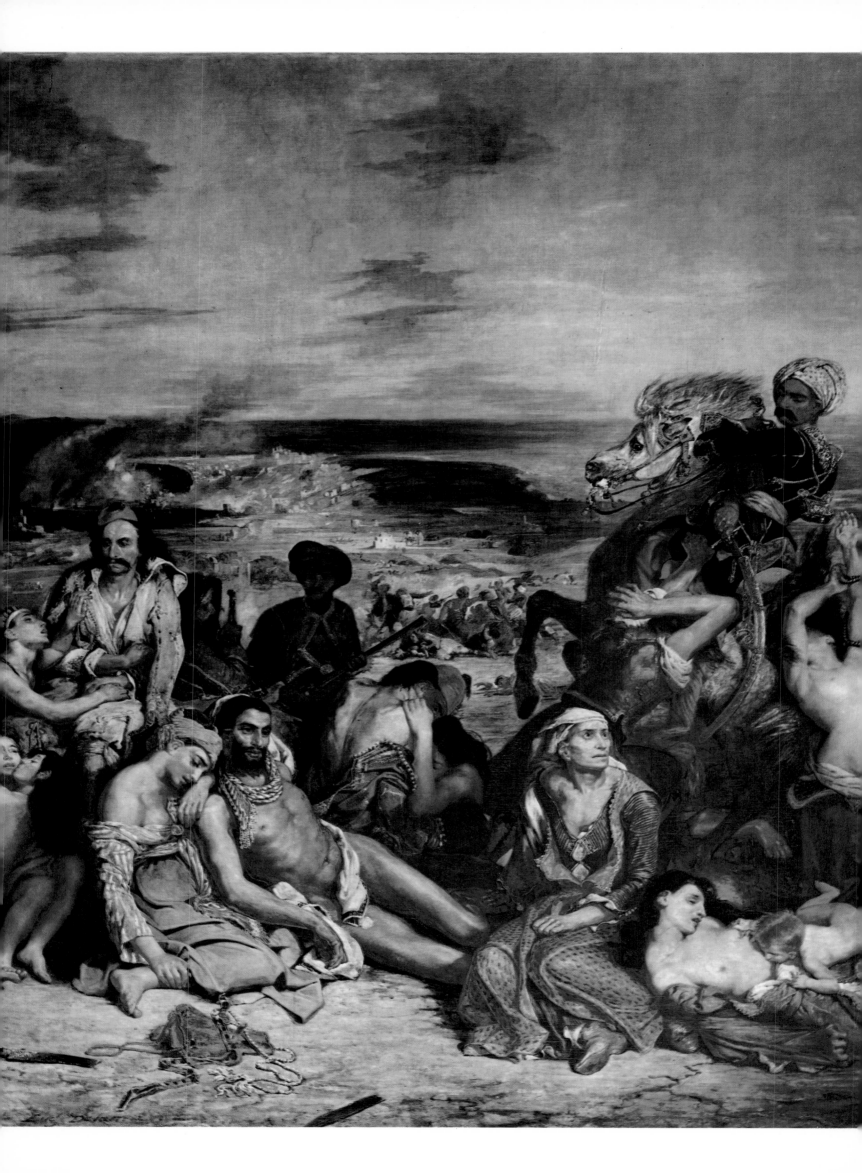

The Massacre at Scio, 1824
(419 x 354 cm)
*Before Gericault, Delacroix in his "Liberty Leading the People" and in this
canvas was painting scenes of current history. The people of the island of
Scio had been massacred by the Turks. The detail shows an infant left alive,
trying to find nourishment from its dead mother.*

Apollo Crushes the Serpent Python,
1850-1851
(130 x 97 cm)
*Delacroix used all the sun of Impressionism to
light the chariot of Apollo. On this lovely
ceiling of the Louvre, the darkness of the serpnt
is surmounted by the god of light and is killed by
his arrow.*

tranquil fields where men underwent single combat and
in streams whose black waters undid the tresses of Ophe-
lias gliding toward their destiny.

His palette was absolutely unique. For Delacroix,
color, which even with Rubens remained material,
became a poetry all of itself; it dreams, it speaks, it acts,
taking to itself the entire register of human feeling,
impulse and hesitation, happiness and pain; it inscribes
itself in time like a fugue. Perhaps herein, in the use of

color, lies the secret attraction of Delacroix's paintings.
That deep enchantment that not only can move but also
obsess the viewer.

He had secrets. He was a secret. At his birth his father
was minister to Holland and his mother received frequent
visits from Talleyrand. We still cannot say with cer-
taintly who the real father was. He went from studio to
studio, but few really knew him. And then came his
voyage into Africa and the Orient, which many poets and
painters retraced at least in their imaginations. Here was a
private man. Yet he also realized great public works in a
fury of concentrated effort that left him drained and
exhausted.

He was a weakling who wanted to surpass himself and
rise to exalted stature, as exemplified by the shepherd
who wrestles with the angel in his painting in the chapel
at Saint-Sulpice. He painted this vision as if touched by
grace, quite near the end. Sometimes in certain of his
canvasses where craft falls by the wayside and technique
recedes into the background, we get a sense of the man
and his enduring sorrow.

He worked devotedly and painted prodigously. His
was a painting of ardent youth, evocative, gestural. He
was the great magician of color, a man outwardly calm
whose repressed imagination seethed with imagery of
carnage. Above all he was a visionary. His painting
opened up a world of emotion that before him had never
been beheld.

EAKINS Thomas

Philadelphia, 1844 - Philadelphia, 1916

Little known in Europe, Eakins along with Winslow Homer was one of the most important American painters of his time. He had the courage to brave the puritan strictures of his contemporaries and employ nude models in his studios, for which he was much criticized.

After having finished his studies at the Fine Arts School of Philadelphia, Thomas Eakins took a course in anatomy at Jefferson Medical College. He journeyed to France in 1866 and studied painting for three years at the School of Fine Arts in Paris.

Following voyages in Holland, Italy and Spain, where he was deeply impressed by the work of Velazquez, he returned to Philadelphia where he lived for the rest of his days. He taught at the Pennsylvania Academy and after two years became its director. He had no interest in painting the Venuses that were then in such demand, preferring sports and medicine as subjects. He was a talented portrait painter as well.

Eakins with Winslow Homer was the only American who could compare with the finest European painters. His principal work (a kind of delayed response to Courbet's *The Studio*) was entitled *The Studio of the Sculptor William Rush*. The canvas is an allegory depicting a nude model in the foreground. On one side stands her mother as chaperone, on the other working in darkness is the sculptor (who along with Eakins defended the use of nude models). The model in the painting was a Miss Vanuxem, the daughter of a friend of the artist. The canvas is in the Brooklyn Museum. Eakins painted a bit more impressionistically in *The Anatomy Lesson.* The most admired of his other work are paintings of canoers he did in the open air.

We were tempted to expand upon the role played by Americans in the Impressionist movement. Such in fact was the theme of two recent exhibits, one in Washington in 1973, the other in Paris in 1982. But if at times the painting was open to the effects of light, it was more often hidebound, confined to the academic. We can nonetheless see the value of Butler's *Curtain* or *Duck Island* of Childe Hassam. Aside from Winslow Homer, whose *Croquet Match* shines with a luminosity reminiscent of Manet, only Eakins, Whistler, Cassatt, Sargent and Maurice Prendergast could be said to have made significant contributions to the leading edge of artistic production.

The Sculls of the Bigles Brothers, 1873
(61 x 92 cm)
This painting of young rowers done in the open air shows that Eakins well understood the new ideas that were changing art. It was done after Manet's The Picnic.

FANTIN-LATOUR
Ignace-Henri-Jean-Theodore

Grenoble, 1836 - Bure (Orne), 1904

A painter of flowers, Fantin-Latour was closely associated with the Impressionists, although he never participated in their group exhibits. He was responsible for a wonderful portrait of Manet as well as paintings of gatherings of the great artists, poets and musicians of his time.

Fantin-Latour, who was one of the finest painters of flowers that ever lived, was a close friend of Manet and many of the Impressionists. However, despite painted tributes to Delacroix and Manet he was never fully engaged in the vicissitudes and explorations of the new school. One can see him with others of Manet's friends in that master's painting *Music in the Tuileries,* and he frequented the Cafe Guerbois, a favorite meeting place for the Impressionists. Despite this close relationship he never joined in any of their exhibitions.

Admiring Frans Hals' paintings of guilds, Fantin-Latour painted groups of artists. The ones he chose to portray are of prime importance for us, though in his day their reputations were by no means assured. In his painting, *Homage to Delacroix,* he has given us our best likenesses of Whistler and Baudelaire. In *Un Coin de Table* where he has brought poets together, we see a young Rimbaud and seated next to him Verlaine. In another most striking canvas, *Studio of Batignolles,* he has given us Manet at work on a portrait surrounded by the standing figures of Renoir, Monet, Bazille and Zola. It is hard to think of another canvas filled with such a distinguished company. Fantin-Latour was an admirer of all art forms and was a particular devotee of Berlioz and Wagner. In some of his lithographs we see Wagner's Rhine maidens.

In addition to his fine portrait of Manet, Fantin-Latour left a series of self-portraits that give us some insight into the various shades of his character. We see a young man of twenty-two years in a cafe, in his gaze a resolution of will that we do not find in his artistic endeavors. Then another painting where he has the look of one trying to find himself. In his most detailed self-portrait he has the expression of an observer who might have widened his imaginative reach. But then he returns to painting nymphs and driads. There he stands at the brink of discovery but lacks the discipline to persevere.

Perhaps this is why he never participated in the group shows of the Impressionists. Perhaps he was afraid of the future or did not want to upset the Institute. It is true that he was not passionately committed to the new school of art. It might even have been out of faithfulness to his buyers, such as the Edwards, who were introduced to him by Whistler. It was indeed the case that most of his admirers were English.

Fantin-Latour spent his summers in Normandy where he did flower arrangements. He would apply a neutral tone as a base for his paintings and then lay down his glorious dahlias or roses. No one could touch him in rendering the detail of a petal. To him flowers were emanations of the feminine.

I still see a table laden with fruits and flowers in the collection of Chester Dale in The National Gallery in Washington, D.C. There is a canvas with apples, oranges and pears in a straw basket, and next to it a bouquet of roses in a blue vase.

Fantin-Latour moved into his studio on the Rue des Beaux-Arts in 1868. He kept it until his death. Casts of classic busts, books, copies of the masters piled up. His whole life revolved around the studio and the Louvre only a few steps from his door.

Fantin-Latour opted for the incontestable authority of tradition, mistakenly ignoring the importance of Cezanne's revolutionary still life. He was a man whose conflicting nature was explained by those who knew him best by a certain dilettantism to which he gave in rather easily. Perhaps if he had resisted that tendency his work would have been freer and more complete. As for Impressionism, he was content to remain on the sidelines and from there paint the participants.

But it is for his flowers that he will be remembered. His bouquets take their place alongside Chardin's carnations, Braque's packet of tobacco and the bottles of Morandi.

The Studio at Batignolles, 1870
(204 x 274 cm)
Here we see Manet painting, surrounded by his friends; Renoir in a hat looking at the painting, Emile Zola talking to Bazille, who is in profile, and behind him the face of Claude Monet.

GAUGUIN Paul

Paris, 1848 – Atouana (Marquesas Islands), 1903

Gauguin was accustomed from youth to long trips. He became the great explorer of painting in fleeing a civilization that he saw as moribund. He went to the South Seas to find the Noble Savage that Chateaubriand looked for in the New World and Rimbaud dreamed of in The Drunken Boat. *After an early flirtation with Impressionism, he went off in a different direction exploring in color sculptural forms.*

Portrait of Marie Derrien, 1890
(66 x 34 cm)
Painted in Brittany, this is a portrait of Marie Derrien, whom he nicknamed "Lagadu." In the background there is a still life after the manner of Cezanne. This is one of Gauguin's last portraits, which he sold out of financial desperation.

Gauguin spent the years of his childhood in Lima, Peru. He was of Spanish-Peruvian descent, the son of a newspaper editor who died at sea in 1852, and the grandson of Flora Tristan, woman of letters and militant socialist. He came back to France with his mother Aline Gauguin, and went to a religious school in Orleans. At sixteen he signed on as a sailor and traveled the seas of the world. Finishing his service, he entered the Bourse where he was a successful stockbroker. He would paint on Sundays, admiring the work of Monet, Degas, Puvis de Chavannes, and the Japanese. He married Mette Sophie Gad, a Dane. But following the crash of 1882, a total catastrophe for the Bourse, he left his job to devote all his time to painting. He was afraid that he would not be able to support his wife and children, and she returned to her parents' home in Copenhagen.

Gauguin remained in Paris. One child, his son Clovis, stayed with him. He had great difficulty making ends meet. In 1886 he went to paint in the Finistere, at Pont-Aven. The next few years he would travel much. He went to Panama and then left there after an outbreak of typhus to remove himself to Martinique. Here he found a little piece of paradise, but strapped for money, he returned to Paris late in the year. By this time he had already distanced himself from the Impressionists to proclaim what he called Synthesism. He returned to Brittany, where, after a visit to Arles to see Van Gogh, he painted *Christ in Yellow.*

Gauguin liked to speak of art in striking aphorisms. These were repeated in the cafes where artists congregated and the ateliers where they worked. For Lautrec he was "the professor." His friends were awed by his adventures in Martinique and his journeys in mysterious and untouched lands, where elements of a new revitalized art offered themselves in virginal simplicity and primal freshness.

Self Portrait, 1889
(79 x 51 cm)
The red and yellow on the large surfaces clash violently. Gauguin gave himself a halo and called this painting his "Saintaise."

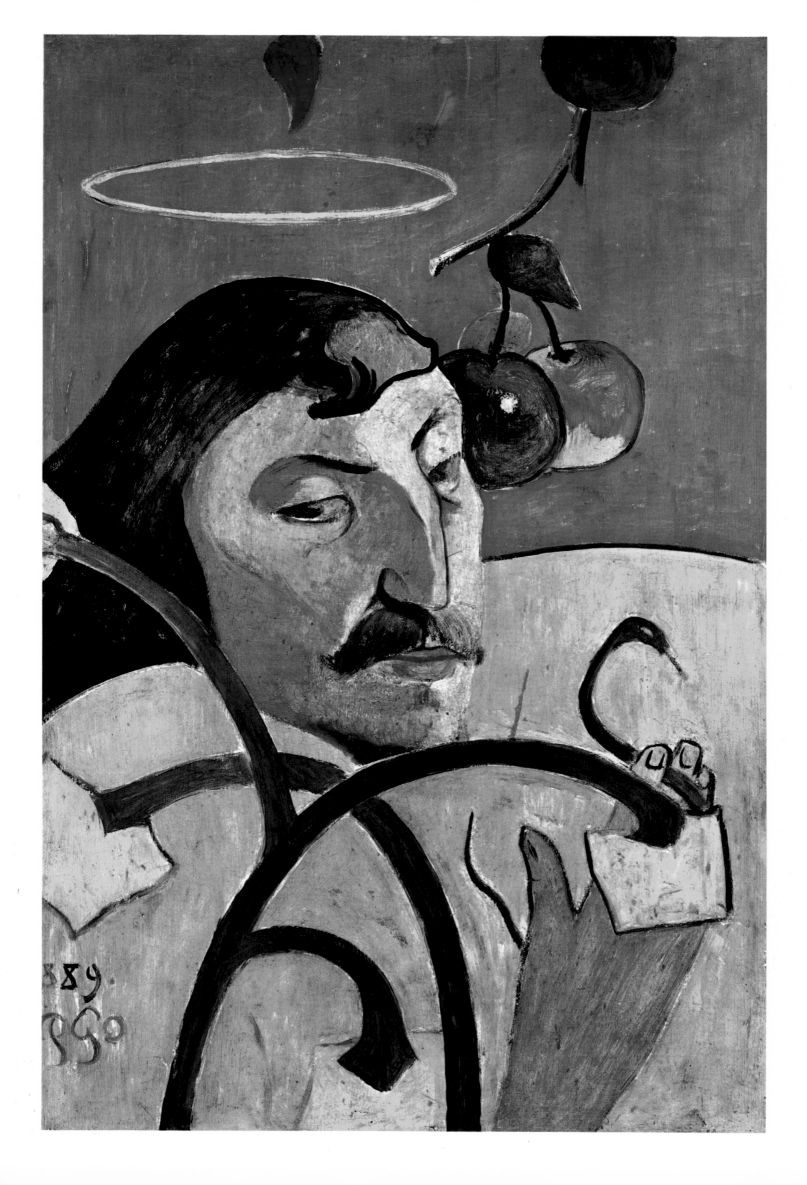

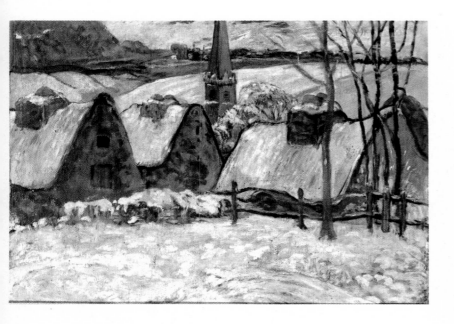

Breton Village in the Snow, 1894
(62 x 87 cm)
This lovely blending of the blue and pink on the thatched roofs surrounding the bell tower was painted when Gauguin was in Pont-Aven and in Pouldu.

The Alyscamps, 1888
(92 x 73 cm)
This colorful landscape was done during Gauguin's stay with Van Gogh in Arles. The stay was cut short when Van Gogh attacked him in a fit of madness.

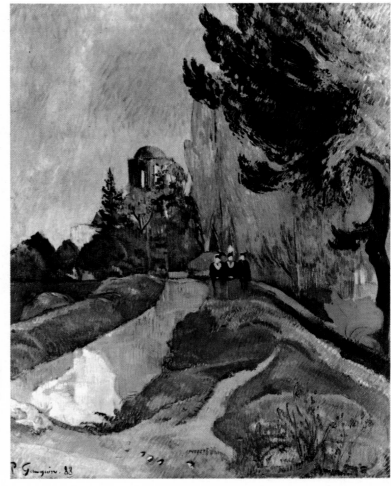

Rimbaud was a seeker after spiritual adventure; Gauguin sought in his wide roaming an earthly "paradise of man's natural state." He looked for radically new influences in the oceanic folklore of the South Seas. Disheartened by European civilization, he never ceased his exotic and esoteric quest. There is in his painting a sense of some guiding meaning or plan that obscurely shaped his life and work. Symbolism, then in fashion, and which found its intellectual in Moreau, found its Robinson Crusoe in Gauguin. According to Eugene Carriere he had "an enthusiasm for exalted color." Gauguin was the inspiration for the mysterious talisman, the landscape painted in pure violets, vermillions and greens that Serusier displayed to his comrades Vuillard, Bonnard, Vallotton, and Maurice Denis. Gauguin had said, "How do you see this tree? Is it a real green? Good, then paint it in green: the most beautiful green in your palate. And that cloud, it's rather blue, isn't it. Don't be afraid to paint it as blue as possible."

Gauguin was akin to the Impressionists in his love of sunlight, in the freeness of his technique, in his fresh coloration and his interest in Japanese models. And in his later monumental works certain approaches he learned from them were not totally forgotten. But he had a stronger sense of composition than any of them and loved the line. Maurice Denis said that Gauguin was to his generation what Manet had been to the previous one. Without joining Ingres in exclaiming "Nulla dies sine ligna" (No day without line!) Gauguin maintained that there were noble lines and lying ones and took great care in the definition of solid forms.

When he was not in the islands, Gauguin spent time at

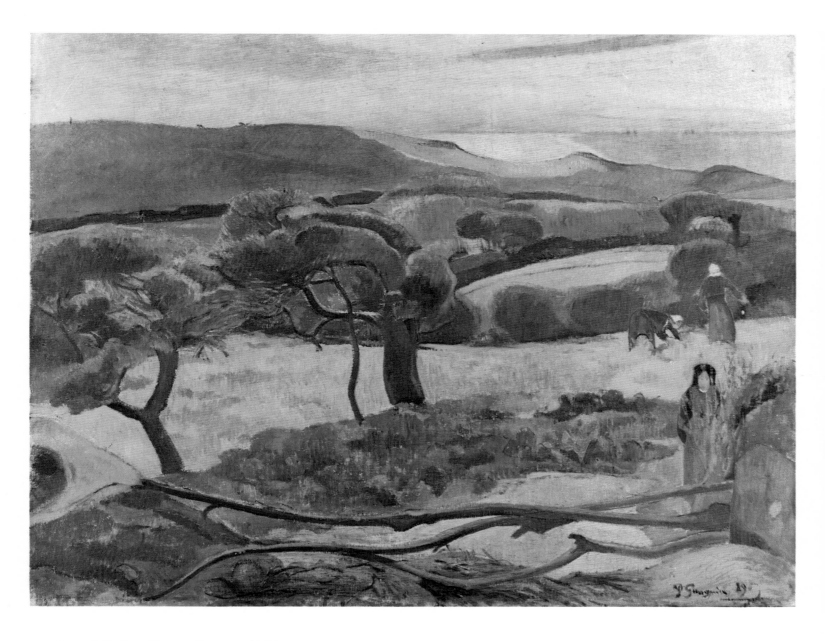

Landscape in Brittany, 1889
(72 x 91 cm)
This work is almost geometric. It is also a study of the curves of earth, sea and the wind-blown trees.

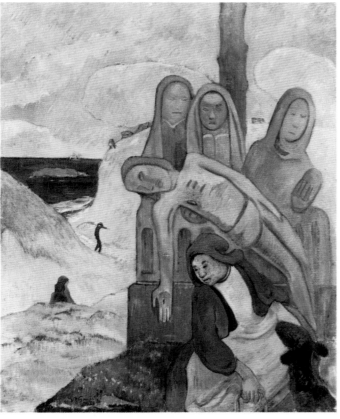

Pieta, 1889
(92 x 73 cm)
This canvas was inspired by a wayside shrine in Nizon, near Pont-Aven. There is a likeness to his Christ in Yellow, *painted in the same year. This work has a strange iconography.*

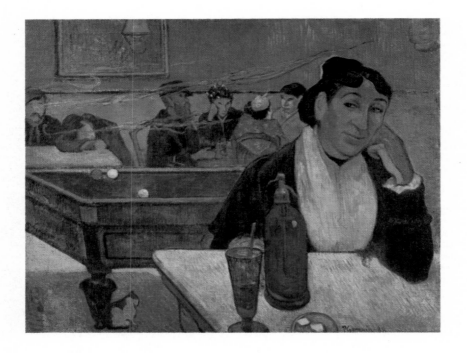

the Place Pigalle, in the company of the poets of The Chat Noir. There was something exotic and archaic about the man. Those who knew him said he would speak with self-assurance and preach the return to a style he christened *"saintaize"* (a compound of the French words for sanity and synthesis). His art showed itself influenced by the cloissonism of stained glass, the flat surface of Japanese prints, and the thick blues of Epinal. Though he attempted to justify himself in speaking of the art he had done in the South Seas, for the most part Gauguin saw himself as isolated from the crowd, perhaps incapable of being understood. There he stands in our imagination on board ship heading into unexplored territories. The Pacific, he said, "is an immense desert of burning vegetation."

There was in Gauguin something that we find to a lesser extent in his follower Serusier, a distorted esoterism, what Baudelaire called "a taste for the infinite." The symbolic mysticism of his Indonesian works one finds in his earlier works as well, such as in *Christ in Yellow.* On the back of the postcard on which he made his sketch for this painting one finds the inscription: "Calvary, cold stone, earth, Breton idea, in Breton dress. When my shoes slap against this granite soil, I hear the heavy, flat and powerful sound that I am looking for in my painting."

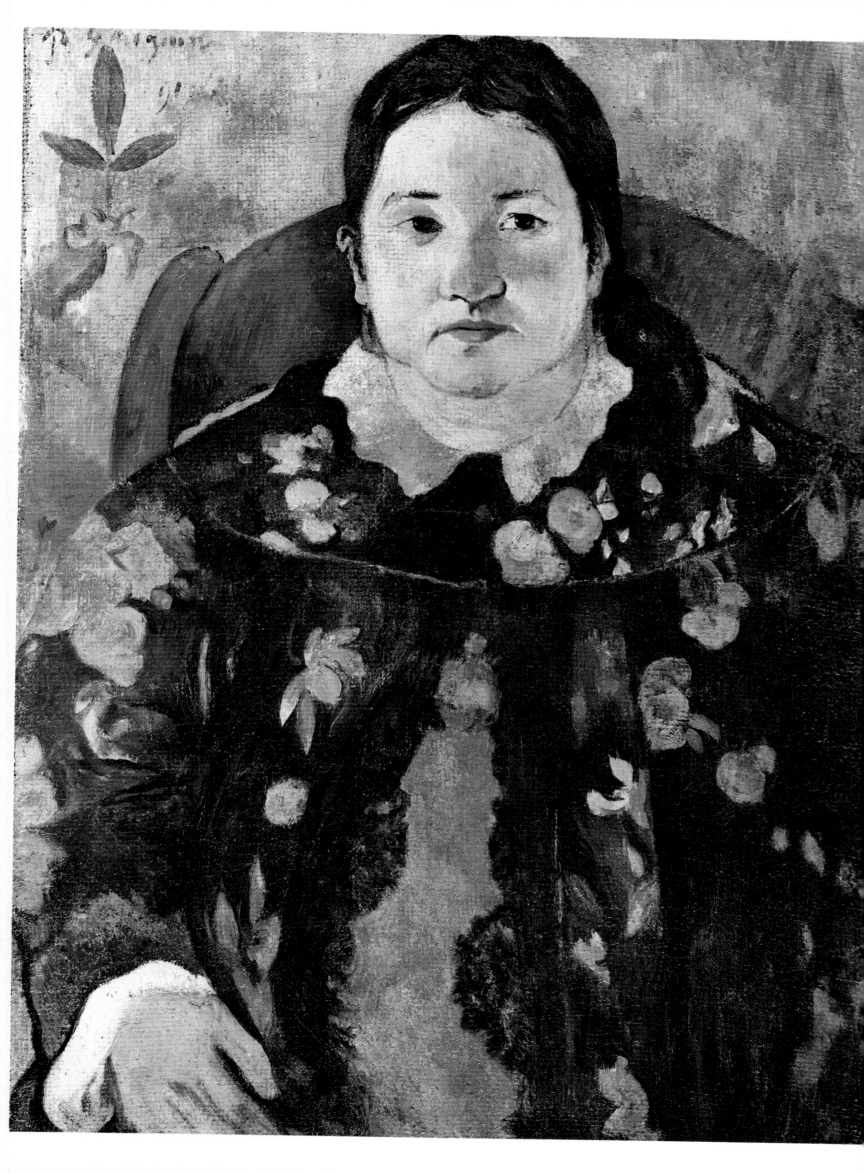

Ta Matete (the Market), 1892
(73 x 91 cm)
Each of the women on the bench is presented in a different attitude. This work was inspired by a photograph of an Egyptian frieze from the British Museum.

Arearea, 1892
(75 x 93 cm)
Gauguin did many versions of this same subject. This one is more detailed than most of them.

◁ **Two Tahitian Women on the Beach,** 1891
(62 x 91 cm)
Rarely has Gauguin done a more evocative picture of Tahitian women. Seated on the pale yellow sand, these two have a grace and a monumental character.

His Impressionist period was, as we have seen, very brief. It began about 1883 at Osny with his *Coming into the Village* and showed the definite influence of Pissarro. By 1888 he was exploring his own path in paintings such as *Vision after the Sermon* and *Jacob Wrestling with the Angel,* which in their stridency of color and imaginative strangeness remind us of *Christ in Yellow* (Albricht Art Gallery, Buffalo) and *Christ in Blue* (Kunsthaus, Zurich).

His great works were spaced out over time after that. In 1897, sick and despairing in Polynesia, he completed one of his most enduring paintings: *Where Do We Come From? Where Are We? Where Are We Going?* Octave Mirbeau has described it very well. "There is in this painting a disturbing, but heady mixture of barbarous splendor, Catholic liturgy, Hindu dreaminess, gothic imagery and a subtle and esoteric symbolism; there are here gripping realities and lost flights of poetry." After this prodigous testament there follow monumental nudes, group portraits, religious scenes where images of Christ (see his self-portrait entitled *Near Golgotha*) rub shoulders with occult rituals. Among this entire prestigious body of work there are some paintings that are most valuable for their exoticism and say to us, "Come to Oceania."

Gauguin always maintained that painting ought to be fully achieved in the mind of the artist before it was committed to the canvas. "It must all be done in one sitting," he said. "Better to start over than to touch up a work."

Before Yeats, the occult poet of Ireland, who brought about a Celtic renaissance tinged with Hinduism, Gauguin spoke of the magical virtues of chanted liturgies and the mystical life of forest dwellers of bygone ages.

Gauguin visited Van Gogh in Arles late in 1888 following an appeal by the troubled artist. At first Van Gogh seemed cheered by the visit, but their tempestuous natures soon clashed. On Christmas Day after a fight the night before, Van Gogh went after Gauguin with a razor. To punish himself for this crazy act Van Gogh cut off his ear and then carried it wrapped in paper to give to a prostitute. "That cut of Van Gogh's," Gauguin wrote soon after the event, "was a terrible cut for me. If Charlopin doesn't give me enough to go to Tahiti I'm done for."

Years later, March 7, 1895, the day before his final departure to Polynesia, Seguin wrote to O'Connor: "The poor old man is very ill. He caught siphylis a couple of months ago and the debilitating effects show themselves very clearly."

From 1897 until his death six years later, Gauguin's painting takes on a certain gravity. The painter was pursuing what in his own words he described as "a luxuriant barbarism envisioned in colors deliberately somber and sad . . ."

The Black Pigs, 1902
(91 x 72 cm)
This is one of the few paintings where the landscape of palm trees and huts is more important than either the people or the animals. The design is, for once, more important than the color.

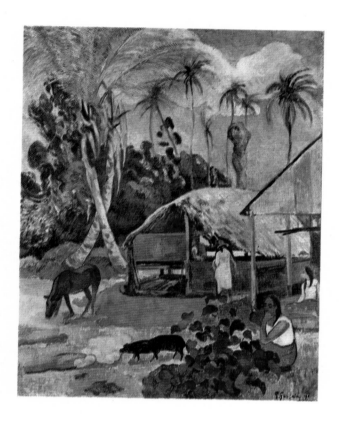

Vairumati, 1897
(73 x 94 cm)
Gauguin wrote in "Noa-Noa": "She is tall, and the fire of the sun glows in the gold of her flesh." He painted his inspiration in front of a background of gold.

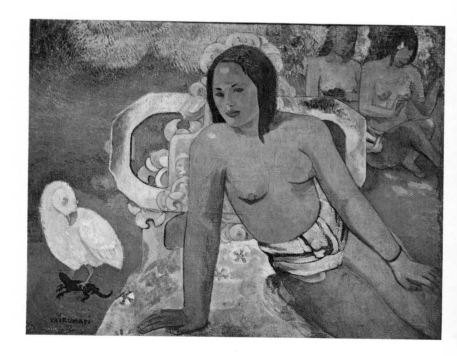

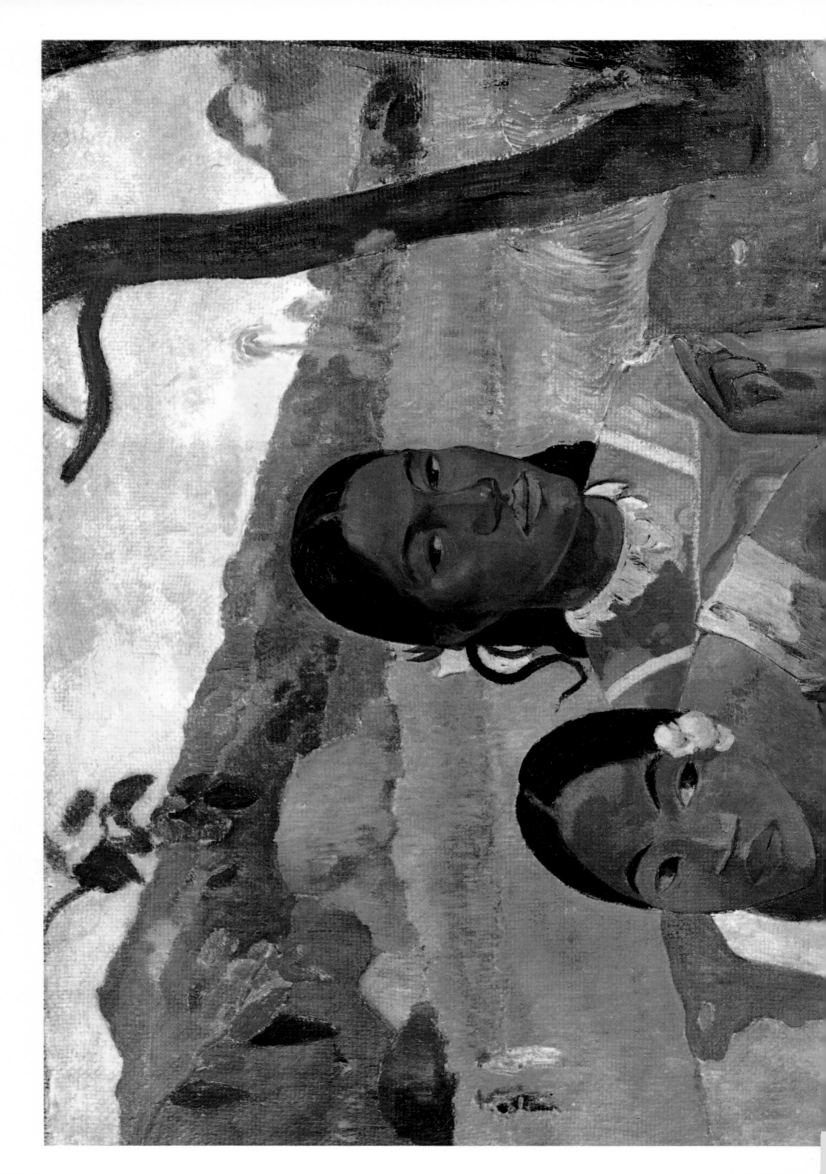

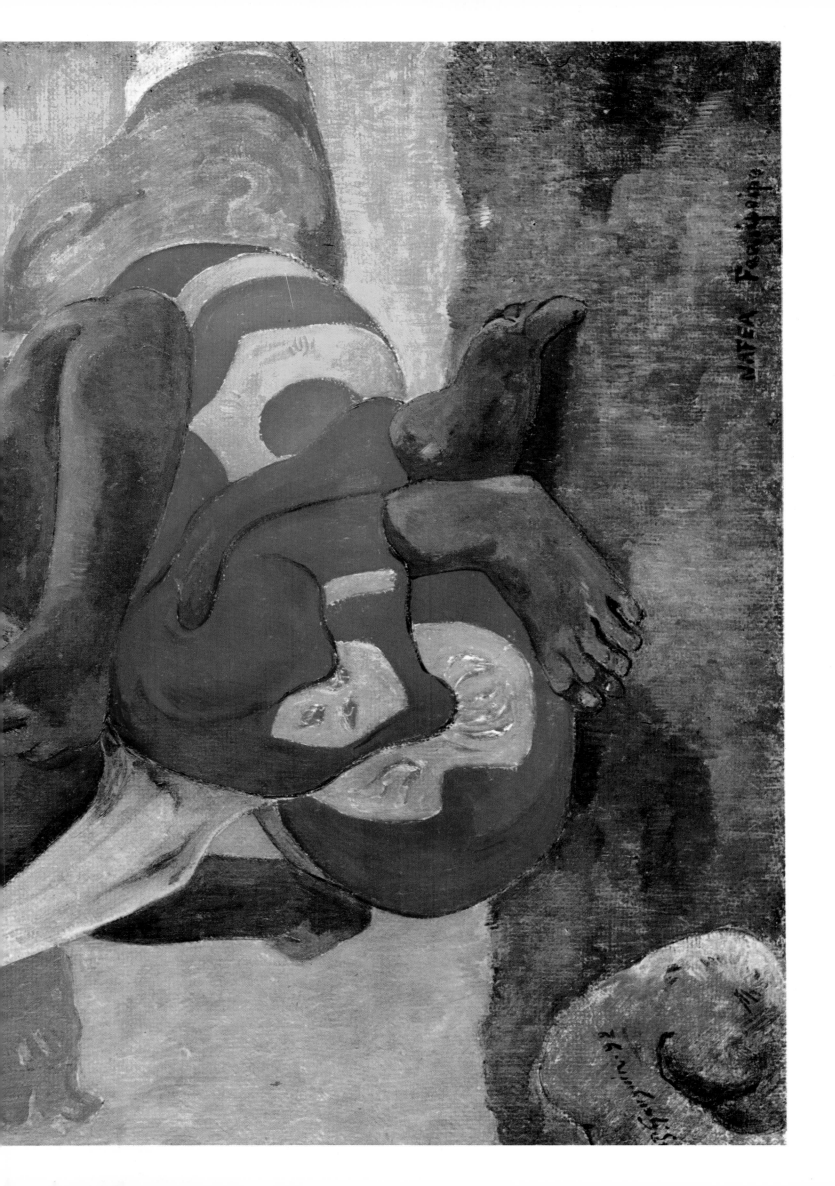

Nafea Foa Ipoipo (When Are You Going To Be Married?), 1892
(101 x 77 cm)
One of the most beautiful of Gauguin's Tahiti paintings. Two women in front of a mountainous background form a lovely composition, the forward figure turned slightly away from her companion.

The King's Wife, 1896
(97 x 130 cm)
In April, 1896, Gauguin wrote to Daniel de Monfreid, "I am painting a canvas of 130 centimeters, that I think is better than all the rest: a naked queen lying on a carpet of greenery."

Despite the varying quality seen when surveying the entirety of his work, there is always in Gauguin, after his very first still lifes and landscapes, a consideration of those compositional issues that he had concerned himself with at Pont-Aven, Paris, Martinique. Among the 638 pieces comprising the oeuvre of Gauguin there are a number of astonishing canvasses, of a color violent and yet harmonious, in a range between vibrant yellows and mauves almost unknown before him. These bear witness to his striking originality as a painter. In truth, Gauguin, coming out of Impressionism, signaled the first reaction to the new school by emphasizing the compositional organization of the canvas.

After his final departure to Tahiti Gustave Kahn, creator of free verse, mourned his loss. "No more will we see in Montmartre his blue frock coat, with mother of pearl buttons, his Breton waistcoat, his putty-colored pants and the pearl handled cane that he had carved himself."

Despite this outfit, Gauguin endured the most extended of solitary periods and the most straitened circumstances. To sell a painting in Dominique or Tahiti, which

was not even in very great demand in Paris, was indeed not easy. Charles Chasse reports the following description of Gauguin in the islands which he received from the Commandant Cochin. "He lived down there in sandals, working without cease, completely nude except for a stitched blanket wrapped around him. His chest was swollen up like a leper's."

During his stay in the Marquesas Gauguin gave to his home in Atouana the name "The House of Joy." It was a vast studio, with a little corner to sleep in. Sick, old before his time, his body and limbs wasted, it was there that he died on the eighth of May, 1903, at 11:00 in the morning, ravished by fever. He was struck down soon after writing: "If my work does not live on, what will endure is the memory of an artist who strove to free painting from many of the defects of academicism and symbolism."

Gauguin remains for us a refugee from an outmoded civilization, the supreme prophet of the doctrine of "the Noble Savage."

He himself has written on his notion of "equivalency" that he sought in his art in Tahiti and that many have found difficult to understand. Let us hear his own words

The Lovers, 1902
(74 x 94 cm)
Listed as missing in the Catalogue of Gauguin's Paintings, we are happy to be able to reproduce this picture here. The colors of the canvas, brown blue and violet, were the artist's favorite range. It is signed on the branch of the tree.

Woman With Fruit, 1893
(92 x 73 cm)
We think the best part of this canvas is the left side with the two seated women. The main figure seems to be uncertainly painted and the colors don't quite seem to belong.

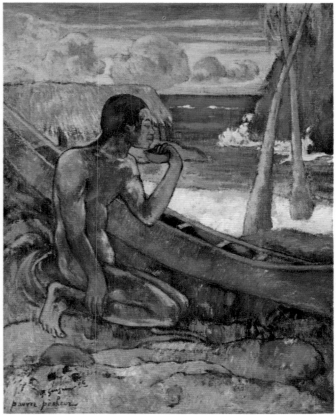

The Blue Idol, 1898
(92 x 72 cm)
This is one of Gauguin's esoteric works. "Strange figure, cruel enigma," he wrote on an engraving on wood that he sent to Mallarme.

Poor Fisherman, 1896
(74 x 66 cm)
Using a palette of purples, this canvas was painted during his second and last stay in Tahiti. This painting was one of nine canvasses that Gauguin sent to his Paris dealer, Ambroise Vollard, on December 9, 1896.

on the subject: "Wanting to suggest nature luxuriant and disordered, a tropical sunlight whch envelops all around it, I have to give to my subjects a corresponding frame. It is indeed life in the open air, which can sometimes be very intimate, here women whisper in vast palaces decorated by nature herself and are enclosed by all the riches of Tahiti. From that stem all these fabulous colors, this atmosphere glowing, but softened, silent. But none of this really exists. The painting exists as an equivalent to that mysterious grandeur of Tahiti that it struggles to capture on canvas."

From the perspective of our time we can better understand the painting of this consummate artist. In the entire body of his work certain canvasses force themselves upon us through their incomparable sonority and the genius of composition that they articulate. We recall the yellow luminosity of a pillow under the head of a copper-colored Maori girl, the powerful vibration of Persian vermillion, the rhythmic frieze of a group of seated women, the elegant arabesque of a horse. Gauguin took up simple, monumental attitudes. The sensuality of the man has created for us incontestable, imposing pictorial realities.

Faa Iheihe, 1898
This is a detail of the right portion of the painting. The woman on the left was inspired by a photograph of a fresco of the Javanese Temple at Barabudur.

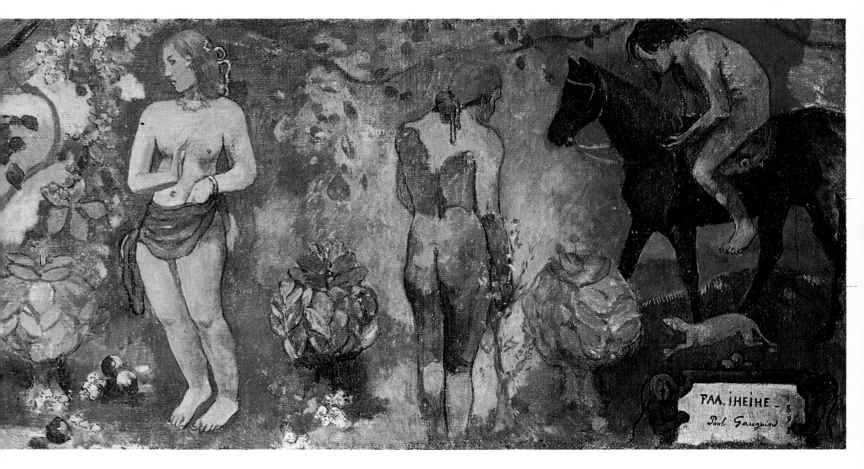

VAN GOGH Vincent

Groot-Zundert (Holland), 1853 - Atyers-sur-Oise, 1890

He came from a background of Dutch pastors. After an unsuccessful attempt at missionary work in the Borinage, he received from the beginnings of his career as a painter only the support of his brother Theo, who sent him a monthly stipend until his death. Always in misery, seeking out difficulties, he was subject to periods of madness. He ended by taking his own life.

There are beings who are more than artists and whose work is a lance hurled at a perverse nature. There are men whose power is to articulate the depth of suffering, and in so doing they bring out, as a kind of reaction, all the intensity of light. With them, the spirit is never in repose; they are what remains hidden and leave us alone and vulnerable before the shattering mystery of consciousness.

Van Gogh burned with terrible experience, living at the very edge. He was a man of love who was never loved, of an intense emotionality that offered forth in art for those who were to follow the sign of a strident fraternity. Armed with all the baggage of meditation, reading, art seen and digested, but a rebel against all apathy, he would not allow himself any easy pathways. Forced beyond the bounds of the conventional, he found himself alone in a landscape of the very greatest equality and compassion, the very greatest love.

He was an intensely difficult being, a seeker after the absolute. All injustice wounded him. It annoyed him to see workers exploited by the great men of affairs. What was he looking for? Simply, true beings who had no care for the vanity of the world—the commerce of human life. He took upon himself the full weight of the condition of ordinary man.

He was the most human of us all, who pursued with his fellows—be they miner or weaver, factory worker or soldier—everyday conversation.

Certain that he was living in a world that was bound to change, where society had lost its soul, van Gogh understood the weakness of a single man turned in on himself. He had the gift of believing in a concrete mission for

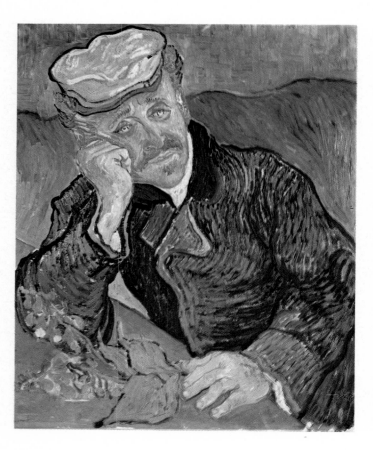

Portrait of Dr. Gachet, 1890
(68 x 57 cm)
Dr. Gachet was a friend of many of the Impressionists who visited him at Auvers-sur-Oise. Guillaumin, Cezanne and many others went there to sketch and paint. Van Gogh did this portrait in seven hours.

Self Portrait, 1889
(65 x 55 cm)
To our knowledge, this is the last of the many self portraits of the artist. It has the staring eyes, the cut lip. Surrounding the head the swirling blue seems to define the torment of the man himself.

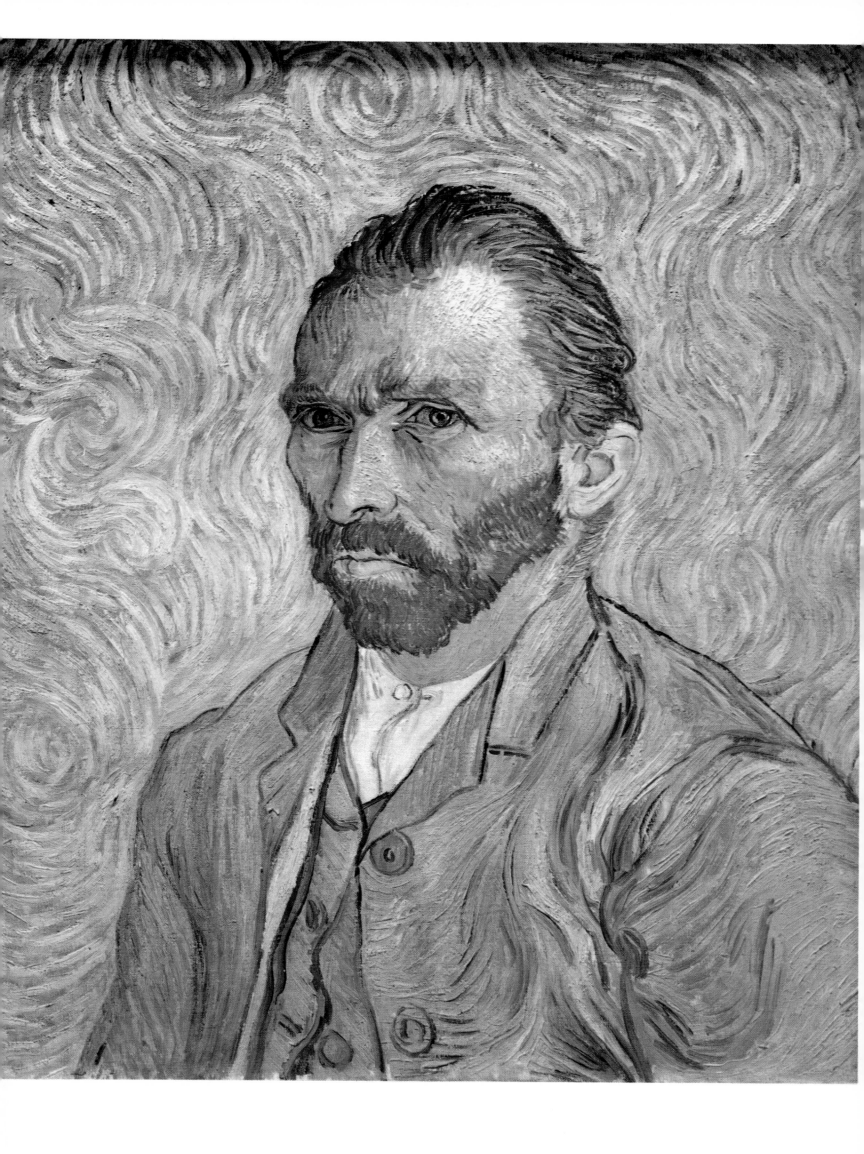

humanity, in the efficacy of goodness, and the power of evangelism. He had tried to live his ideals in the Borinage where he distributed bibles to miners whose faces were blackened with soot in a total engagement of his being.

His life began in the light of a coal fire, formed in hazy sunlight, lost itself under the heat of noontime at Arles and starlit nights, and ended in gun fire.

Let us look at van Gogh's work from the point at which he discovered his own style. He knew well the surroundings of Paris, its warm landscapes, its factory chimneys belching smoke night and day. He painted the city, the innumerable broken-down tenements, the street lights in procession under the palisades; and on the Rue Lepic where he stayed at the home of his brother, the window and sill on which rested the pot of catnip.

Then there are his bouquets: red gladiolas, hollyhock and iris that assume under his touch an almost astral vibration.

Bony, jaundiced, cheekbones wide apart, his most famous subject is van Gogh himself, angular, choleric with red hair and beard and little piercing eyes as much green as blue. And always the ghost of a smile. Certainly he wasn't a handsome man. And if he painted himself over and over again, it was not because of a desire for self-aggrandizement, but rather because he could not afford to hire models. And so it is Vincent in blue, Vincent in red, Vincent feverish, Vincent haggard, Vincent without a pipe, Vincent with his pipe clenched between his teeth, Vincent standing, Vincent sitting. Vincent in the midst of suffering, with eyes of green flame and the face of a salamander.

In Arles he painted and drew as if hallucinating. He was crazed with sunlight which he symbolized in his canvasses of windmills. "I believe that I have windmill sickness," he wrote his brother, with whom he corresponded regularly, and who always sent him a monthly stipend.

After long shattering quests under the implacable light of day, van Gogh sought out other delights in the trembling light of gas lamps of the cafes. And there we see him in the brothels of the county seat with his head dragged down, his triangular eyes and his terrible impulsiveness.

Bedroom in Arles, 1888
(58 x 74 cm)
Here we have two chairs, in a painting of Van Gogh's bedroom in Arles. He wrote, "It is a very plain bedroom; only the color gives distinction, a feeling of peace and of sleep."

The Painter's Chair, 1888
(94 x 74 cm)
This is the wooden chair from his bedroom in Arles. The painter left his pipe and tobacco on the straw seat. The whole presents a troubling simplicity.

The Caravans, 1888
(45 x 51 cm)
In 1888, Vincent wrote to his brother, "a small study of some stationary itinerant wagons, both red and green." He always had a friendly feeling towards vagabonds.

Chimnies, 1890
(60 x 73 cm)
Painted in Auvers in May 1890, this pastoral was part of the old Morosov collection.

Green Wheat, 1889
(46 x 56 cm)
This canvas dates from his stay at Saint-Remy. To show the richness of the field, the painter has meticulously designed the foreground.

Chimnies at Cordeville, 1889
(73 x 92 cm)
In a letter to his brother Theo dated June 10, 1890, Van Gogh speaks of "two studies of houses in greenery." This one painted in a sinuous baroque style formed part of Dr. Gachet's collection.

Field With Butterflies, 1890
(81 x 64 cm)
Vincent had a very personal style of painting plants. In a sense, it was like that of the old Dutch Masters. It is possible to tell each variety.

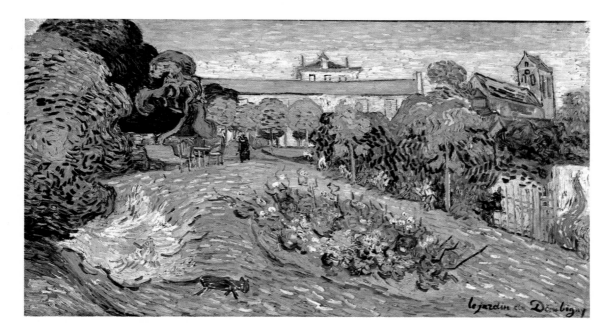

The Garden at Daubigny,
(56 x 101 cm)
*It was undoubtedly while
Van Gogh had his studio on
a canal barge that he painted
this garden. In this mostly
blue and green canvas there
are many small motifs.*

Of what terrible malediction was he the target, this
man in the fur hat who painted that little room in white
wood with the pot of water on the table and the chair,
that famous chair.

He dreamed of an army of artists and had Gauguin
come visit him to attempt a cooperative venture: com-
mon purpose and common pocketbook. But discussions
led to arguments and fallings out. Van Gogh had bizarre
reactions.

One evening Gauguin heard someone walking behind

Mademoiselle Gachet at the Piano,
(120 x 50 cm)
*Here is Maguerite, daughter of Dr. Gachet. In
her white dress, she is posed in front of a
spotted wall.*

◁ ***The Church at Auvers-sur-Oise,*** *1890*
(94 x 75 cm)
*Vincent wrote to his sister Wil in June, 1890,
referring to this canvas: "I have a large picture
of the village church in which the edifice seems
to soar into the intense blue of the sky."*

him. He turned, it was van Gogh running after him, razor in hand. Stared down, van Gogh returned home, cut off the lobe of his left ear, carefully washed the piece of flesh, slipped it in an envelope and brought it to a prostitute. Soon after he was committed to an asylum.

In Saint Remy in *Tormented Provence,* flaming cypresses rise toward a dark foreboding sky.

For a moment he would attain a kind of serenity. And then again, it was the infernal dance, the ultimate convulsions of the spirit in a dislocated universe, the deluge of fire.

His mental state grew worse and worse. He alternated between mental crises and periods of intense work. His brother Theo came to visit him. Vincent was obsessed with black birds, painting crows flying over a cornfield. He worked quickly, "quickly and pressed by time like the harvester." Everything is knotted and twisted, thatched roofs, the petals of almond trees, all is taken up in a desperate shuddering.

All too quickly, in the hospital, life for him was becoming insupportable. He returned to Auvers-sur-Oise, where he was followed by Doctor Gachet, who besides being a doctor was a friend to many of the Impressionists, and was himself a painter. He took lodgings at the Pension Ravoux. In the trance of his volcanic world, he painted a portrait of himself encircled with flames. His expression is sinister: one thinks of windows out of which madmen stare.

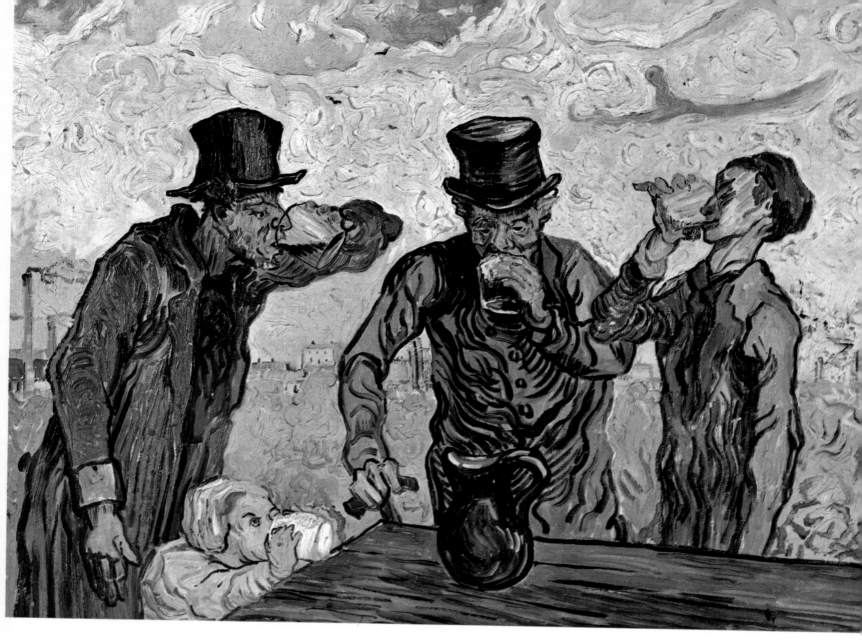

Drinkers, 1890
(59 x 73 cm)
*Van Gogh liked Delacroix and Millet. He
also had great admiration for Daumier, which
is shown here in* The Drinkers. *This canvas
was painted at Saint-Remy in June, 1890.*

Walk At Dusk, 1899
(49 x 45 cm)
*Here, once again, everything seems to turn and
roll under the large crescent moon. To draw
attention to the foreground, Van Gogh repeats
the dusky yellow of the sky in the woman's
dress.*

On Sunday, the 27th of July, discouraged, feeling his world grow increasingly dark around him, which his occasional periods of clarity made all the worse to contemplate, van Gogh left his lodgings. He made for the field that he had recently painted watched over by crows. There behind a dung hill, he fired a bullet into his chest. He had just enough strength to make it back to the inn where he was staying, buttoning up his blue jacket to conceal his bloody shirt. Notified in Paris, Theo came running. Seeing his sorrow Vincent said to him, "Don't cry. I did it for the good of all." The next day he lost consciousness. He died at one-thirty in the morning. He was thirty-seven years old.

For van Gogh the function of the artist was not to explore technique, make formal experiments or even to produce masterpieces but rather to transmit spiritual values. For this man, thirsting for communion, paint was a method, an imperfect language with which to communicate with others. And to show those who had eyes to see, the drama of existence. "His story," said one of his biographers, "is a story not of eye, palette or paintbrush; it is of a solitary heart beating against the walls of its prison." "But when will I paint this starlit sky," he said, "this tableau that always preoccupied me?" The starlit sky, he was going to paint it one night, a chapel surrounded by twinkling candles.

His painting, which was so disturbing, won few admirers. The man lacked the gift of attracting his fellows. He suffered from the absence of love all his life. "In that place where is housed the soul there is a great emptiness, and no one ever comes inside to warm it up. Passersbys only perceive a little bit of smoke rising from the chimney and continue on their way." This recluse hardly knew any other women than prostitutes. There once had been a young girl, a pretty neighbor in Nuenen. She completely lost her head over him, but family considerations forced her to move away.

He painted the woman with her hand on the man's shoulder, fleeing towards a happiness that was not for him.

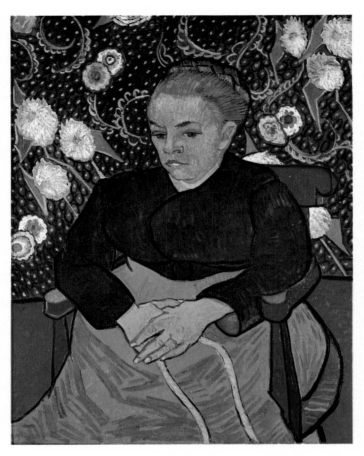

Portrait of Madame Roulin, 1889
(93 x 73 cm)
At Arles, Vincent did four portraits of Mme. Roulin, calling the group "The Lullaby." This one in green, sliced by the white flowers, seems to be the last of the series.

The Student, 1899
(63 x 54 cm)
This child in a cap was painted in November of 1889, at Saint-Remy. He is Camille Roulin, son of the postman.

GUIGOU Paul-Camille

Villars, 1834 - Paris, 1871

Before Cezanne, Guigou was a painter of the landscapes of the Gineste, which he inundated with sunlight. It is time to give credit to a painter who though not wholly unknown has nonetheless been underrated by posterity.

One could say that Guigou has been forgotten. This is a pity because his art, very little celebrated, almost always dazzles. Like Cezanne he painted the sun of Provence, glistening skies in all their radiance.

Guigou was an admirable evoker of country roads, fields and stones. "How many times," wrote Andre Gouirand, "in climbing a steep hillock, bordered by a field of wild thyme and sage in between the sweet-smelling pines of a Provencal valley, do we not cry out in surprise upon glimpsing in the distance the foot of some mountain covered with jasmine: 'Ah! Here is a Guigou.'"

There is in Guigou's work a quality of sunlit aridity. "We still have to discover this observer of stone and pale azure," remarked Edmond Jaloux. Guigou was a poet of the mineral world, architectural, where his light instilled with some superhuman emotion descends upon a wash of color.

Guigou's paintings, perhaps because of their marvelous luminosity, arouse an olfactory response in the viewer. Here beckon all the perfumes of the sun-drenched countryside where out of gray rocks tumbles a stream that welcomes us with its freshness.

Theodore Duret, who discovered Guigou in the Cafe Guerbois, where he was in conversation with Theophile Gautier, Pissarro and other of the Impressionists, describes him as an extremely modest man, thoughtful in speech, balanced in the expression of his ideas. "He painted," said Gouirand, "with a naievete of vision and spirit."

Guigou spent long periods of time in Paris and on the shores of the Marne. He returned to Paris to finish his days as tutor for the Baron Rothschild. His future was guaranteed, but a cerebral hemorrhage struck him down in his studio. Two days later he died at the hospital.

The Road to Gineste Near Marseille,
1859
(89 x 117 cm)
There is wonderful quality of light in this picture, which the painter not only captured but exploited with the finese that characterizes his work.

GUILLAUMIN Jean-Baptiste-Armand

Paris, 1841 – Paris, 1927

Guillaumin was a curious individual. After very remarkable beginnings, rare successes with tableaus of the quais of Paris, he painted a long suite of views of the Creuse almost entirely in browns and violets.

Of a family originally from Moulins, Armand Guillaumin began by working in the atelier of Pere Suisse, where he met Cezanne and Pissarro. He was employed in Orleans and later in Paris in public works. On Sundays he would paint fine evocations of Paris and its suburb.

In 1874 Guillaumin made the first of many trips to Auvers-sur-Oise to the home of Doctor Gachet, who became one of his best friends and most ardent collectors. The same year he took part in the first formal exhibition of the work of the new school. He showed three landscapes. He participated in every Impressionist group showing except those of 1876 and 1879.

Upon a windfall of 100,000 francs (a fortune in those days) won in the lottery, Guillaumin retired to the Creuse, where he spent a long time painting landscapes in browns and amethysts. It is largely on his account the Impressionists were branded as violetomaniacs (*violet-tomanie*).

We have not paid enough attention to Guillaumin. It is true that his production is erratic, but there are moments in his painting that suggest Neo-impressionism and announce Fauvism. See in this regard his *Sunset at Ivry* (Louvre, Musee du Jeu de Paume).

During his visits with Doctor Gachet, who was himself a painter, Guillaumin met Van Gogh, who was much taken with Guillaumin's work. It was at Auvers that Guillaumin initiated Cezanne into the art of engraving. One can find in the print collection at the Biblioteque Nationale of Paris the first engraving of Cezanne. It bears the inscription "After Guillaumin." It was in Guillaumin's atelier on the Ile St. Louis (where he was a neighbor of Cezanne) that Pissarro met Paul Signac. Guillaumin was also a wonderful renderer of nudes. Van Gogh was particularly impressed by the *Reclining Nude* of 1877.

Critical opinion has perhaps been mistaken in relegating Guillaumin, who was in fact a pre-Fauvist, to the ranks of the minor Impressionists. His work deserves an extensive exhibition. One would see, and recognize him in all his range and power, not only as the painter of those monotonous paintings of the Creuse; one would then see that very little-known canvasses bear the stamp of a distinct and memorable artistic temperament.

Sunset at Ivry, 1873
(65 x 81 cm)
This picture of the suburb with its reddened sky was shown at the first exhibition of the Impressionists. An admirably intense canvas, it heralds Fauvism.

JONGKIND Johann Barthold

Lattrop, 1819 - Sant Rambert Asylum near Grenoble, 1891

This Dutchman was an original, an innovator. He suffered mental lapses in which he would undergo paranoid delusions brought on from the abuse of absinthe. His wife was a very strong woman, Mrs. Fesser, a kind of mustachioed guardian angel. She dragged him away from Paris to bring him south to Grenoble.

A direct precursor of the Impressionists, Jongkind was a unique painter. His character was unpolished, even at times wild. He expanded, to find a more personal form of expression, that which he had learned from his master, the artist Isabey, who had made of him his protege and had seen in him his disciple.

Jongkind at first worked in the Flemish style of van de Neer and the painters of Averkamp, before embarking with an extreme freedom of motion on rapid strokes in both drawing and watercolor.

He spent time at Honfleur, and made frequent visits to Pere Toutain's farm in Saint-Simeon, where Boudin, Courbet and Baudelaire used to get together. Anticipating Utrillo, he painted advertisements on walls and in shop windows.

Jongkind's artistic method was to paint only the essential, to fix the viewer's attention on the principal points of color and light with an emphasis that is unique to him. A good example of this method is his *View of Paris* with Notre-Dame in the distance.

Jongkind's mental illness intensified just as he was beginning to achieve a certain amount of success. His last days were spent at the Saint Rambert asylum near Grenoble, where he died at the age of 72.

View of Paris: The Seine,
This is one of a number of Jongkind's paintings of Paris and the Seine.

LIEBERMANN Max

Berlin, 1847 - Berlin, 1935

After periods spent in Berlin, Weimar and Barbizon and a career of painting after traditional German models, Liebermann discovered Impressionism during a visit to Paris. He submitted to the influence of Manet and lightened the range of his colors. He is responsible for bringing to Germany the new school of French painting.

Son of a well-to-do industrialist, Liebermann began his studies in philosophy, but they were quickly interrupted by an irresistible attraction to painting. He did his first paintings at Weimar. He began with familiar scenes of peasants in the style of Millet and paintings inspired by small tradesmen and domestic laborers. In 1873 he completed his first important canvas: *The Feathers of Geese,* which caused a small scandal on account of its realism.

Arriving in Paris, Liebermann allied himself with the painter Munkaczy who was installed there. He was at that point 26 years old. A voyage to Holland allowed him to get to know the work of Frans Hals, whose rapidity and sureness of touch made a deep impression on him. In 1874 he found himself in Barbizon, where he studied paintings of Corot, Daubigny, and most importantly Millet. He exhibited one painting in the Salon in Paris in 1876, *Workers in a Turnip Field.*

On his return to Berlin he was temporarily laid up by a broken leg, but he was soon up and about again and voyaged to Venice where he met Lenbach, portraitist of Bismarck. Back in Munich he painted *Jesus Surrounded by Learned Doctors.* Soon, becoming aware of the value of Impressionism, and in his admiration for Manet and Degas, he lightened his palette. This did not prevent him, however, from doing fairly conventional portraits of Constantin Meunier, Wilhelm von Bode, the art historian, and Gerhart Hauptmann, author of *The Weavers.*

It was after this time that he painted his most important canvasses. He had a remarkably long period of creative work between 1900 and 1921, and surprisingly never lapsed into the ordinary or the routine. He died at the ripe old age of 88. It was through his influence that the new avenues of French painting were spread through Germany. Liebermann was also an important engraver.

Open Air Restaurant, 1905
(71 x 88 cm)
This canvas was painted with a luminous pallette; trees, people seated, the splashes of sun on the ground, all conspire to make this a fine Impressionist painting.

LORRAIN Claude Gelee

Chamagne, 1600 - Rome, 1682

Along with Nicholas Poussin, Lorrain was the great representative of French painting in the seventeenth century. He passed almost his entire life in Italy, where he showed himself to be a precursor of Impressionism in his landscapes. He was a simple soul, a lover of sunlight and water.

Claude Lorrain was at one and the same time the contemporary and opposite of Nicholas Poussin. They both lived in Rome at the beginning of the seventeenth century. As much as Poussin's work was produced through study and reflection, so much was Lorrain's a product of a kind of spontaneous and untutored genius.

We marvel at the cocoon which could produce such a beautiful butterfly.

He began as a shepherd in Chamagne and came into Italy with a group of cooks and pastry chefs. He studied painting in Rome as a apprentice. It is impossible to go down the coast in that part of Italy without recognizing throughout seascapes that Claude had put on canvas three centuries before.

Lorrain was the first painter to work at different times of the day to capture the varying effects of light. Thus his paintings mark the hours, anticipating by over two centuries Monet's famous series of paintings of the Cathedral at Rouen.

In the works of Lorrain, in his *Campo Vaccino,* in his seaport scenes, which inspired Baudelaire, there is already that subtlety of values which was to characterize the painting of Corot and that radiant atmosphere, which was to become a hallmark of Impressionism.

"Claude," said Kenneth Clark, "was capable of subordinating all his gifts of observation and all his awareness of nature to the poetic sentiment of the whole."

Before Turner, who deeply admired his use of light, Claude Lorrain was the painter of light sparkling and dancing on the sea.

"Landscape is a state of mind," said Fredrick Amiel. This fresh, impalpable air, this breeze, these almost spiritual brushstrokes, this light taken in by the eyes and brought forth through some miraculous transsubstantiation, all this was created by Lorrain with one stroke, as a spontaneous act.

His legacy to the Impressionists was water, sky, sunlight and the evocative power of the paintbrush.

St. Paul Departing for Ostia,
(211 x 145 cm)
This is the most important of the four canvasses ordered by Philip IV of Spain. The light caresses and unifies the whole picture. Claude, who was known as a landscape painter, was said to need help in painting people.

MANET Edouard

Paris, 183 (Holland), 1853 – Atyers-sur-Oise, 1890

The Old Musician, *1862*
(187 x 249 cm)
A youthful work by the painter who found his models in the quarter of Paris known as "Little Poland." In spite of the lovely little girl in blue and the boy in the straw hat, the painting lacks unity because of the grouping on the right.

From a bourgeois family Manet, without embracing the trappings of a rebel, consistently opposed all forms of conventionality. A revolutionary in spite of himself in his painting and a close friend of Baudelaire, he ended up marrying his piano teacher. In his work there is great purity of light and a sense of color that is fresh and unexpected. "Manet et manebit" was the motto his friends gave him. "He endures and will endure."

Manet was the son of an important bureaucrat at the ministry of justice. After having completed a course in the law and sailed as far as Rio as a student at the Naval Academy he entered the School of Fine Arts under the tutelage of Thomas Couture. This, however, did not last long. He soon left "that little hunched-over fat old man" with whom he had practically nothing in common. At the time he spoke about his experiences in art school. "I don't know why I am here. Everything I cast my eyes on is useless. The light is false, the shadows are false. When I arrive at the atelier I feel as if I were entering a tomb."

Edouard Manet was a strange case. He was the last precursor of Impressionism, the one who opened the door wide to open space, blue sky and sunlight. He sounded the death knell for conventional painting. Steeped in Parisian life, he was a friend of Baudelaire and at the same time sought the approval or at least the understanding of bourgeois society. All of his friends were, however, practitioners of the new school of painting and considered social pariahs. Manet was directly responsible for bringing Berthe Morisot into the movement.

His life was an extraordinarily rich one. He painted a portrait of Mallarme and one of Clemenceau as well. He illustrated the *River* of Charles Cros, the poet and inventor of the phonograph. He had the good fortune to have Emile Zola come to his defense over the painting *Olympia,* which caused such a scandal that the young painter had to flee to Spain. He died in the arms of Chabrier.

Baudelaire much admired the work of Manet. For his part Manet found Baudelaire's poetry a revelation. They

The Artist, 1878
(191 x 130 cm)
*A portrait of Marcellin Desboutins, master
engraver, who was a friend of many Impres-
sionists and frequented the cafes Guerbois and
Nouvelles Athenes. He is the man in Degas'
canvas* l'Absinthe.

often dined together. One sees Baudelaire's influence
very strongly in Manet's first important canvas, *Music in
the Tuileries.* In this painting one spies for the first time
many faces that were to become familiar subjects in later
Impressionist paintings. Following Courbet's *Girls on the
Shore of the Seine* Manet painted *The Picnic,* which brought
painting out into the open air for once and for all. Witness
as well the explosion of color in his painting *Lola de
Valence.* In these early paintings we already see in Manet
the dancing brush stroke and clarified palette of those
who were to succeed him. One senses that there was at
the beginning at least on Manet's part a kind of jealous
rivalry with Monet, until he invited him to Argenteuil,
where on his floating studio Manet painted Monet's
portrait.

The Fife Player, 1866
(161 x 97 cm)
*After a viewing, the judges of the Salon refused
to admit this painting. It was too straightfor-
ward, no shadows, and the colors were too
exposed and strong. Emile Zola wrote, "I
would not believe it possible to achieve a feeling
so alive, with so little artifice."*

Let us look for a moment at his *Olympia,* this nude for
which Victorine Meurend, who was to become his favor-
ite model, posed. Victorine lived on the Rue Maitre-
Albert and played the guitar. With a red flower in her
hair, a band of lace around her neck, and one slipper half
off her foot, she gazes out at us. She was the woman with
auburn hair that Manet had already painted in the nude in
The Picnic. At the time of this painting she was twenty
years old.

Manet has created that which Whistler calld a sym-
phony in white. The white blueness of the sheets contrast
with the rosy pink of Olympia's body stretched out on the
oriental sofa, which on the whole, gives off a yellowish
white impression. Olympia looks straight ahead without
paying the slightest bit of attention to the bouquet
wrapped in white paper that the black lady brings her.
Manet had certainly seen the *Venus of Urbino* of Titian. His
model gestures in the same modest way with her left arm.
Manet, however, had the courage not to embellish or
beautify his model. Victorine's head, for example, was
rather plain and square. Thus did he paint her. But
nonetheless this admirable composition of white is an
illumination. One could say that the painter, in the pres-
ence of this woman lazily rising from her pillow, wanted
to create a new type of beauty, flesh offered in all its
nakedness without any of the idealization still so dear to
painters such as Ingres. It was a reengagement with
pictorial reality, the model being present only to permit
the painter the opportunity to explore color, light and the
values of white. Not since Goya had a painter shown such
courage. *Olympia* was a glove thrown in the face of the
bourgeoisie.

The painting caused a scandal at the Salon of 1865.
Two guards had to protect it from the assaults of canes
and umbrellas. The critics considered it an insult. Ernest
Cheneau in the *Constitution* of May 16 said that the posi-
tion of Olympia's hand caused "hilarity, verging in some
cases on wild laughter." Even Gautier was affronted. He
wrote that "the flesh tones are dirty. The model is
nothing." One writer, Felix Deriege, wrote in the *Cen-
tury,* "This brunette is of an exceptional ugliness, her face

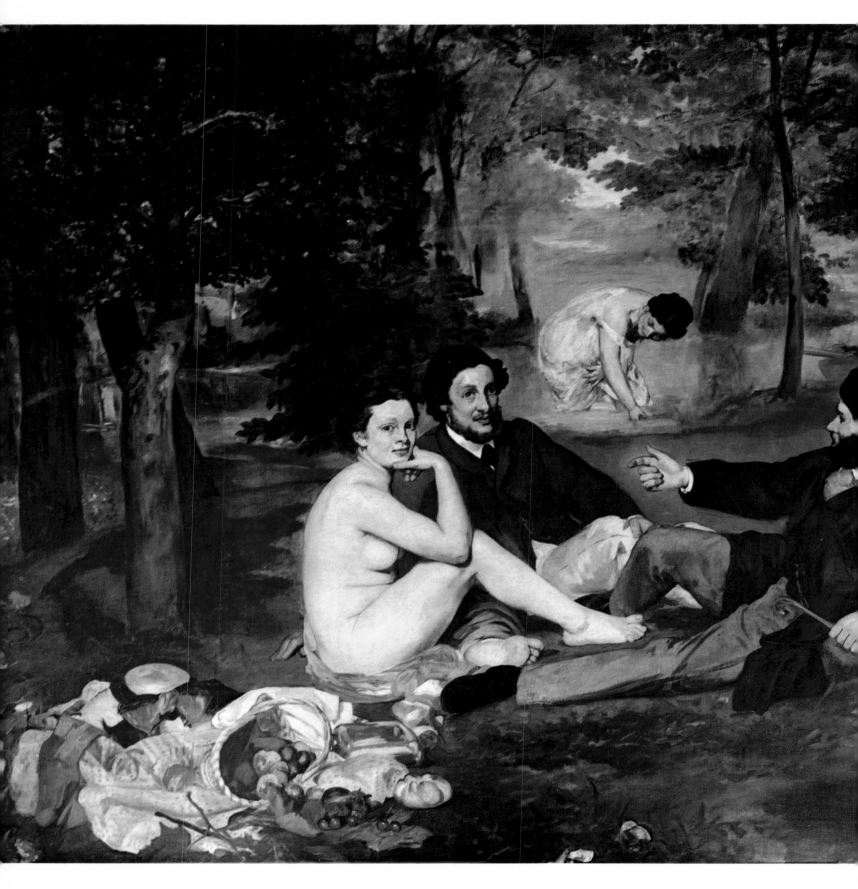

Picnic, 1863
(208 x 265 cm)
After Courbet, this is the first large picture in the open air. Manet used his most constant model for the figure of the nude swimmer. It was the idea of a naked figure in the middle of such ordinary happenings that truly shocked the public.

The Balcony, 1868–1869
(170 x 125 cm)
*In the front at the left, Manet painted Berthe Morisot in a Spanish style. The man in the
middle is Guillemet, a landscape painter, and at the right is Mlle. Claus, a violinist. The
work is enclosed by a strong green color, a mark of Manet's painting.*

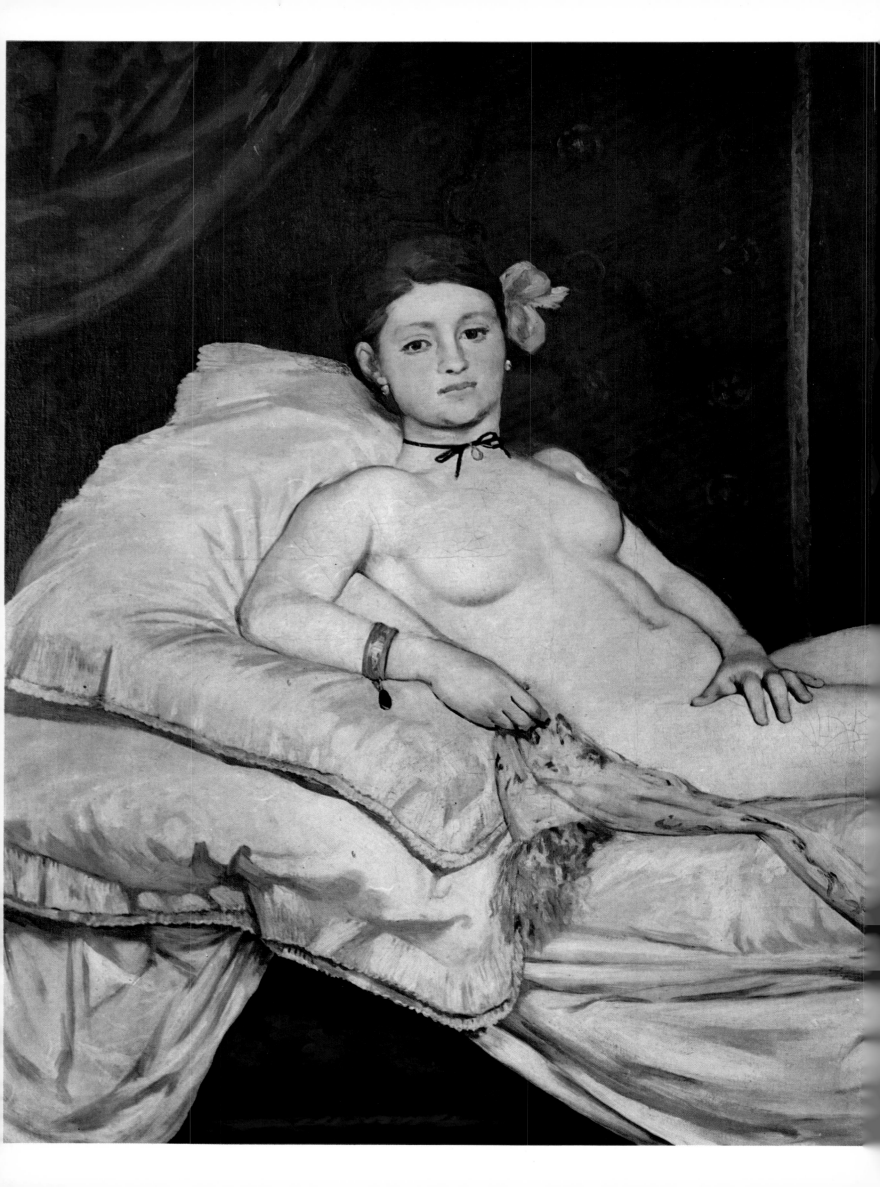

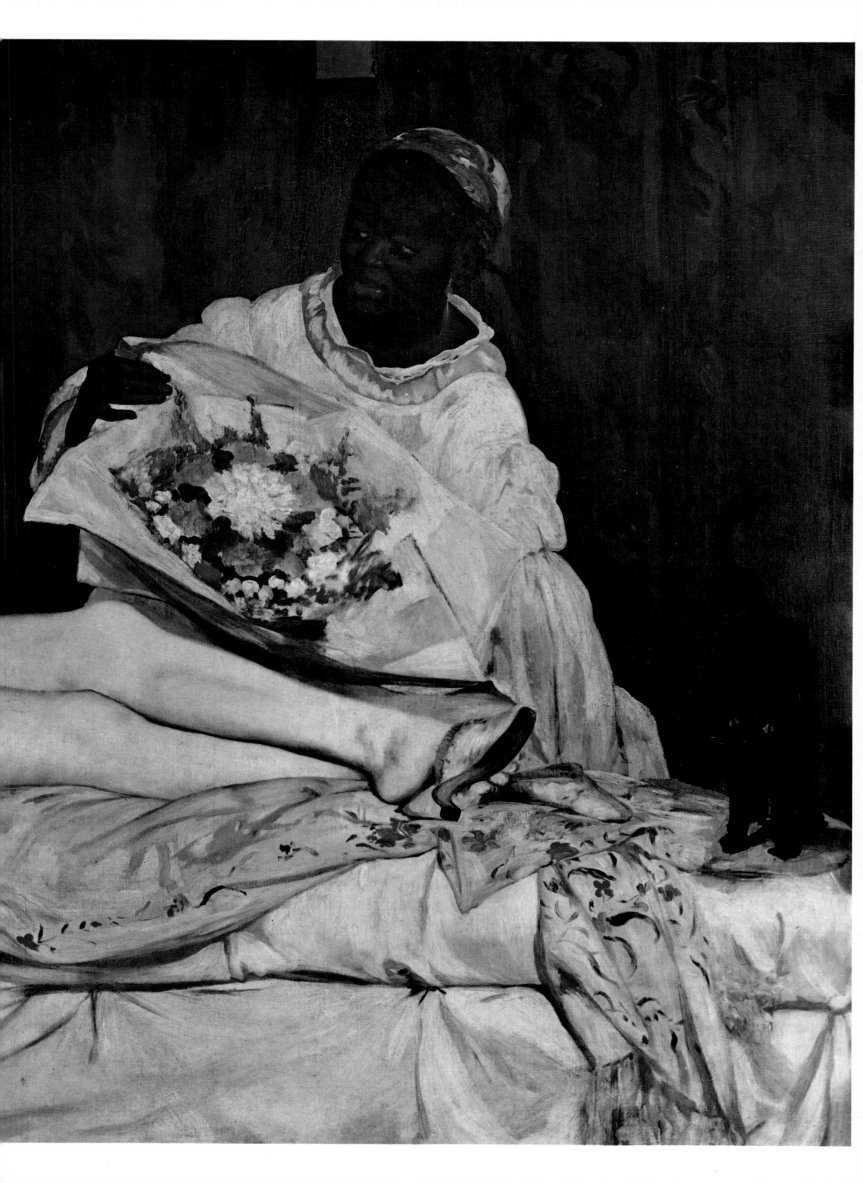

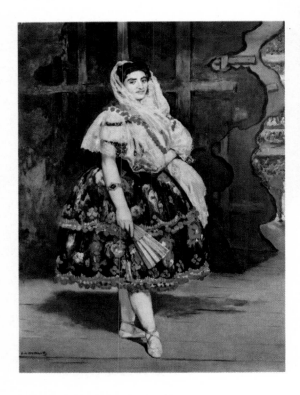

◁ *Olympia,* 1863
(131 x 190 cm)
Strangely enough, "Olympia" was accepted by the Salon of 1863, but it took two guards armed with canes to keep detractors from damaging the painting.

Woman With a Fan, 1863
(90 x 113 cm)
She is seated, one foot sticking out from under her spread crinoline, her hand resting on the side of the chaise; she who was called the "Black Venus," although she was not black. Her name was Jeanne Duval.

Lola of Valencia, 1862
(132 x 92 cm)
Here is Manet at his best as a colorist. Baudelaire wrote a famous quatrain on the etching of this picture, which he published in 1863. Lola was the star of a troupe of Spanish dancers.

Woman with Beer Steins, 1878
(98 x 78 cm)
We have here a music hall. In the background, a dancer is performing. The serving maid has two glasses of beer in her hand, while in front a young workman sits smoking his pipe.

is stupid, her skin cadaverous. Manet has so mangled her in his rendering that it is hard to imagine how she could move her arms or legs."

Manet was anything but insensible to this critical lashing. Baudelaire wrote him from Brussels: "You are not the first man to find himself in this position. Are you a greater genius than Chateaubriand or Wagner? Remember they also were objects of public derision. But they didn't die from it'" Needing a change of scene, Manet departed for Spain. On his return he was heartened by the courageous defense of his work published in *l'Evenement* by Emile Zola under the pseudonym of Claude.

To protest the jury's constant rejection of his works (*The Fife Player* had just been turned down) Manet set up a small shack on the Place de l'Alma where he showed the whole of his work. (For his part, Courbet was doing the same.) It was about this time that he met Berthe Morisot and had her pose as the Spaniard in his painting *The Balcony,* along with Mademoiselle Claus, the violinist, and the painter Guillemet. This woman, a painter of great talent, is seen in many of Manet's paintings. We see her in different attitudes, full face, stretched out on a couch or with her face hidden behind a fan. The nature of Manet's relationship with this lovely woman who was to become

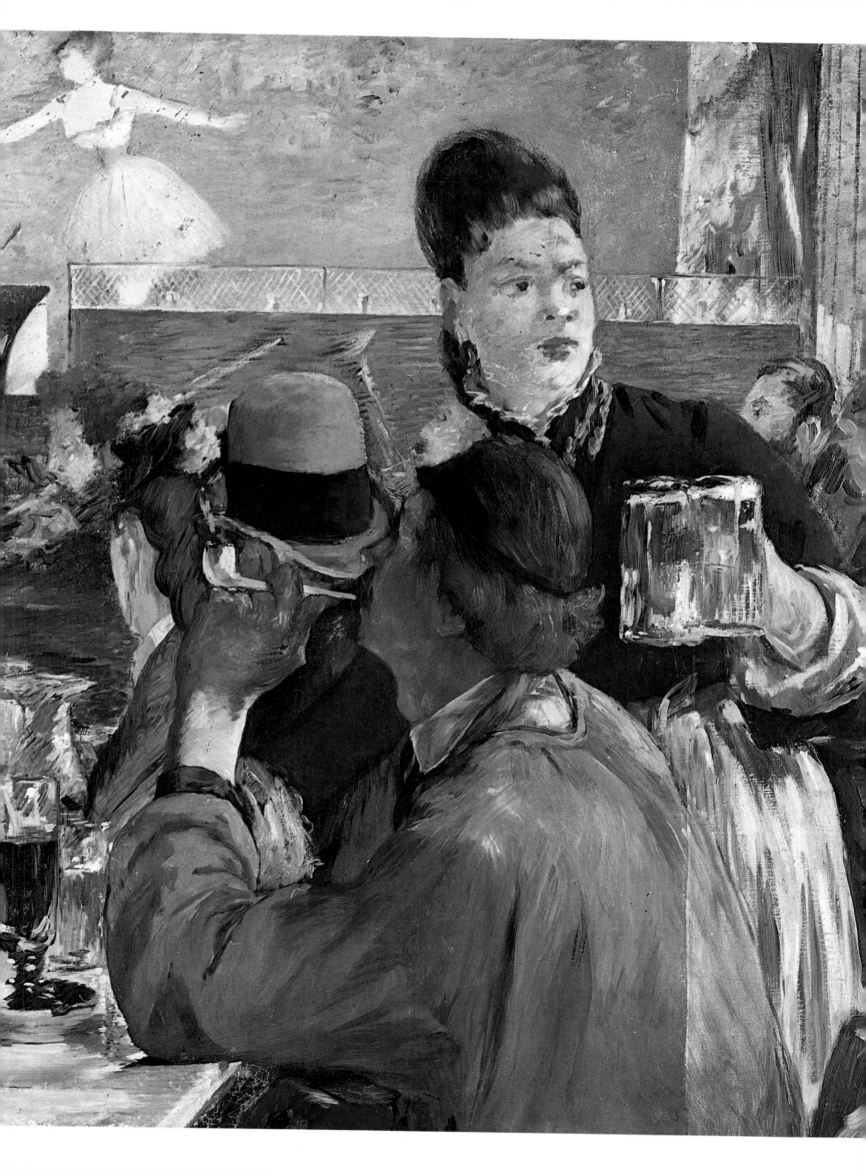

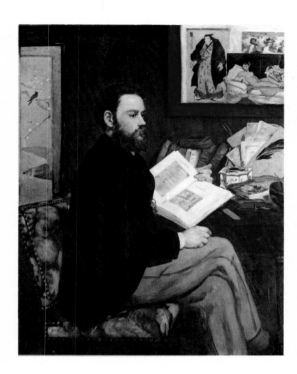

Portrait of Emile Zola, 1868
(85 x 71 cm)
Emile Zola was one of the first important defenders of Manet, and he published many articles introducing him to the public. Manet shows him here with reproductions of "Olympia," a Japanese print and a bit of Velasquez in the background. This is the Zola of Therese Raquin.

his brother's wife has not been definitely established. There is the mystery surrounding the birth of Leon Koella (he called Manet his godfather) whose existence was a secret between him and his old piano teacher, who was to become his wife. There was in Manet something of the libertine, which his wife was forced to accept philosophically.

Little by little Manet came to be regarded as an original in the life of Paris. Refined, a trace of arrogance showing at the corners of his mouth, a smile of faint superiorty, he was a character. While his comrades persisted in their vocal opposition to the Salon, Manet arrived at a rapprochement and ended by being admitted to the jury.

Manet was acquainted with Mallarme, whose portrait he painted in 1876. Mallarme described him as "having a heavy jaw, but a fine beard and head of hair. He was sarcastic and elegant. In the studio he approached the empty canvas with a confused fury, so that a casual observer might conclude that he had never painted before."

In 1874 Manet sojourned with Claude Monet. But where Monet was direct and straightforward, Manet's character was more complex, oblique. Of all the generation of painters with whom he is associated he alone with Cezanne was not tormented by the need for money. He was often there to assist his friends (e.g., Monet, Zola). He had taken the easy road in life. In those moments when he felt ashamed Baudelaire was his conscience, Baudelaire who before dying as an aphasic kept repeating in Doctor Duval's clinic, "Manet, Manet."

Manet had very cordial relations with Mery Laurent, with whom Mallarme was also in love. Mery had been the mistress of Evans, Napoleon III's dentist, and was reckoned one of the great beauties of the end of the Second Empire. It was she, who when Manet was too weak to travel the distance from his home on the Rue Saint-Petersbourg to his studio on the Rue Amsterdam, brought to him or had her maid Eliza bring him the bouquets of roses and lilacs that he painted in his last canvasses. Manet was in fact dying of venereal disease, a sickness that in that epoch was unpardonable.

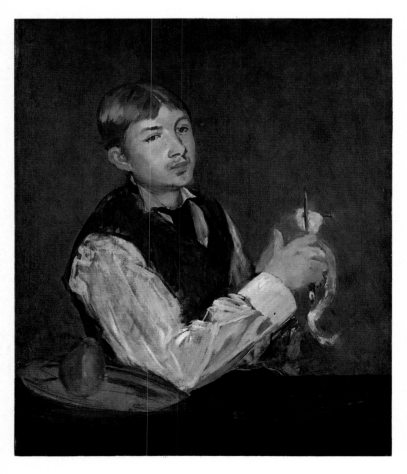

Young Man Peeling a Pear, 1868
Here, Manet uses a delicate palette. One must admire the sure touches of the sleeve and the shirt. As always, the final composition is a harmonious whole.

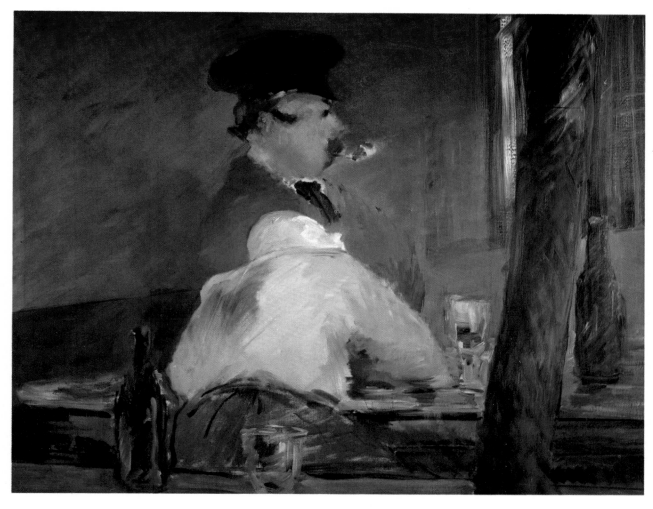

The doctors were forced to amputate his left leg to avoid the spread of gangrene; but before this he had painted the *Bar of the Folies-Bergere* and had Jeanne Demarsy, a ravishingly beautiful flower of the streets of Paris, pose for him in profile, holding a parasol in *Jeanne* or *Springtime*.

Manet can truly be called the father of Impressionism. It was he who opened up the doors to the light of the open air, the clarity of color and the engagement with forms of contemporary life that mark the best works of this movement. He never retreated into historical painting (unlike Meissonier under whom he served in the defense of Paris in 1870).

A revolutionary in spite of himself, Manet reconciled experience and poetry. His work opens up a broad avenue to the future. And for us it has the effect of removing obstacles in the path of vision, of forcing us to see anew.

Woman in a Black Hat, 1882
(55 x 46 cm)
This is a portrait of the Viennese Irma Brunner. Towards the end of his life, Manet started to use pastels. Here he drew the delicate profile of a friend of Mery Laurent. By contrasting the rose of the bodice with the black of the hat, he has made a wonderful study.

The Tavern, 1878-1879
(77 x 92 cm)
The piece is raised behind the light mass of the recumbant woman. The serious, absorbed man has a penetrating gaze.

MONET Claude

Paris, 1840 - Giverny, 1926

Claude Monet is the Impressionist painter par excellence. His brush strokes are quick, variable, inimitable. He finished his work with his transcendant Water Lilies. In the style of Claude Lorrain he marked in his painting the different hours of the day. He would work on several canvasses at once, recording the appropriate lighting on each as the day progressed.

The son of a grocer, Claude Monet spent his youth at le Havre. There he met Boudin who commissioned him to paint. He had difficulties with his family and spent his two years of military service in Algeria. In 1862 he went to Paris where he attended the Gleyre Academy. His colleagues there were Bazille, Renoir and Sisley. Having had his *Women in the Garden* refused at the Salon, he joined the new school of painting that in derision was called "Impressionism," a name derived from his painting *Impression, Sunrise.* After a period of serious financial troubles he was finally able to exhibit fifty of his paintings at Durand-Ruel. He at first resided in the town of Vetheuil and then later moved to Giverny where he lived until the end of his life. He died at the age of eighty-six.

Born on the same day as Rodin, Claude Monet, like the great sculptor, was a headstrong person who took a combative stance towards life. In the beginning he attracted attention for his caricatures. He was very young—eighteen years of age. A fine painter of sky and seascapes, Eugene Boudin, taught him how to paint with oils and how to mix his colors. Then, all of a sudden, he joined Gleyre's studio, but a few weeks later he fled town to set up his easel in the forest of Fontainebleau. He had but one idea: to make painting important in the style of Courbet. But when the teacher from Ornans suggested he paint in the "chic" style, he had to rebel, if, in his own words: "I want to see actually how things were in nature."

During this period he made the acquaintance of an older artist, Edouard Manet, from whom he received some inspiration. Later on, however, Monet was to give much more than he was to receive.

Monet, at this point, decided to make an intensive study of the effects of the sun on his landscapes.

"Speak of light and leave the shadows alone."

We know how, in the public eye his work entitled *Impression, Sunrise* was scorned by the critics. It was not until 1889 that Impressionism gained respectability in the art world.

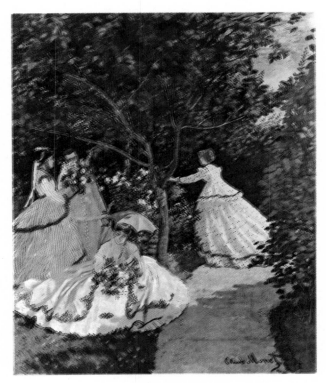

Women in the Garden, 1867
(255 x 205 cm)
This was painted in a house he rented in Ville-d'Avrey. It seems he used Camille, his companion (she later became his wife), as the sole model for the four women who form a sort of circle in the greenery. The sun slants on the path. In a white costume, under an umbrella, Camille studies a bouquet of flowers. Here one sees all the clarity of Impressionism.

Monet is the Impressionist painter par excellence. His followers, united by the verbal attacks and aspersions launched by the official art world and echoed by the general public, all took different paths. It is truly amazing that the term Impressionist was used to refer to such a diverse group of individuals as Monet, Sisley, Pissarro and Guillaumin. Degas was to devote himself to his bitter realism, relieved only by the gaiety of his ballet dancers. Berthe Morisot was to elaborate on Monet and even bring his work further along with the rare insight of her femininity. Renoir was to extend himself, immersed in painting nudes and large subjects. Pissarro was to concern himself with the solidity of objects that Cezanne was to transform into power.

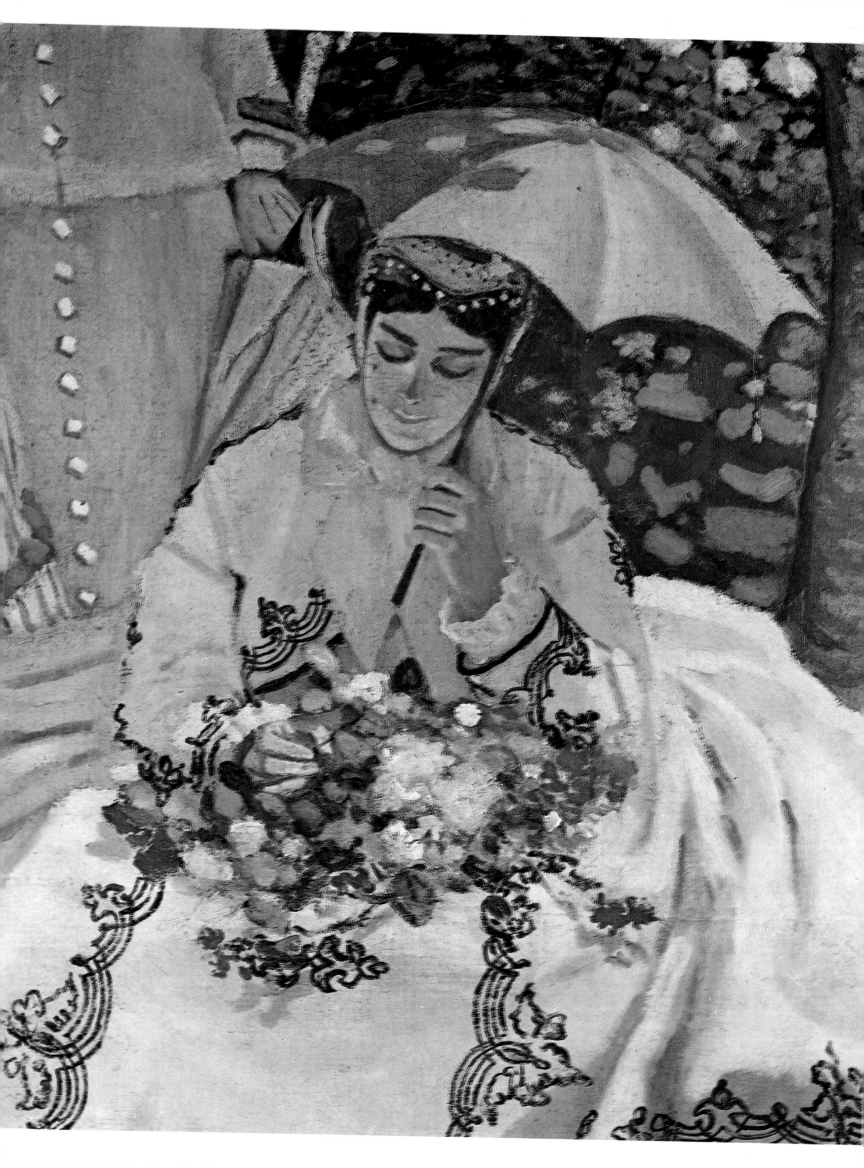

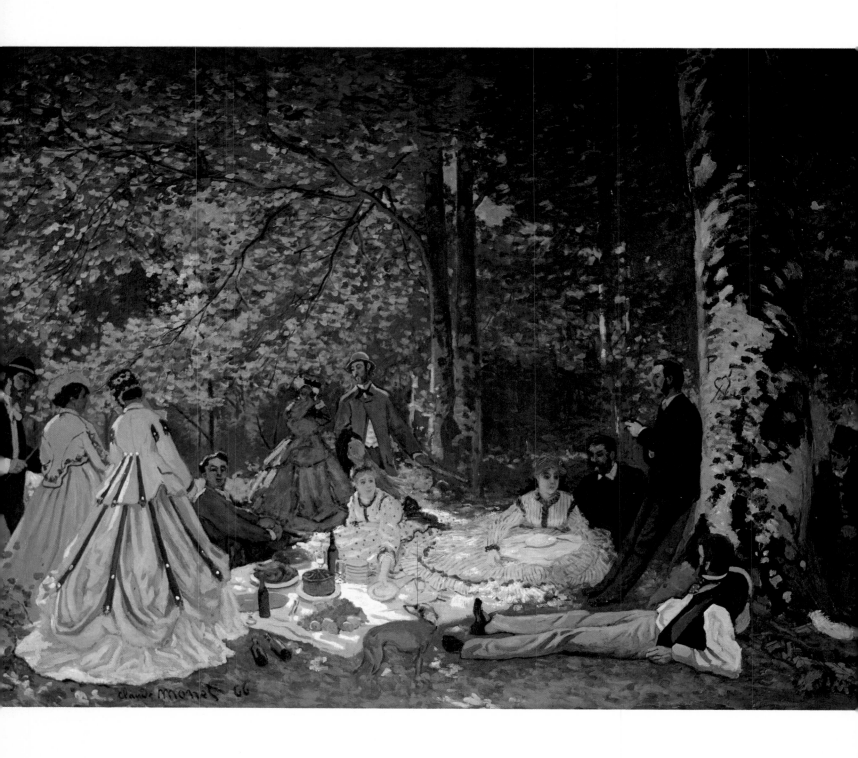

The Picnic, 1866
(130 x 181 cm)
Monet copying Manet paints this superb picture in the open air in the shade of a large stand of trees. Here he posed Camille and his friend Bazille, with whom he worked at Chailly. Monet was 26. It is surprising that after such a promising start, Monet so rarely did any more figure painting.

Claude Monet always stood alone. I hear him walking in the countryside. His feet resound heavily on the solid road that he had decided to follow to the very end. Above him, the sun, god of his torment and his happiness. The painter is a little child who admires, without asking why; who knows what inner wisdom protected him from vanity!

His first paintings are strewn with clothing and people—above all with clothing. The women that he portrays strolling in the parks interest him less than the puffed-up fabric of their clothing on which the light plays. Little by little, the dresses desert the woods where

only light can penetrate. Light! That is the distiller. Light preoccupied him so much that one would be tempted to fault his work for not showing enough of the human presence and for not expressing his inner thoughts.

With these works the observer can thrill to the sheer joy of painting: No manifest structure. Monet is more concerned with recording the glistening of the water and the rustling of the leaves, and the shape of a vanishing cloud. Monet does not synthesize all these revealed sensations, in order to give us the quintessential morning, noon or evening. His precise eye focuses on the nuances, capturing the most delicate and elusive visual events. He was a painter of details, a colorist of the moment. For him each minute has its own special tone, each month its own raiment, each season its own kind of light. How far is this instantaneous artist from a photographer? Contrary to the opinion of many people who see him as an embroiderer of themes that permit his hand to follow the caprice of his inspirations, there is one facet of his art to which the painter devotes himself entirely, a sign by which Monet identifies himself through ever-fresh vision and his ravishing technique, and that facet is his brush stroke. He has a way of making the waters of the "Grenouillere" tremble and zigzag, of showing Paris decked out for a 14th or smoke at the Saint-Lazare train station. Then there are the flashing brush strokes of the sea pounding the rocks of Etretat or of Belle-Ile, or dancing on the flower-covered foot bridges of Giverny.

Do you not notice in his rarest paintings how each stroke, each comma, recaptures for us his trembling? His feelings are in his hand, and, by some mysterious enchantment, the sum total of all his strokes that translate with brilliance the orchards and walls, communicate to us his abundant perception of the universe. It could be either the impression of a humid country day, an odor of dew or the approaching evening that his juxtaposition of strokes creates. It is midday exploding in its golden richness, a soft snow that sticks to the ground under an opaque and confining sky, or the rippling water that erases the outline of a reflected branch. With Monet, a brush stroke plays the same role as a word in the poetry of Mallarme or a note in the music of Debussy. It is imprecise, fragile as glass but can suggest an infinity of ineffable things that go beyond the instant and which eternalize it. To make these things felt is the essence of Monet and the man lives his secret. He painted because he enjoyed painting. He believed, as Renoir did, that one should never be bored while painting.

His subjects are often as naturalistic as can be, but the way in which his hand translates them is that of a poet awakened by nature. Claude Monet received and transmitted the secret life of haystacks, the poplars and the cathedrals through the tip of his brush. Why in fact do we

Corner of the Garden at Montgeron,
1876-1877
(172 x 193 cm)
This profusion of greenery and flowers shows once again the attention Monet paid nature, just by suggestion.

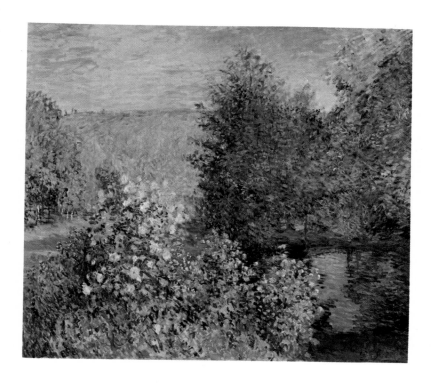

Woman in a Garden—Sainte-Adresse,
c. 1865
(80 x 99 cm)
There is a touch of poetry in the appearance of the young woman dressed in white, carrying a white parasol. She walks in the sun, cradled in greenery.

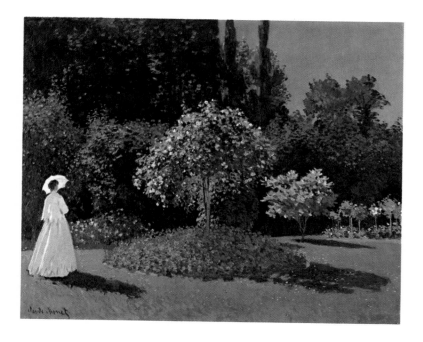

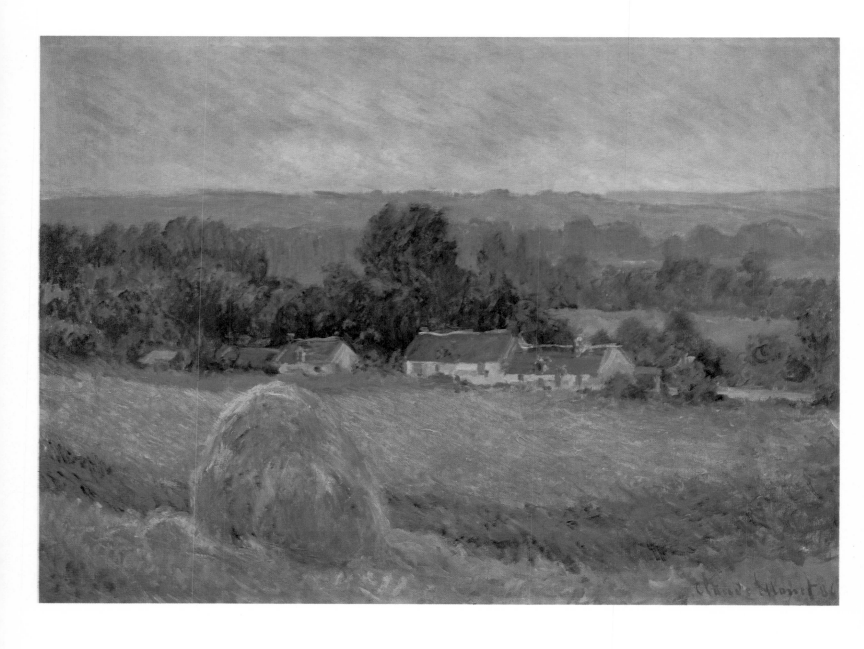

The Hay Stack, 1866
(61 x 81 cm)
This canvas was in the old Morosov Collection. It blazes with reds behind the haystack and in front of the farm buildings. This was painted on the spot.

call him great? Is it for his successive images of Rouen, where we are hard put to recall any particular one from out of the whole series? We may not remember the particular subjects of Monet, but we can't forget the whole of his work. It is a symphony in which each brush stroke calls forth a different sonority. These brush strokes produce a marvelous spectacle in *Street Decked with Flags,* where to celebrate Bastille Day, coinciding with the World's Fair, Monet shows the tricolors floating in the windows of the houses on the Rue Montorgueil as a flight of birds, a swarm marvelously vibrating, pulsating with brush strokes that reach all our senses. This canvas is the perfect representation of Impressionism.

The heart's blood does not run in our young painters. Though they are at times fascinating, how many of them paint from the heart? Theirs is a painting born out of the

mind, over-intellectualized. They know what to do, but do they have enough love for beauty? They search for a vocation, in default of truly having one. The educated painters succumb to the weight of their erudition, forgetting that all men are children before the mystery of death. Others resort to tricks and are taken for geniuses. Too much analysis and orderliness on the one hand mixes with a lack of order and maturity. It is as if we were to beatify a priest who has not overcome temptation. How can we make such great claims for painters who have yet to demonstrate that knowledge and awareness which alone can combat the many pitfalls in the path of the artist? Often painting today complicates what ought to be simple. Everyone wants to prove a greater or lesser familiarity with the geometrics of cubism. And many of them might have better spent their time painting apple trees in flower. How much cant for one Picasso!

Monet knew how to give us the fruits of a tree without grafting on any exotic branches. "His is only an eye," said Cezanne. "But there is none other like it." We can be glad that for Monet the eye, the painter's vision, was more important than thoughts about painting. Monet's method was opposite that of the constructive efforts of the Master of Aix. But standing before his work no less than before Cezanne's one has to confess, "This, this is painting."

Monet could have verified in his lifetime the reservations a younger generation of painters felt about him. It would not have astonished him to learn that he would for a time fall out of fashion.

The order of the cubists, the rebirth of composition, the return of black to the artist's repertoire of colors, the increasingly subtle analysis of shadow, which suddenly veered away from blue, because blue is a luminous color, that when overused kills the properties of light, all this Monet understood. But he was an exceptional man who knew the history of art is one of reaction and counter-reaction and that what is discarded by one generation will be discovered anew by the next.

Monet's technical discoveries have given us a new sense of landscape that is not inconsequential. We could say as much for only a very few other artists. He joins the select company of Poussin, Ruysdael, Hobbema, Corot, Courbet and Cezanne.

Monet listened much to nature, too much according to some. But what would they have? Would they have wanted him to follow in Cezanne's footsteps and occupy himself with form, or pursue the theoretical experiments of his disciple Seurat?

For Monet the brush stroke was supreme. It assumed more importance than even the artist's eye. This painting takes hold of you. It betrays a soul naive and confident and a joy in living that kept him young despite all the best efforts of life to stifle his enthusiasm and deaden his soul.

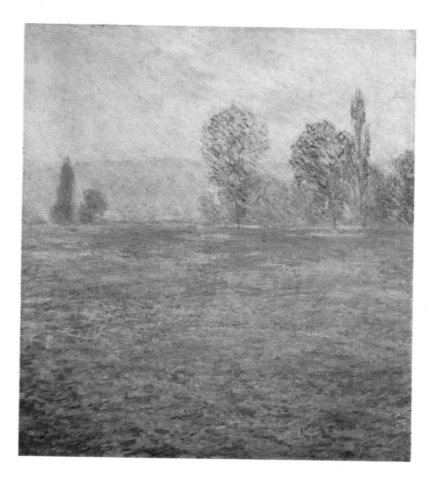

Field at Giverny, 1888
(92 x 80 cm)
This is a misty impression of the countryside with delicate modulations and tones of blue.

Vetheuil, 1878
In 1878, Manet left Argenteuil to live at Vetheuil in Val-d'Oise. He often painted the houses of this little village, grouped around the church.

We always resent a subtlety that challenges our capacity for definition. But how can we easily explain that effect of delightful melancholy that we feel on the shores of Monet's Seine? We can try to explain the power of these paintings as the product of a surpassing technical ability, a virtuosity that plays upon the configuration of sunbeams as a Landowska would play upon the harpsichord. One can, certainly, note his palette with its absence of black and remember the famous words of Ingres, "My black hat is not black." There is in art poor technique that stops at the facile and about which no more need be said. There is also perfected technique, which forces us to recognize that one can never strictly delimit, especially with words, the translation of techniques into the realm of human emotion. There precisely lies the miracle of painting. It is impossible in painting to distinguish the virtuoso from the composer, as it is in music where the two functions are nearly always separated. In the paintings of the true artist, performer and performance are mysteriously comingled. And the technique of the painter, even when it is new, new as that of Monet, is not simply the game of a technician. Just the opposite.

That's why I maintain that the whole of Monet is in his brush stroke.

However, everything has not been said, nor has everything been painted. The last of his works open up entirely new worlds. All is change, all must change. After 1890, Claude Monet surpasses Impressionism to attain an even more lasting value.

We will see in speaking of Turner, that the English painter finally arrived at the dissolution of the object in the dazzling color of the gouaches and oils painted at Petworth. We have seen that, excepting Cezanne, Impressionism was still to a very large extent bound to the representation of reality. But toward the end of his life Monet rejoined Turner in freeing himself from this stricture. The series of cathedrals at Rouen is still representational. But then comes his suite of water lilies. He uses them as a pretext, bit by bit he deconstructs them to give birth to an infinity of petals. The object dissolves into the color of an enchantment of waters and reflections. Monet gave this a lot of thought. In writing to the art critic Gustave Geffroy he says, "I've been taking up once more impossibilities, namely waters with waving grass below the surface. It is beautiful to see, but it drives me crazy to represent it. Ah well, I am always attempting things like that."

Clemenceau, a politician of great vision, had the idea of encouraging Monet to paint a series of panels with total freedom of conception and execution. Thus was born his final suite of *Water Lilies*. Clemenceau, to show them off, had a special annex built at the Orangerie des Tuileries, a kind of rotunda where the long canvasses could be put up.

Regatta at Argenteuil, 1873
In the clarity of this picture, Monet shows himself a master of the brush stroke. It is a masterpiece of light and joy. On the facing page is a detail, the signature shown on the bottom.

Pond With Waterlilies, 1899
(90 x 92 cm)
Here we have the first version of Monet's final series. It is full of reflections, glistening colors—echoes of flowers—like the faint sensations of a dream.

Monet died before seeing the work installed on the walls of this "Chapel."

Often I find myself before this marvelous beating of petals. I experience a strange disorientation. I am transported in golden mist that powders these canvasses set between water and sky, "these chalices that hang suspended on the waters." For a moment carried far from everyday reality, I feel a kind of vertigo. I arrive at that dazzlement which Clemenceau called "that indescribable storm where through the magic of painting our blinded eyes receive the shock of the universal."

If until now the definition of Impressionism could be summed up in the words: reality and imagination; it would become with Monet who rejoins Turner: imagination and reality.

This painting reunites the colors of seasons and days, closeness and distance. It is the painter's swan song, the culminating synthesis of the artist's life.

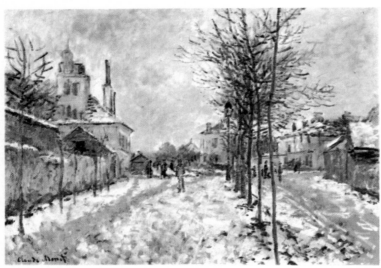

After the Snow, 1870
(60 x 81 cm)
One must admire the way in which Monet manages to paint tufts and slabs of snow on this village street.

The Cathedral of Rouen, 1894
(107 x 73 cm)
This is one of a series of the Cathedral of Rouen that Monet painted at different hours of the day. It reminds one of Claude Lorrain and his studies of light.

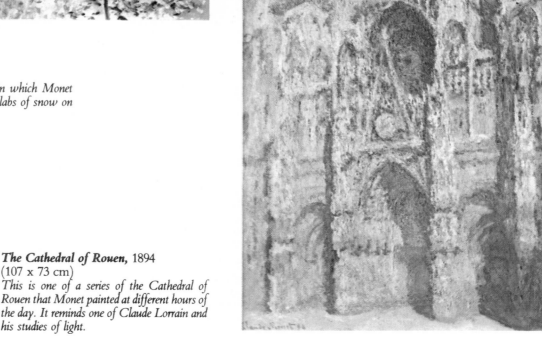

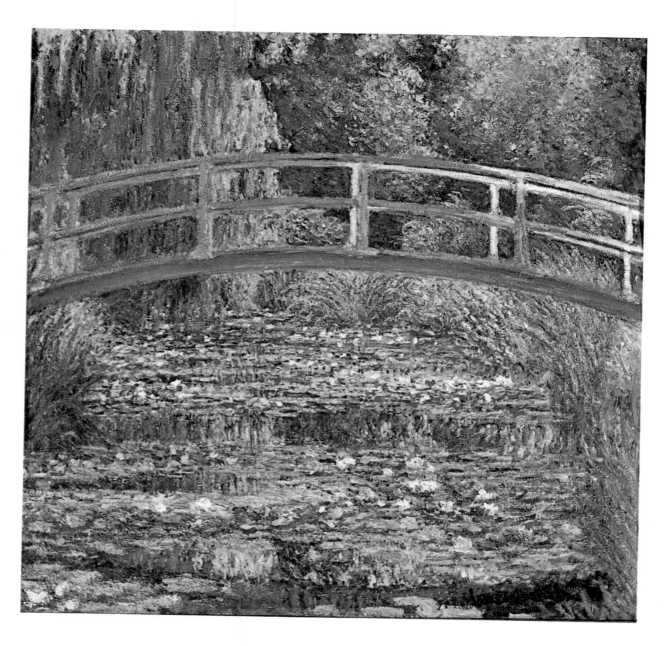

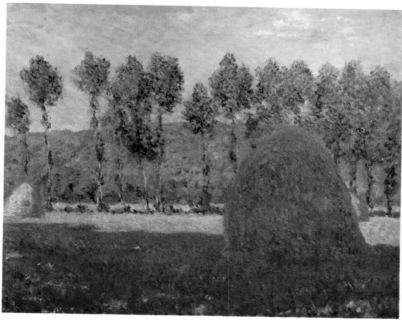

The Pond With Waterlilies, 1899
(89 x 92 cm)
This is one of the enchantments that inspired Monet at Giverny. It is the wonderful scattering of brush strokes that creates this poetry made visible.

Countryside With Haystacks, 1880
(65 x 81 cm)
Here, in contrast, we have a naturalistic countryside, where green predominates.

Waterlilies, 1914 (detail)
It is here that Claude Monet attained the heights. It is a symphony of glimmering color, relfections of water and sky, all aglow between space and time.

What did he look like, this extraordinary man? We see him at twenty years old, with a serious demeanor full of determination. Then on his boat at Argenteuil surprised by the brush of Edouard Manet. But it is Nadar's photograph taken in 1901 that stays in our mind. One sees him, his eyes still shining (this was before his cataract operation), bearded, with a face of magnificent viritility. And finally his self-portrait, in tonalities of violets and greens, a head rendered in a few brush strokes. He gave this to his friend Clemenceau. "Take it." Monet said to him, "and don't say any more about it." (Monet had already destroyed two other self-portraits painted in the same year.)

MORISOT Berthe Marie Pauline

Bourges, 1841 - Paris, 1895

She did not claim to be his student, but Manet was the formative influence in Morisot's life. Before meeting him, she had known Corot. In her finest moments she can truly be called the queen of the Impressionists. Her sensibility is expressed in zigzagging brush strokes. Manet did a number of portraits of her; she was to become his sister-in-law, marrying his brother Eugene. She is best known for her paintings of domestic scenes.

Berthe Morisot was one of the leading lights of the Impressionist movement. She was the great granddaughter of Fragonard. Her father was a ranking government official. After some hesitation in choosing a mentor, she made the acquaintance of Corot. She painted with him in the open air. Her sister also studied painting. Their father had an telier built for Berthe and her sister Emma in his gardens at Passy. Berthe often went to the Louvre to copy the works of the old masters, where she met Fantin-Latour. He, in turn, introduced her to Manet, for whom she acted frequently as a model. In the course of events the Morisot and Manet families met often. Soon Berthe had made the acquaintance of Baudelaire, Degas, and the musician Chabrier. In 1868 she posed for Manet's *Balcony*. He painted her often. In 1874 Berthe married his brother Eugene.

Mallarme speaks of her "clear iridescent tableaus" and her facility to transmit to "carnations, orchards, skies, all the delicacy of her craft."

Even more than Manet, Morisot is in the mainstream of Impressionism. Qualities of freshness and delicacy fill her paintings, which are almost always centered around familiar or familial scenes. She would paint her sister, her daughter, her dog.

In her self-portrait of 1885, we see her with wide open eyes, her neck wrapped in a scarf. The work is executed with a surprisingly subtle freedom of touch that seems to avoid all unnecessary representation. She knew very well how to create a suggestion without making the subject explicit.

Never leaving her own circle, Berthe painted rooms decked in flowers, children scattered in the grass. While tending to her sick daughter, Julie, she caught the infection and died soon after. She was fifty-four years old.

The Cradle, 1873
(56 x 46 cm)
Here is Emma Pontillon, sister of Berthe Morisot, who is painted in profile looking through the veil of the cradle at her sleeping child. This picture was painted at Maurecourt.

Wheat Field, 1875
A young man in blue in front of a wheat field gives us the feeling of summer in Genevillers. The land was owned by Manet.

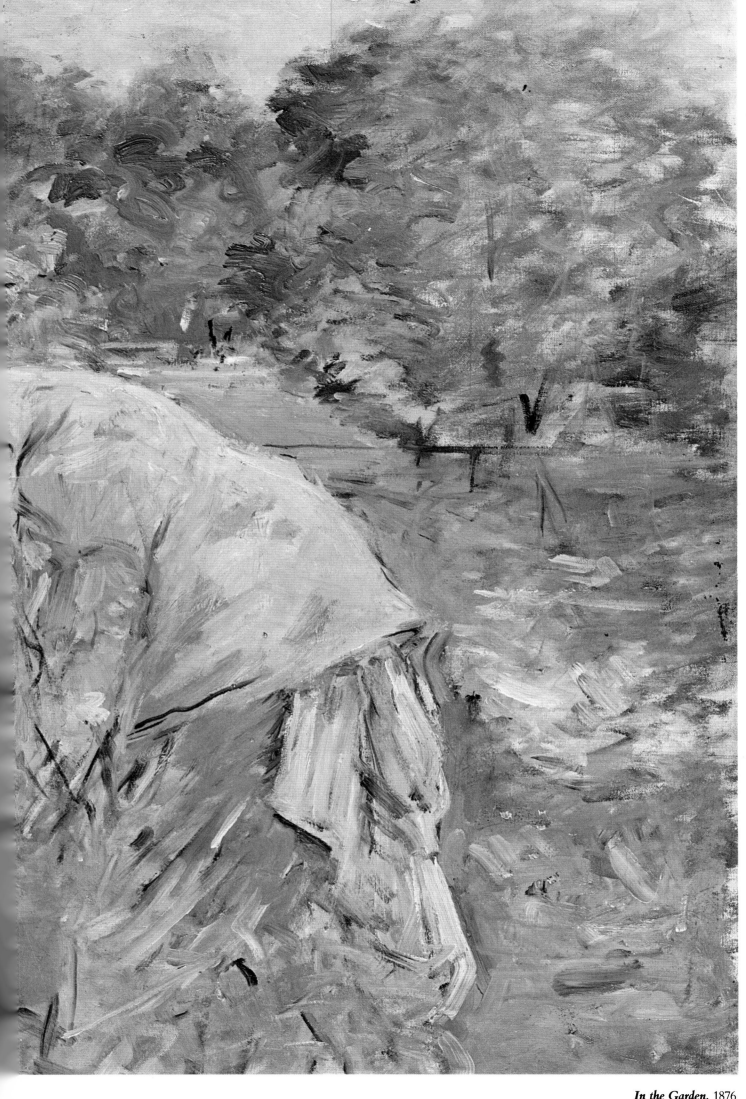

In the Garden, 1876
(61 x 74 cm)

PISSARRO Camille

St. Thomas, 1830 - Paris, 1903

Pissarro was born in the Virgin Islands, at that time the Danish Antilles. He was a formative influence on Cezanne. Of all landscape painters he was perhaps the closest to the earth and to farmers. At Pontoise, Rouen, and Eragny he painted trees, houses and markets. Later in life he concentrated on scenes of Parisian life.

Pissarro was the elder statesman of the Impressionists. He was eleven years older than Renoir and Guillaumin, ten years older than Monet and nine more than Cezanne and Sisley. At the age of forty-three he was already bald and had a long grandfather's beard.

Pissarro studied at a pension in Passy. After a brief stay in Venezuela, Camille went back to France, where he turned his back on commerce (his father was a successful merchant). Visiting the World's Fair of 1855 he was struck by the work of Corot, Delacroix and Courbet. He

decided to become a painter. He had his studio on the Rue Notre-Dame de-Lorette and kept to his family's lodgings at Muette. In 1857 he began to paint in the open air. During this time he received financial support from his family.

In 1859 Pissarro placed his first entry in the Salon. He lived at 38 *bis*, Rue Fonatine and worked in the liberal atelier of Pere Suisse. There he became friends with Claude Monet and met Cezanne. It was under Pere Suisse's genial eye that most of the innovative artists of that time starting with Delacroix had their beginnings.

Soon after he had a son by Julie Vellay. He was to marry her eight years later. Rejected by the Salon, he formed part of that famous group which also included Monet, Manet, Sisley, Renoir, and Bazille, that would get together at the Cafe Guerbois. Soon finding himself in stratened circumstances Pissarro was forced to paint along with Guillaumin advertising displays for store windows. At that time he lived in Louveciennes. Along with his companions his style of painting caused him to be blacklisted by the jury of the Salon.

Since he was not French, Pissarro did not fight in the Franco-Prussian War of 1870. In London where he relocated with his family he ran into Claude Monet. It was at this point that the two of them were exposed to the full range of the work of Turner. As their future would testify, it made a deep impression on them. By this time Pissarro had abandoned the use of black. With only the seven colors of the rainbow he painted a train pulling out of a station at Penge. It's very likely that it was from Turner that he got the idea for this painting.

Returning to Louveciennes at the end of June in 1871, Pissarro found out that the Germans had destroyed his canvasses during the occupation. (He finally received 835 fr. in reparation payments on a claim of 51,156 fr.)

In 1873 he moved to Pontoise. Cezanne joined him there and came under his influence. Already Pissarro had revealed himself as a naturalist, "A painter of earth and sky" (Zola). At Auvers-sur-Oise in the studio of the aquafortist Doctor Gachet, which was open to young artists, Cezanne made a copy of Pissarro's *View of Louveciennes,* and under the tutelage of Guillaumin made his first etchings.

The following year Pissarro participated in the first showing of the Impressionists. He contributed five land-

Entrance to the Village, 1872
(46 x 56 cm)
Pissarro was 42 when he painted this picture. It is possible he was remembering the influence of Corot. The painter invites us into his countryside. The trees throw long shadows on the road, which goes to Louveciennes.

Countryside of Pontoise, 1876 △
(65 x 51 cm)
Here one sees the relationship between the painting of Cezanne and Pissarro. The latter, in his thick brush strokes and subject matter, pays homage to the Master of Aix.

Norwood, c. 1870
(35 x 46 cm)
This snowy landscape shows how much sympathy Pissarro felt for nature. The people, houses, the sadness of the village under the clear sky, make a harmonious whole.

Red Roofs, 1877
(55 x 65 cm)
A painting of a corner of a village in late autumn, when the leaves had fallen (probably in the Pontoise region). It is painted with a pallette of warm colors.

scapes. He already had one son, Georges, but lost his daughter, Jeanne, the same year that his second son Felix was born. Life was hard for him, even though Mary Cassatt did her best to provide him with financial assistance.

When his third son, Ludovic, was born he had a pied-a-terre in Montmatre, on the Rue des Trois-Freres. Gauguin came to visit and work with him at Pontoise where two years later his daughter, Jeanne Marguerite, first saw the light of day. But Pissarro was unhappy. He wrote to his good friend Murer, who was a fervent admirer of his painting, "What's to become of me? Not a prospective sale in sight. The silence of death descends on art in the middle of a universal merrymaking. No use in counting on the exhibition at Durand-Ruel, where under one roof masterpieces of the finest artists of the age will

be assembled. I'm sure it will be a flop, greeted by the most perfect indifference. The public has had enough of this morose, demanding art. It's all too serious. Doesn't progress mean being able to see and feel without effort and above all being able to entertain oneself. What do we need art for? Can we eat it? No, well forget it!"

Again to Murer (later in the same year, 1878,) he writes from Pontoise, "Hardship, nay even misery, has the run of the house; it's a constant fact of life. It is barely endurable, all my efforts are insufficient. I can count on only a sale to the young American lady [Mary Cassatt]. But even that is only a small thing, a little canvas for 50 fr. When can I get out of these desperate straits and at least earn a livelihood from my art? I pursue my studies without any following, without any enthusiasm. It seems to me that I'm going to have to find some other career and begin again as an apprentice. This is terribly discouraging."

L'Avenue de l'Opera, 1898
It was from the hotel room that he rented that the painter watched the busy street. He was unable to paint in the open because of eye trouble.

In 1884 the painter moved to Eragny near Gisors. For this lover of nature it was a period of rejuvenation. He was most comfortable in orchards among trees or beside the cool waters of the Epte. As Geffroy commented, "He knew intimately the rhythms of flowerings and harvest, the passage of natural time." Corn, cabbage, potato, he was as familiar with them as is the farmer whose livelihood depends on them. He loved the rusticity of country women, the shepherdesses and haymakers, and rendered them with light and dancing strokes.

In 1885 after another son, his last child, was given to him, he met Signac and Seurat. For a short time he painted in the pointillist style. He espoused liberal politics, read *The Proletarian* and placed himself in the ranks of the poet, the farmer, the worker and the doctor. He became so involved that he refused to attend a dinner given in honor of Manet. "I don't believe in selling my works in Rouen," he wrote to Murer. "It is possible that some of my black canvasses might be accepted by a few art lovers, but have no doubt, my dear Murer, that my most recent work would be greeted by a rain of rotten apples. When you think how backward we still are in Paris it is impossible to conceive of an art that attempts to upset established ideas and is at the same time commented favorably upon in Rouen. After all the place is the home of Flaubert. The whole thing is absurd."

Thanks to Theo van Gogh, Vincent's brother, Pissarro had the opportunity to show his work at Boussot and then Valadon a year before the death of Seurat. His eyesight began to fail him at this time and he voyaged to London.

Then came a change. Because of his weakened eyesight, he could not longer paint in the open air. He began to concentrate on painting Parisian street scenes and sell his canvasses to Durand-Ruel (thirteen paintings for 10,000 fr.). He spent time at Rouen where he painted the port and the markets, established a friendship with Felix Feneon, spent time in London and then returned to Paris where, going from hotel to hotel he created enduring pictures of city life.

After his long period of painting the countryside his change to depicting urban scenes, partially undertaken on the advice of Durand-Ruel, his dealer, was an especially felicitous one. Along with Monet, Pissarro knew best how to capture the comings and goings of pedestrians, the liveliness of the crowds on the boulevards, the spread-out gardens of the Tuileries. From the Hotel de Russie on the Rue Drouot he executed his series of boulevard paintings. Alone he attempted to capture the effects of nightime in his *Boulevard Monmartre:* in so doing he achieved one of the indisputable masterpieces of Impressionism. Its light fading into obscurities, its houses and peopled streets all are completely unexpected. From the Hotel du Louvre he painted *Place du Theatre-Francais* and the *venue de l'Opera.*

Le Pont Neuf, 1902
(55 x 46 cm)
*After renting an apartment on the Place Dau-
phine (his last home), Pissarro painted a series
of the bridge "Le Pont Neuf."*

La Place du Theatre-Francais, 1897
(65.5 x 81.5 cm)
*In love with Paris, here Pissarro shows us the
springtime green of the trees in la place du
Theatre Francais, in the time of horse-drawn
buses and carriages.*

Boulevard Montmartre, 1897
(73 x 92 cm)
*Pissarro, along with Claude Monet, was a
painter of the streets and places of Paris. This
boulevard Montmartre, in tones of pink under a
gray sky, was one of his most successful
efforts.*

After finishing his day's work Pissarro repaired to the
cafe. Gustave Kahn has described his routine for us. "He
would ask for cold grog, fill a glass with water and leave
the alcohol untouched."

Listen to Henri Matisse describe the aging painter,
when he worked at the Hotel Meurice and painted his
views of the Tuileries. "He was an extremely sympa-
thetic man. A large man with a white beard, he made one
think of one one of the prophets from the *Well of Moses* at
Dijon. Coming from the Virgin Islands he was a bit
petulant. He was a great friend of Cezanne, with whom
he had worked. He said to me: 'Cezanne wasn't an
Impressionist.' To which I replied, 'But what then is an
Impressionist?' 'An Impressionist is someone who paints a
different canvas every time. Cezanne was a classical

123

Woman in a Paddock, 1887
(55 x 65 cm)
From time to time during 1886-1887, Pissarro used the neo-impressionistic style of Seurat. This sunny orchard dates from this period.

Springtime in Pontoise, 1877
(66 x 81 cm)
It was at Pontoise that Pissarro painted these lovely flowering trees, one of the most beautiful of all Impressionist spring scenes. The view was from his house on the Embankment Pothuis, where Cezanne often came to work.

painter who never painted the sun. For him the weather was always cloudy.' "

Madame Pissarro, Mother Pissarro as she was called, did not have a great understanding of painting. She is supposed to have said to her husband, "You never know what you want to do. First you paint like a pointillist, then you stop. Either they're right or they're not."

Pissarro confided to Matisse how he began to paint. He went to the Rue Lafitte and looked in the windows of the galleries. Most of all he liked Corot. One day he brought his canvasses to Corot. Corot said to him, "Very good my friend. You have the gift. Work and don't listen to anybody."

After his paintings of the Tuileries, Pissarro took lodgings on the Place Dauphine, where he executed his celebrated series of paintings of the Pont-Neuf.

He wrote to his son of the Feydeau sale, "It was of capital importance. All the dealers predicted that it would be a failure for the Impressionists. One Sisley, the *Bridge at Moret,* brought 28,000 fr. [Sisley had died two years earlier, leaving his widow in abject poverty.] . . . A Monet, *Stone Bridge in the Mist,* brought 10,000. This sale will have enormous consequences. The other dealers were beside themselves with anger. . . . It is a great victory. The Bernheims have established for themselves an enormous reputation."

The following year Pissarro went to Moret to visit his son Georges. At the beginning of November he moved to number 1, Boulevard Morland, after having been to Dieppe and le Havre. It was there that he painted his final canvasses and lived out his days.

Among the many self-portraits painted at various stages of his career, it is the one painted in the last year of his life that is perhaps the most moving. One sees the old artist under the brim of his hat. His eyes are still alive behind his glasses. Out of his long beard would issue, according to Maurice Denis, a voice sweet and carressing, which spoke calmly of a future life.

Pissarro's work bears the closest resemblance to that of Monet. Less light in touch perhaps, still perhaps more attuned to gardens and orchards. Influenced by Corot, Pissarro brought a sense of the monumental to his glorification of nature. Often in considering his oeuvre, one fails to give proper credit to his canvasses in which the human figure is represented, his scenes of farming life and country markets. No other painter since Millet gives us a more delightful view of country women or haymakers, shepherdesses, harvesters and bathers on the shores of rippling streams.

Pissarro was a man of the earth, of the soil. He was attuned to the voices of earth and sky. He loved frankness and truth and disdained above all those things he called *"bougereauties"* (after the painter Bougereau).

REDON Odilon

Bordeaux, 1840 – Paris, 1916

Although Redon was a part of the community of poets and painters of his time, he himself was an artist apart. He was able to reroute Impressionism towards a fantastic symbolism thus making him a precursor of Surrealism. He was haunted by the mysteries of existence involving Christ and Buddha, and was a visual expositor of Edgar Allan Poe. He was also a master lithographer. The bouquets of flowers which he painted during the last years of his life are infused with an oriental touch that is quite opposite from Fantin Latour's treatment of the same subject matter.

Following the advice of his father, Odilon Redon pursued his studies in architecture at the School of Fine Arts in Paris. It was during his studies that he befriended the great botanist Clavaud, who loved literature and inspired the future painter's interest in the secret life of the plant and animal world.

In 1863, he met the engraver Rodolphe Bresdin who Baudelaire admired for his eerie, fantastic imagination, and who was portrayed by the author Champfleury in his novel *Chien-Caillou.* Bresdin had a direct influence on Redon's work.

After serving briefly in the army during the Franco-Prussian War of 1870, Redon started working on his first lithographic plates. In 1880 he married Camille Falte, a Creole woman who provided him with the calm and happy home environment he needed for his work. He published *Dans le Reve* (Inside the Dream), an album of engravings that are at the source of pictorial symbolism. His sketches were shown at the *Vie Modern* (The Modern Life Exhibit) at the time he began his album of engravings based on the poems of Edgar Poe (1882). He was a friend of the poet Mallarme and the writer Huysmans, and illustrated Flaubert's *The Temptation of Saint Anthony.* Twelve years later he was given a large retrospective by Durand-Ruel, and did a lithographic series on *The Apocalypse* for Vollard.

In 1904 an entire room was devoted to his work at the Salon d'Automne. The same ho. or was given that year to Cezanne, Renoir, and Toulouse-Lautrec. Redon also executed a mural based on the themes of *Day* and *Night* for the library of the Cistercian Monastery at Fontfroide, in the Aude.

Soon after some forty of his works were exhibited at the International Armory Show in New York, the painter made a last trip to Holland. He became extremely anguished by the loss of his friends. In *A Soi-Meme* (To

Oneself), his diary, he wrote that his heart "was moving closer and closer to an ever-darkening point that would inevitably be his death." Redon's only son had gone into the army at the outbreak of World War I, and had not been in touch with him. Redon caught a chill and fell ill. His son was urgently called home, but Redon died before he arrived.

Redon's work is filled with eerie reveries that shift between purity and agitation, between the Communicant and the fallen angel. It contains obsessional images, which include the decapitated head of John the Baptist and the drifting head of a drowned man. Redon himself was constantly floating. He moved from subjects like the birth of Venus to the eye of the Cyclops which he envisions ascending into space, and from Buddha to Christ.

Flowers in a Turquoise Vase,
(60 x 65 cm)
This enchanting bouquet with all its assorted colors clashes gently with the blue of the vase.

RENOIR Pierre-Auguste

Limoges, 1841 - Cagnes, 1919

Of all the Impressionists, Renoir was one of the most prolific and the most brilliant. He started out painting plates and ultimately became the chronicler of the Paris and Montmartre of his time. His young girls and his female nudes are remarkably modelled paintings.

While most of the other Impressionists were seduced by the countryside, Renoir preferred the human landscape of 19th century Paris. There has been too much emphasis on the hurried works he painted in the course of his travels to Italy and to Algeria, without taking into account the major works that include *la Loge (Box Seat)* (1874), *le Moulin de la Galette* (1876), *Luncheon of the Boating Party* (1881), and the nudes and bathers of his later years. His work ranks with Cezanne, and with Monet's later years.

Renoir's work perpetuates a style which is quintessentially French, as did the work of Watteau and Manet. Certain of Renoir's landscapes are as successful as his human figures. His work expresses an emotional knowledge of life. His painted scenes of dance halls in Montmartre and his Sunday seamstresses and oarsman along the banks of the Seine are filled with the flesh and blood of life.

Renoir's father, Leonard, was a simple tailor who came to Paris from Limoges with his five children. Pierre-Auguste went to public school. Charles Gounod, the future composer of *Faust,* tried to orient him towards the study of music, but Renoir preferred drawing. He also had to work to help support the family. In 1854, at the age of thirteen, he went to the Rue du Temple to apprentice in a workshop where they painted on porcelain. He earned five cents for every dozen plates he decorated with tiny flower bouquets. Before long, he was painting fans and religious subjects that could be peddled on the street. He spent his free time at the Louvre sketching classical models. He admired Francois Bouchet's painting of *Diane in her Bath.* It was his first exposure to the female nude which he would later glorify in his own work. He also liked to visit the *Nymphs* at the Fountain of the Innocents in the heart of the Halles. The *Nymphs* were sculpted by the 16th century artist Jean Goujon. Renoir then went to the atelier of Gleyre where he held his own alongside of Monet, Sisley and Bazille.

In 1863 Renoir was introduced to Fantin-Latour, five years his senior. He discovered the paintings of Manet at the Salon of Rejected Painters (des Refuses). The following year Monet and his friends persuaded him to leave Gleyre's atelier, and they all went to Fontainbleau to set up their easels. This is where Renoir met Diaz, who advised him to paint more transparently. He was accepted into the official Salon with *Esmeralda,* a painting he would later destroy.

During his stay in Marlotte with Sisley, he painted *Old Mrs. Anthony's Cabaret,* which is now at the Stockholm Museum. Sisley is seen from behind in the painting, with a dog at his feet. Renoir painted himself standing behind a table. The canvas was refused by the official Salon. After having worked on some Paris street scenes with Monet, Renoir went to Chailly with Bazille and Sisley, and brushed off another refusal from the Salon, this time for his *Diana the Huntress,* painted in the style of Courbet. In 1868, his *Lisa with the Umbrella* was accepted by the jury of the Salon during the time he was painting a ceiling for the mansion of Prince Bibesco. Renoir shared Bazille's last atelier on Rue de la Condamine. Both he and Monet lived in virtual poverty. He painted his own version of the *Frog*

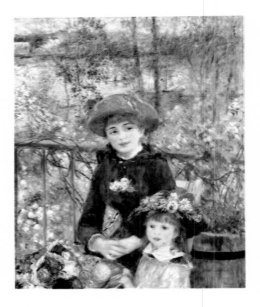

On the Terrace, c. 1879
(100 x 81 cm)
There is a sort of magic in this way of showing a young mother and daughter on a terrace with a baset of colored wool in front. The small blue-eyed girl with her hat full of flowers has a gentle tenderness.

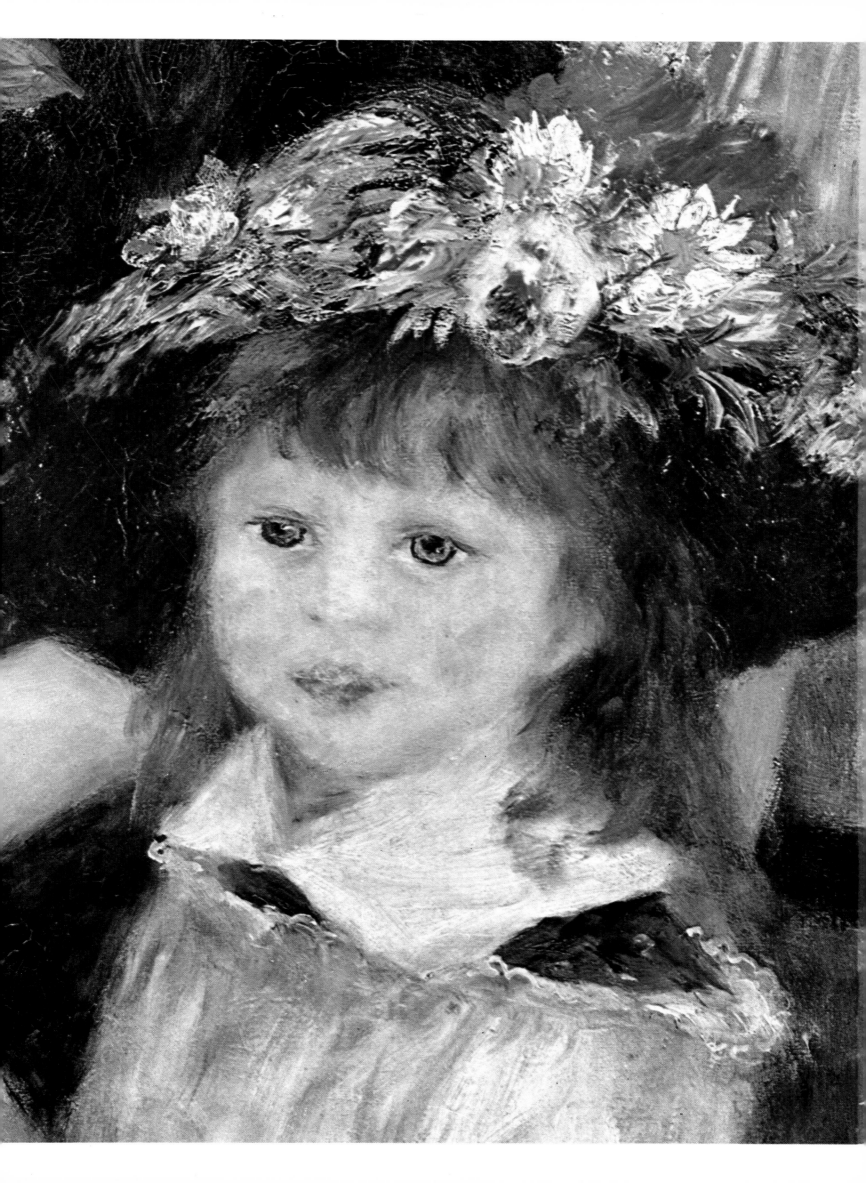

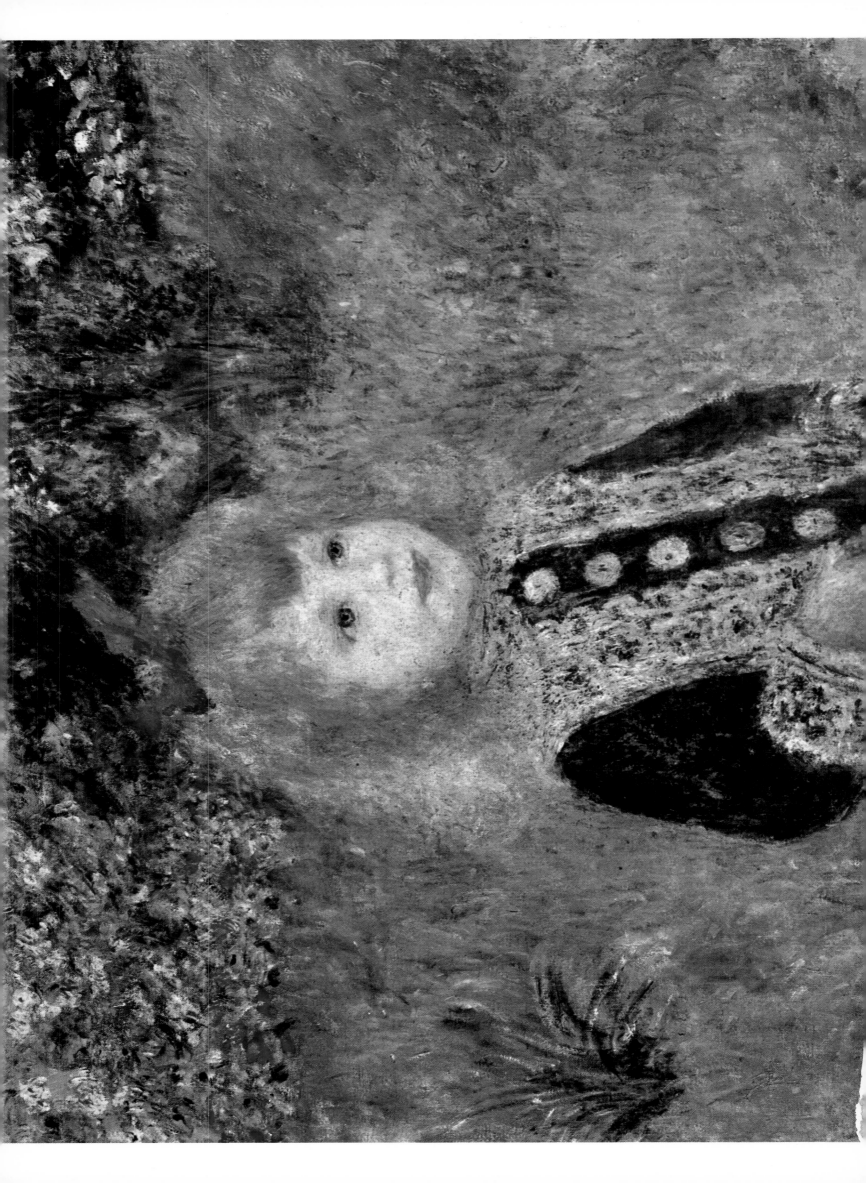

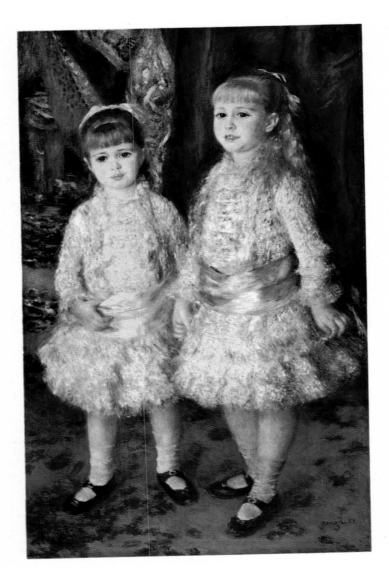

Pink and Blue, 1880
(119 x 74 cm)
Renoir called these small girls "Pink and Blue." It is portrait of the little Cahens of Anvers. Their expressions and attitudes are completely natural.

◁ **Girl With Watering Can,** 1876
(100 x 73 cm)
This little girl in her blue dress with its pretty embroidery is holding a watering can in her hand. The whole forms a gentle harmony with its background of greenery. (A small amount of the greenery on the left is missing in this reproduction.)

Pond (1869) which was rather different from the one Monet did. Monet's painting was better composed and more unified, but Renoir would later evoke this type of scene in a marvelous way.

Gustave Coquiot tells us that the frog ponds of Bougival, Chatou, and Croissy were "frequented by a large number of actresses, and there was dancing and laughter everywhere. Oarsmen strutted about on the docks, and the celebrities of the day walked about in full-falling trousers with long coats. This became the ultimate place to go to meet people and be seen, and then go off to drink and eat pomme frites at the Fournaise. Manet was the one who made it all fashionable. . . . When the weather was good, no one would want to go back to Paris. People would linger at Bougival, and all along the banks of the Seine, light-filled restaurants would be packed to the brim."

Renoir jointed the adepts of the new painting that gathered around Manet at the Cafe de Batignolles in Guerbois. Armand Silvestre described the man who painted the unconventional portrait of *The Sisley Couple* as "tall, pale, and a bit awkward. You could see that he was extremely sensitive."

Renoir returned to Paris during the Commune and rented an atelier on Rue du Dragon. He would go to the suburbs to paint landscapes. In 1872 he moved to the Rue Notre-Dame-des-Champs. The jury of the official Salon rejected his *Parisian Women Costumed as Algerians,* which was done as a type of hommage to Delacroix's *Women of Algiers.* Renoir's large canvas revealed his strong attraction to the female figure. He met Paul Durand-Ruel who started buying his paintings, and rented a large atelier at 35 Rue Saint-Georges, where he painted a gathering of his friends.

1874 was the year that the new painters grouped together in the space left vacant by the photographer Nadar. It was there that Monet exhibited his *Impression: Sunrise.* The painting, initially received with laughter and protest, nonetheless went on to give its name to the whole movement. Renoir exhibited his *The Box Seat* in this space, as well. It's a thoroughly captivating work. The woman with her black and white corsage has such an imposing presence that one can almost feel the rhythm of her heartbeats. Her fair countenance conveys a certain melancholy, and she is like a greenhouse flower from a wonderful bouquet. Her limpid blond hair embellished with a rose, her white gloves, the gold theatre glasses, the man slighty behind her with the purplish-blue hue in his complexion and who's casting a glance into the tiers, all vie for our attention and admiration.

A year after Monet showed his *Regattas,* Renoir painted his *Seine at Argentueil,* his portrait of Victor Choquet, the art patron, and his *les Grandes Boulevards.* After becoming

Portrait of Marthe Berard, 1879
(128 x 75 cm)
Marthe Berard is painted here in a dark dress, enlivened by lace and ribbons. She has a slightly annoyed air about her, and is less straightforward than the others.

Little One with a Bundle, 1880
(65 x 54 cm)
This was painted during Renoir's "Ingres" period, when he was trying to paint in a more linear fashion.

associated with Caillebotte, the painter and art collector, he rented an atelier on Rue Cortot in Montmartre that had an enclosed rear yard. While he lived there, he worked on *The Swing* and *le Bal au Moulin de la Galette* (1876). The latter is over six feet long. It was painted at a park in the suburbs where people would gather for refreshments, music and dancing. Renoir's friends helped him transport the canvas.

Renoir loved his Sunday get-togethers with his friends, most of whom were artist's models. Many of them are portrayed in *le Bal au Moulin de la Galette:* in the foreground we can recognize Estelle, wearing a blue and pink-striped dress. Lamy is next to her. Goeneutte and George Riviere are sitting at the table. In the center of the painting the Spanish artist Vidal de Solaris y Cardenas is dancing with

Young Girls at the Piano, 1892
(116 x 90 cm)
Renoir did many versions of this theme, among them The Daughters of Catulle Mendes. *These two musicians are the daughters of M. Lerolle, a friend of the painter. It was the first of Renoir's canvases to be purchased by the government.*

Magot. Renoir's technique of showing the effect of the light of the sun on the Monmartre festivities was very new at the time. Everything in the painting is hierarchically composed. A "reading" of the canvas can thus take place just as the painter intended. Renoir was thirty-five when he painted this masterpiece. He was the only one of the Impressionists to paint such large groups with a vigor and spirit worthy of the Venetian masters.

Renoir started receiving requests for portraits soon after completing *le Bal au Moulin de la Galette.* His portraits of young girls superbly capture them with their blue or pink ribbons, their flowing hair, and the folds in their silk dresses. There is another portrait of Jeanne Samary that is now at the Pushkin Museum. It's an extraordinary little oil painting—a bust—which captures the actress' penetrating expression and glowing complexion, which Renoir described as a quality of light that "illuminated the area around her." The same year, he exhibited the large canvas of *Madame Charpentier and her Children* at the official Salon. This highly significant work portrays the publish-

Young Girls in Black, 1885
(31 x 65 cm)
*These young women are painted with a colora-
tion that resembles the even duller colors of*
The Umbrellas.

The Reader, 1876
(47 x 38 cm)
*The reason for reproducing this painting even
in so small a size is that it is one of Renoir's
most enchanting compositions, full of sunlight,
color and life. The model, Margot, is also seen
in* The Ball at Moulin de la Galette.

er's wife in her parlour. She's wearing a black dress with a white a lining. Her two daughters are dressed in blue. One of them is leaning against the family dog, a Saint-Bernard. There's also an earlier painting of Madame Charpentier, a bust at the Louvre, which is really quite wonderful.

Renoir's home was in Wargemont where he painted a family portrait. He also was a guest in the home of old Mrs. Fournaise in Croissy.

The Fournaise restaurant, located on the banks of the Seine near the Chatou Bridge, was a stone and brick structure with a first-floor balcony. Maupassant, who was a regular customer at the restaurant, and who would arrive with Flaubert and Francois Coppee, described this boatmen's haven in the following way: "Everyone would be calling out and screaming in the front of the restaurant. The hale and hardy oarsman would gesture with the oars on their shoulder. Women in pastel dresses would carefully board the skiffs, take their seats at the helm and then gather their skirts around them." Renoir started painting

The Boatsmen's Lunch (1881) on the balcony of the Inn above the restaurant. Aline Charigot, the artist's model and Renoir's future wife, is in the painting playing with her little dog. Sitting astride on the chair opposite Aline is Renoir's friend Caillebotte.

During an Ingresque period, Renoir started to concentrate on the straightness of line in his painting. This period is often referred to as the artist's "sharp" phase. Paul Jamot described Renoir during this phase as: "Less classical in training and taste than Degas, but perhaps instinctively more traditional." *The Umbrellas* was painted during this period. Renoir employed a range of lavender-greys and silvers, defined with blues and beiges, creating a delicate balance of harmonies. The painter pays hommage to the young dressmaker in the foreground on the left, and to the lovely young woman behind her who is poking a gentleman with her umbrella. On the right is a ravishing little girl holding a hoop, who seems completely undisturbed by the rain. The painting is choreographed as a ballet of umbrellas mingling in the rain.

The Umbrellas, c. 1879
(180 x 115 cm)
*With all the gray-blues, there seems to be a
dance of umbrellas—except for the maid in the
left foreground and the adorable little girl with
the hoop at the right. Renoir used this strategy
to show these two figures off at their best.*

Renoir painted both *The Umbrellas* and *On the Terrace*
in 1879. In the latter, the use of reds in the leaves and on
the water is striking. An adorable little girl with a
flowered blue hat and blue eyes, staying close to her
mother who's wearing a scarlet-colored hat, rests her
hand on the rim of a basket filled with balls of wool.

It seemed that Renoir had reached the heights of his
talent, at least in his assemblages of people, with the
Moulin de la Galette and *Luncheon of the Boating Party*, only
because there was a temporary lull in his artistic output.
However, after painting *The Reader* and the sun-filled
canvases, and after the *Box Seat* and his gatherings of
people, he became obsessed with a theme that would find
expression in all the works that followed: the bathing
places where he would adoringly portray the female nude
in the open. His landscapes are rather fleecy, but his
full-breasted bathers with their lustrous blue-veined skin,
broad thighs and rounded buttocks are outstanding por-
trayals of femininity.

There's an aura of happiness and fecundity, an almost
animal sensuality in these women with their abundant
hair falling around their shoulders. One can sometimes
find the unsettling expression of Jeanne Samary in the
faces of Renoir's bathers. In *The Bather Drying Herself,* the
female body is endowed with a sculptural fullness. He
considered *The Bathers* to be his most important work.
The painting, now in the Caroll S. Tyson Collection in
Philadelphia, was inspired by the *Bathing Nymphs* by
Girardon which Renoir had seen at Versailles. Although
Renoir was accustomed to having his worked scoffed at,
he wasn't prepared for the jeers that *The Bathers* pro-
voked. He wrote: "When *The Bathers,* which I consider to
be my masterwork, was finished, after three years of
groping and starting over again and again, I exhibited it at
George Petit's. I was rolled over the coals! This time it
was unanimously agreed, Huysmans leading the outcry,
that I was washed up as a painter. Some of them even
accused me of indolence, and God knows how hard I
worked!" Renoir was then forty-six years old.

Renoir's women have the freshness of ripe fruit. The
beauty of the nudes is too evident to suggest any kind of
boudoir eroticism. The painter often intensified the color
of his nudes to render them more dazzling and alive,
knowing that he would find the tonalities he was seeking.

The Opera Box, 1874
(80 x 64 cm)
*This is one of Renoir's great works. There is
an irresistable femininity in this picture, a look
that one can never forget.*

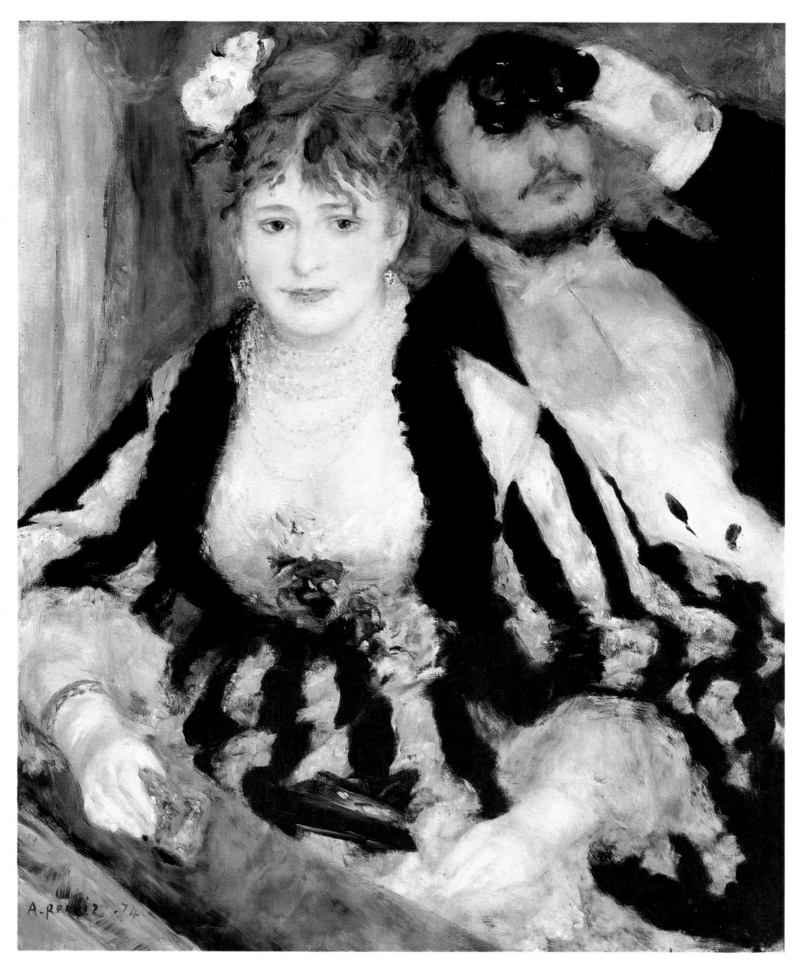

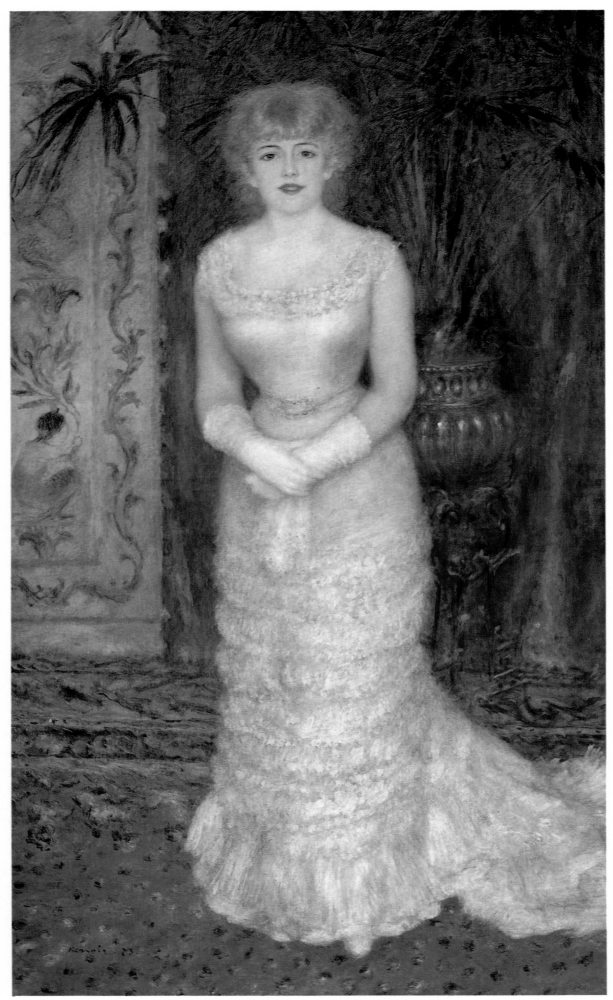

**Portrait of
Jeanne Samary,**
(173 x 103 cm)
*This is the large portrait
of the beautiful actress
Jeanne Samary. Renoir
also did a waist-length
study of her that is in the
Pushkin Museum. In
both pictures, the look in
her eyes is unforgettable.*

He also had a way of applying his brush strokes with a flowing lightness of touch. He would say: "That won't be accepted for another fifteen or twenty years."

In December of 1888, just after seeing Cezanne, Renoir was stricken with a facial paralysis that demanded attention. It was at this time that he rented an atelier on the Boulevard Clichy. In 1891 he spent several days with Berthe Morisot in Mezy. The following years brought positive changes. His work was being very well received, and for the first time he sold a painting to the French government. His wife gave birth to their second son. Invitations accompanied his newly found popularity. He became the Executor of Caillebotte's estate after the collector's death in 1894. He met with a good seal of resistance when he tried to get the Luxembourg Museum to accept the seventy-two Impressionist paintings from the art patron's collection. Three years later, after much hemming and hawing, the bequest was finally admitted, but damaged! Renoir travelled to England and to Holland and was very successful in both countries. He moved

several times, and then bought a house in Essayes.

From 1899 on, Renoir suffered from severe arthritis attacks. He spent an entire winter at Cagnes, and underwent useless treatments at Aix-les-Bains. He spent the year of 1900 in Magagnose. The following year his third son, called Coco, was born. His health continued to worsen. In 1904 the Salon d'Automne devoted an entire room to thirty-five of his paintings. The following year Renoir bought the Collettes property above Cagnes, in order to save the endangered thousand-year-old trees. When he moved in, he was suffering from a bronchial condition and had to walk with two canes. He wrote the Preface for a translation of Cennino Cennini's *Libro dell-arte,* an informative book on the techniques of 16th century Italian painting. In 1912, after an arthritis attack left him unable to use his arms and legs, he became interested in sculpture. He worked on a small portable atelier set up in a corner of his garden that he could carry in a sedan chair.

During the beginning of World War I, his sons Pierre

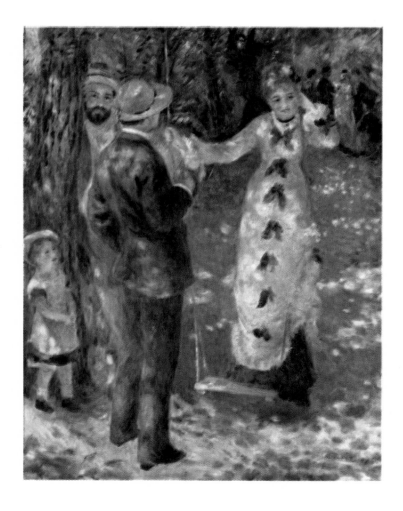

The Swing, 1876
(92 x 73 cm)
This canvas was painted in the garden at Rue Cortot, where Renoir moved after painting The Ball at Moulin de la Galette. *Of all Impressionist paintings, this is the one most dappled with sunlight.*

A Road in the High Fields, 1875
(60 x 74 cm)
A day in summer, full of green, and in the middle a woman holds an umbrella as a child kneels to smell the flowering herbs.

and Jean were both wounded in action. Madame Renoir went to Gerardmer to care for Jean. She fell ill there, and exhausted, died.

Renoir lived on at Collettes. Henri Matisse visited him, and told us that: "His body was riddled with rheumatism, but every morning at 9 a.m. he would tremble with impatience, thinking that a model was waiting for him in his atelier. While his nurse, Louise, bandaged the rheumatic sores on his hands and body, he would lecture her about keeping him from his work: "Hurry up, Louise! Don't you realize that there's a model waiting for me?""

According to Matisse: "Renoir didn't waste a moment. He refrained from working on Sundays, but made sure he was carried to his atelier, nonetheless. That's where I would find him. The hope of adding something new to his work kept him alive. He was then working on a "bath" canvas which is now at the Jeu de Paume. *The Bathers,* painted around 1918, was hard for him to do because the canvas was large and his hands were no longer agile. Contrary to what has been said, he didn't have a special apparatus on his hand to allow him to paint. He just wore compresses on the palms of his hands which were held by a white band tied in a knot on the backs of his hands. His fingers were deformed, as well. He held the small handle of his brush between the first joint of his index finger and the last two joints of the corresponding thumb. He worked on *The Bathers* for three years. Auguste Renoir would always say: 'When I have finished this canvas, I will die.'"

Although Renoir had resigned himself to physical suffering, he could never accept that his creative life was over. With a half-paralized hand, and the brush attached to his wrist, he continued to paint. "I can't think of one day going by without me painting," he said.

Renoir died after having lived a very fertile creative life. It is only normal that some of the extraordinary number of canvases he painted seem less than perfect. He used a wide variety of models for his work, but always preferred the full-figured models. During his last years, Gabrielle was his favorite.

Towards 1883, Renoir felt that he had gone as far as he could with Impressionism. He told Vollard that: "In painting from nature, the painter is only getting the effect, and ceases to compose. This very quickly becomes monotonous. . . . There's a wide variety of light outdoors. In the atelier it's always the same. But outdoors, you're so concerned with the light that you don't concentrate on composition. You don't see what you're doing when you work outdoors, either. I remember one day in autumn . . I was painting in Brittany under a dome of chestnut trees. Every brush stroke of blue or black that I applied to my canvas looked magnificent! However, it was the golden

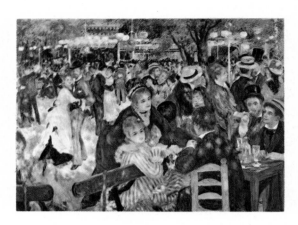

The Ball at Moulin de la Galette, 1876
(131 x 175 cm)
A summer Sunday under the trees in the enclosure of the Moulin de la Galette. One group sits around a table of refreshments while behind them is a group of dancers. Among the people one recognizes models and friends of Renoir. This is a marvelously conceived work, a masterpiece of light and color. The two dancers in the detail are Margot, in a pink dress, and a Spanish painter.

transparency of the trees that made my canvas seem that way. Once I returned to the normal light of atelier I realized that the canvas was a failure."

Towards 1908, Renoir started working with "mass". With the help of Guino, a student of Maillol, he gradually started to sculpt, since he could no longer use his hands properly.

His glorification of the female body during the last years of his life is a veritable golden age for the painter's imagination. the bathers combing their hair, toweling themselves, gathering in groups along the water, or the three bathers in *the Judgement of Paris,* conveys a wonderful "joie de vivre", the joy in which Renoir himself worked, despite his physical suffering.

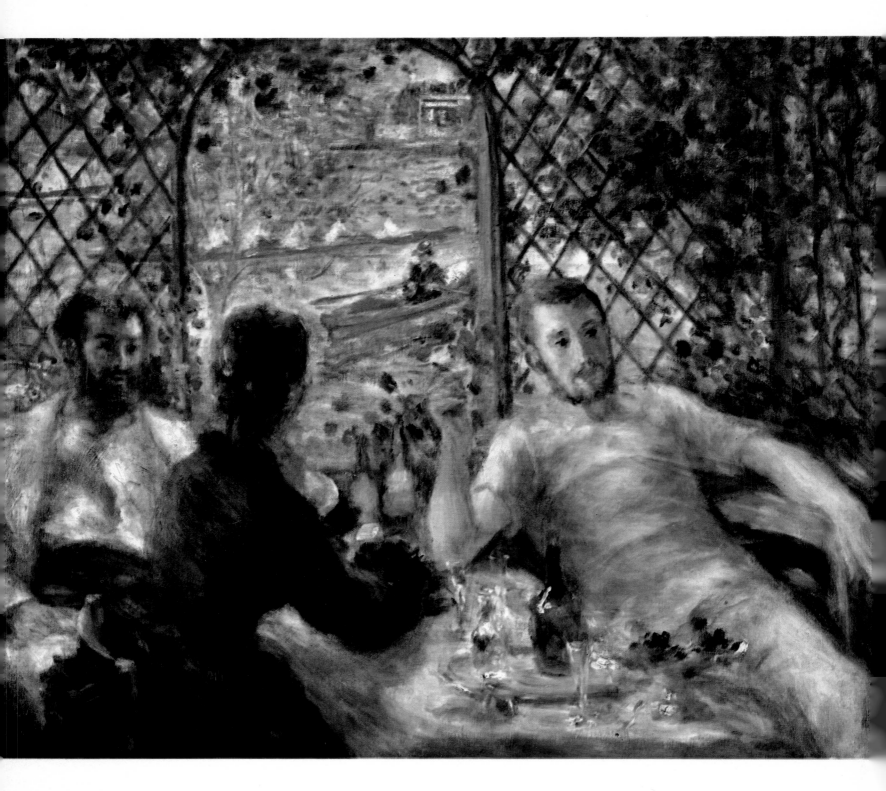

Luncheon of the Boating Party, 1880
(55 x 66 cm)
This is a variation of the boaters at lunch in the Phillips Collection, but set in a different location. While these rowers are finishing their meal, others are on the Seine. Behind them is a woman in a rowboat.

Elie Faure has written about the painter's work with a great deal of insight: "Renoir was seeking a weighty density and a compact depth of form in the materials he used, or rather *discovered,* while bringing his forms into being from space. There is a progressive condensation that looms up vaguely, and gradually takes shape. I can see the thick charcoals insinuating themselves like folds of flesh around the hips, the stomach and breasts to convey the weighty burden of maternity, to mold the complicitous shadows of the child's flesh into that of her mother, and to augment the luminous protruding breasts through this contrast. I can see the onctuous red chalk gathering like a sanguine flower on the surface of the lower back, and on the knees, arms and shoulders until it envelopes the nude bathers in its flaming waves. Reflections of water reddened by sunsets tremble on their bodies and spread through the red hair flowing around their faces."

The poet Guillaume Appollinaire clearly foresaw the future impact of Renoir's art. In the February 9th, 1912 issue of *Le Petit Blue,* he wrote: "Renoir the greatest painter of our time, is devoting his last days on earth to painting these voluptuous and admirable nudes that will be admired by generations to come."

Renoir himself modestly commented: "I think that a sufficient number of my works will survive for me to merit a place in the French School which I so dearly love. It is such a gentle and clear tradition, not at all loud, and I would be in such fine company."

When we can manage an even greater distance in examining Renoir's works, it will become more and more evident that he was both a witness to and a participant in Parisian society of the late 19th century. I would almost go as far as to say that he was the chronicler of that time. His paintings bring to life the characters of his day, with the variety of Sunday revelers who lived on the outskirts of the traditional bourgeoisie, and with his portraits of

The Marsh, 1869
(66 x 81 cm)
It is interesting to compare this picture with the one of Claude Monet, painted about the same time, using the same subject. Possibly this one is the more charming: full of improvisation and lovely color.

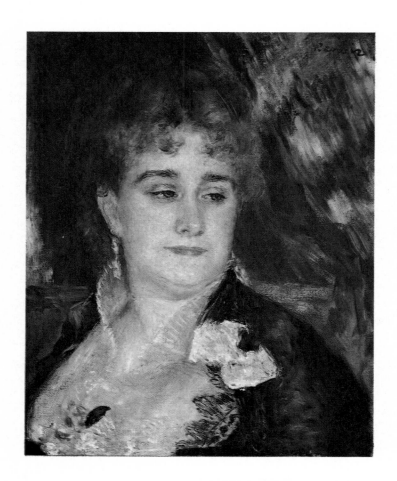

Portrait of Madame George Charpentier,
1877
(46 x 38 cm)
She was the wife of a famous editor, and entertained most of the important writers of the time. Renoir did a large portrait of her, surrounded by her children, but this one seems to have more charm.

young girls and women set in the context of their surroundings. Through all of them he captured and perpetuated a happy vision of life, instinctively adding to this his own special grace. Whether it be greenery or fruits, flesh, a smile, or the most beautiful eyes, everything that moves and grows on the space of his canvas takes on an unalterable quality.

Renoir's paintings are filled with radiant vitality. Looking at them I feel as if I'm touching their very substance with my eyes: It's the color, the flesh tints, the unfurling of form, the smile of life itself. I have an enduring love for his lusterous bodies and his blues and pinks. Renoir's sensuality is gorged with the most precious wines, colored with his rarest gifts, filled with his most generous offerings.

Without grandiloquence and without intellectual pretense, but rather by the mere strokes of his brush on the canvas, Renoir was able to make us believe that joy still exists on this earth. He achieved this in the contour of a lip, in the fairness of a complexion, or in the trembling black velvet at the heart of a poppy.

Renoir had an exceptional range which went from the most delicate sensitivity to the robust emotions of his glorious pillars of flesh. His emblem could be a rose, a rose with the body of Aphrodite, a Callipygian rose, a fertilizing rose, a rose that is always blooming.

In his last self-portrait, his brilliant, lively, sharp, and searching expression, though thin and almost painful, is still ready to seize the day and transmit to us the enchantments of painting through color and light.

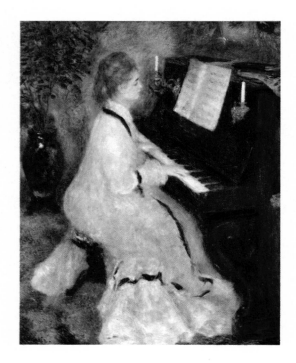

The Pianist, 1875
(93 x 74 cm)
The harmony of black and white is sustained throughout as she studies notes placed on the piano.

Torso of a Young Girl, 1875
(81 x 64 cm)
This is the start of a series of nudes. The painter uses for the skin tones mauves and browns, with scintillating touches of gold.

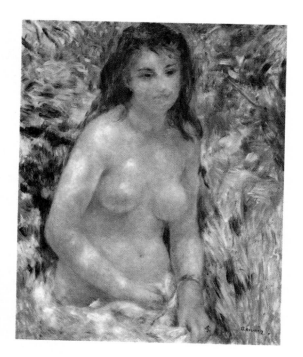

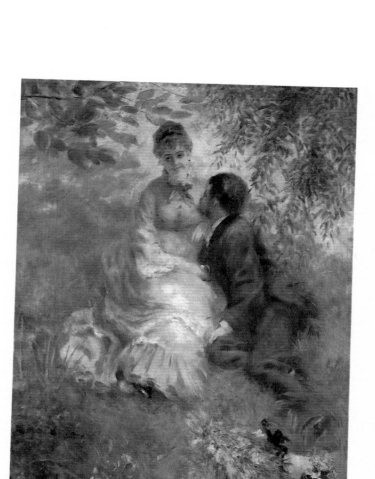

The Lovers, 1875
(175 x 130 cm)
Here is a youthful work of Renoir. It is slightly senimental, even a little facile, but already the brilliant colorist is obvious.

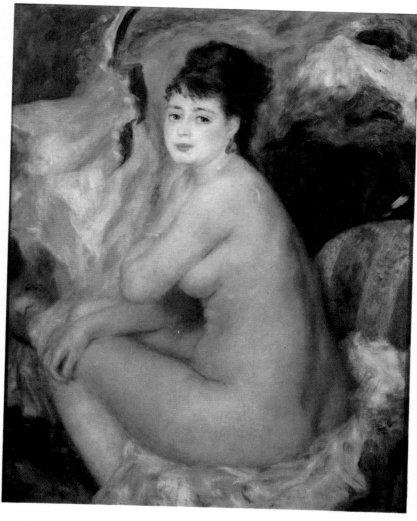

Nude, 1875
(92 x 73 cm)
This is the pose that Renoir preferred: a woman in all her glorious nakedness, among a pile of rich fabrics.

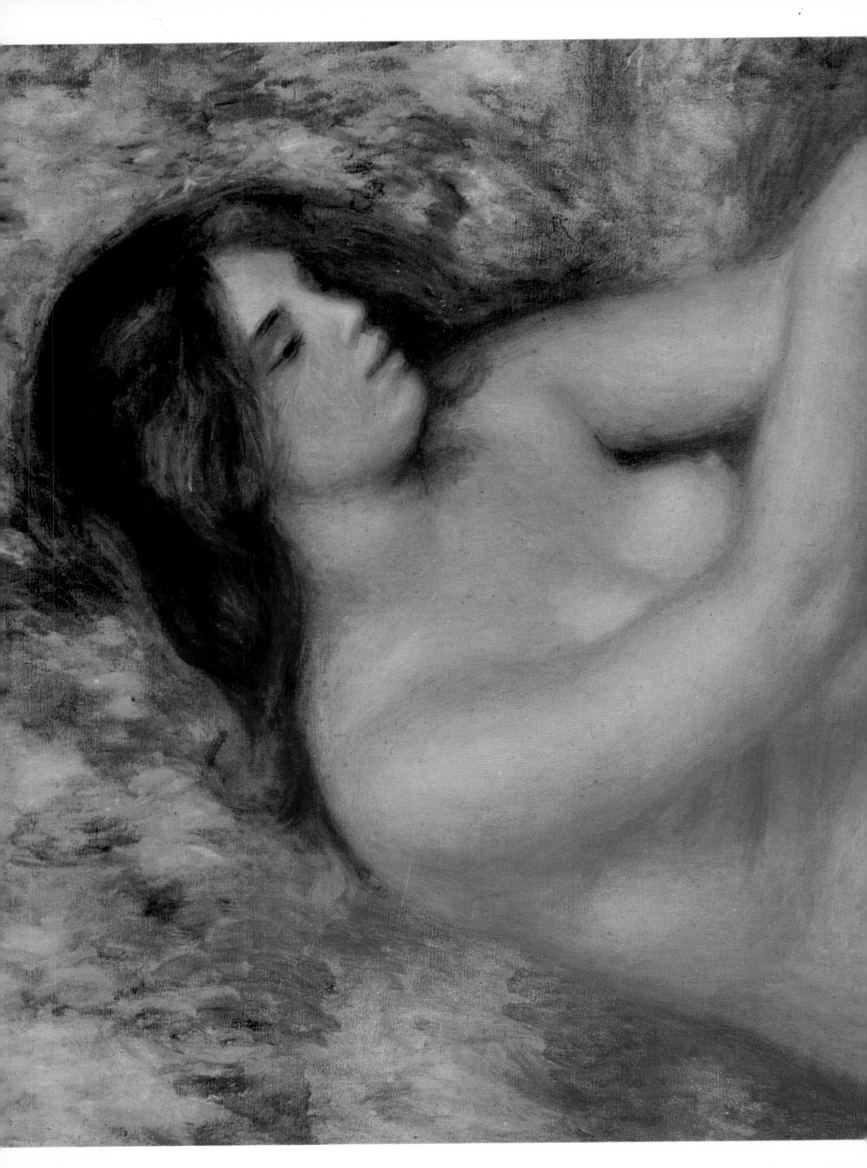

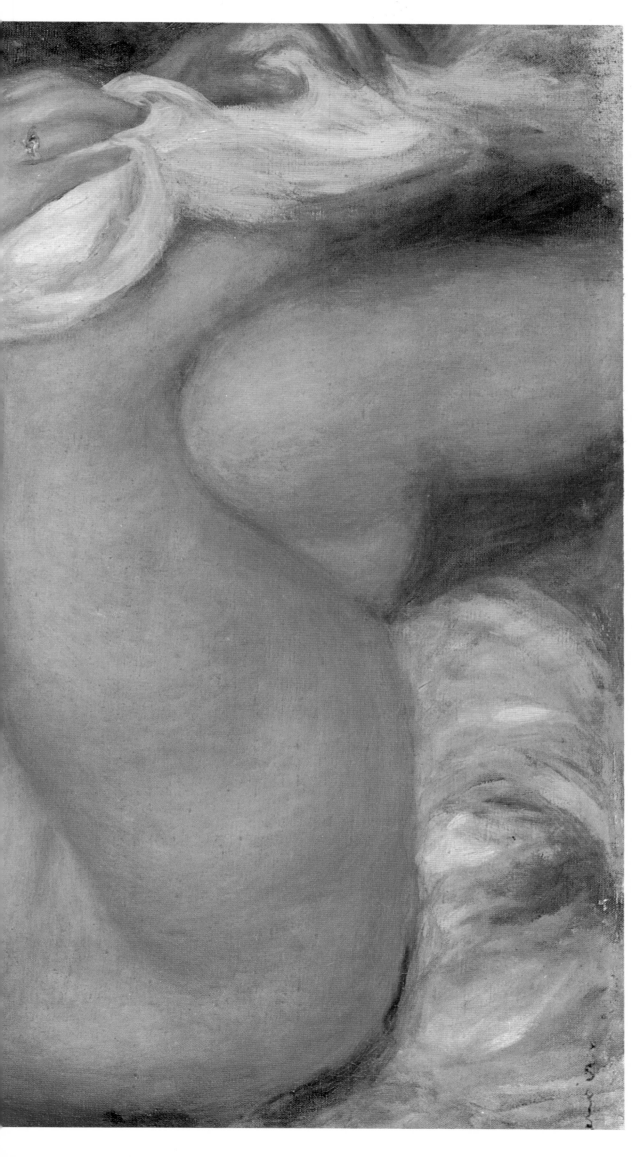

Bather Drying Herself, 1905
(84 x 65 cm)
Soon, there was a great expansion of Renoir's painting of the nude. He preferred dark-haired women. Estranged from Impressionism, he tried to recapture the form of classic sculpture.

SARGENT John Singer

Florence, 1856 - April, 1925

Sargent went back and forth between painting portraits on commission and his own pure and tender paintings. He was a friend of the Impressionists, especially Monet, who he painted a beautiful portrait of. Although he occasionally flirted with artistic conventions, his work often stands admirably on its own.

Like Whistler, Sargent was an American who spent most of his life in Europe. Sargent travelled between Rome, London, and Paris, where he and his family finally settled in 1874. In October of the same year he started painting at the atelier of Carolus Duran, who had earned recognition in the fashionable circles around Paris with *The Lady With the Glove,* Duran boasted widely of his friendships, with Manet and Monet. In 1876 Sargent travelled to the United States and Canada. After his work was exhibited at the Paris Salon, he went to Morocco and to Holland with Paul Hellen, who he knew from the School of Fine Arts. His *Portrait of Madam X* caused quite a stir at the Salon of 1884, when everyone who was anyone in high society knew the woman in the portrait was Madam Gautreau, one of the "grandes dames" of Paris, who could always be seen at Elysee receptions. People took offense at her plunging neckline!

In London, Sargent lived at 13 Tite Street, in the same studio that Whistler had lived in. During this stay he met the novelist Henry James, who admired the purity of his palette. Sargent also painted two portraits of Robert Louis Stevenson, the author of *Treasure Island* (1883).

In 1887-1888 Sargent again travelled to the United States where he had been commissioned to paint various portraits. He exhibited some twenty paintings in Boston, among which *The Daughters of Edouard Boit.* He was a member of the Salon's jury upon his return to Paris, and spent time with Monet in Giverny. He also participated in the World's Fair of 1889. The following year he received commissions from Boston and New York for several portraits and mural paintings. He travelled to Egypt for his research.

Despite the fact that he travelled a great deal and was very successful—he painted Theodore Roosevelt's portrait—he still managed to remain an outstanding painter. In 1905, he started to work with aquarelles and decided to abandon portrait-painting. Twelve years later, however, he was again painting portraits. Sargent died in his sleep at the age of sixty-nine.

Along with Thomas Eakins, Whistler, and Mary Cassatt, Sargent is one of the rare American painters who achieved worldwide status. His palette was always fresh, but he occasionally fell into the pitfalls of success and the temptation to settle for conventions. Sargent had the fabric of a great painter who would have gone even further had he been strong enough to resist the constant switching of genres. Like Monet, Sargent also painted out-of-doors, at times, and did a very lovely portrait of *Madame Edouard Pialleron in the Garden at Ronjoux.*

The Sketchers, 1914
(55.9 x 71 cm)
Here one can see how gifted Sargent was in using the pallette and touches of Impressionism. The woman painting in the foreground and the man seated before his canvas behind combine to give a sensation of the joy of sketching in the country on a sunny day.

SEURAT Georges Pierre

Paris, 1859 - March, 1891

Seurat established the Neo-Impressionist school of painting. He had the rare quality of allying his artistic temperment to a scientifically precise and richly colored composition. He momentarily marked the end of a period of "sketchers" in modern painting.

Without wanting to sacrifice the light and colors of life that Impressionism had celebrated with delicate brush strokes blue shadows, fleeting clouds in windy skies and the beautiful nudity of women bathing, Seurat, a born innovator, felt that something else was needed.

Seurat assembled and completed Impressionist technique through the solid structuring of his canvases, and in doing so anticipated Cubism. His art combines artistic intuition with educated skill. He was an orderly painter who had none of the Bohemianism of Murger, for example. Degas spoke of him as "the Attorney" when he would see Seurat walk by Avenue de Clichy impeccably

coiffed and dressed in the latest fashion. Seurat would be on his way from his parent's house, where he ate his meals, to his atelier in Pigalle.

The painter was born at 60 rue de Bondy in Paris. His father was from Champagne, where he owned a house with a garden in Raincy. His mother, Ernestine Faivre, was Parisian.

After doing his military service in Brest, Seurat returned at 19 rue Chabrol in Paris, nearby his mother's house. In 1884, he completed *Swimmers at Asnieres*, which was refused by the jury of the official Salon. He then

Swimmers at Asnieres, 1883-1884
(201 x 302 cm)
There is a sense of summer torpor, people stretched out on the river bank, even the swimmers themselves seeming a little lazy. In the detail on the next page, one can see that the young swimmer is painted quite large in a form that holds all the ideas of the best of Impressionism. One can almost hear him whistle through his fingers.

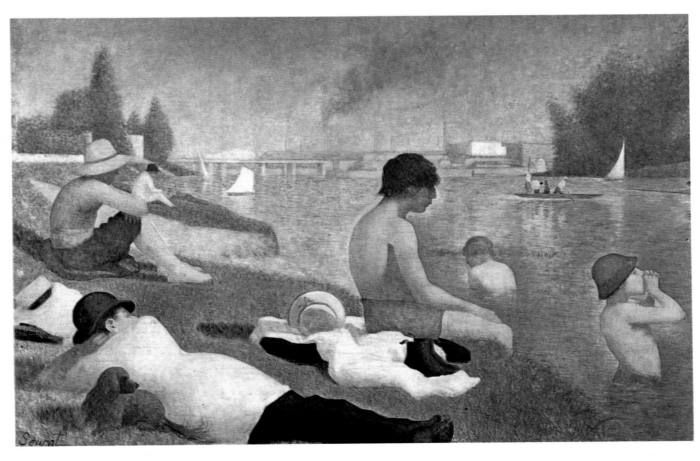

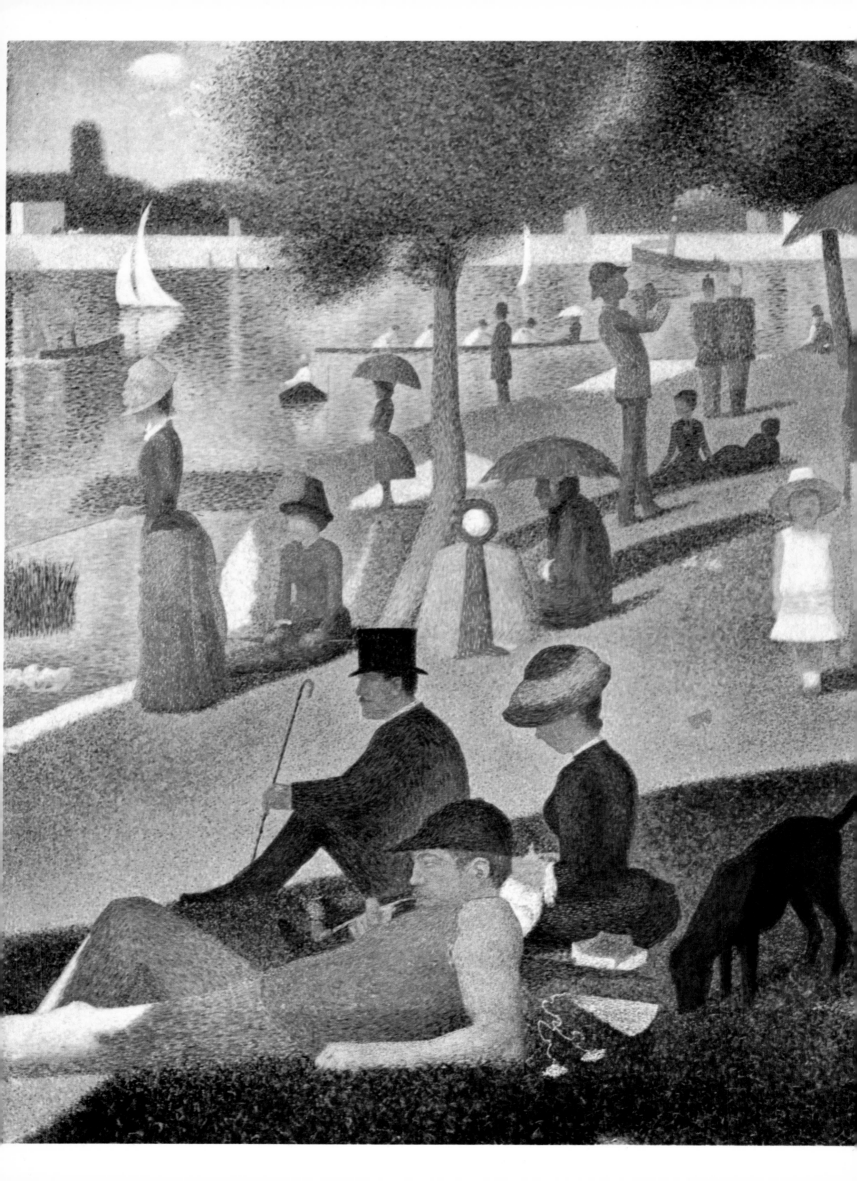

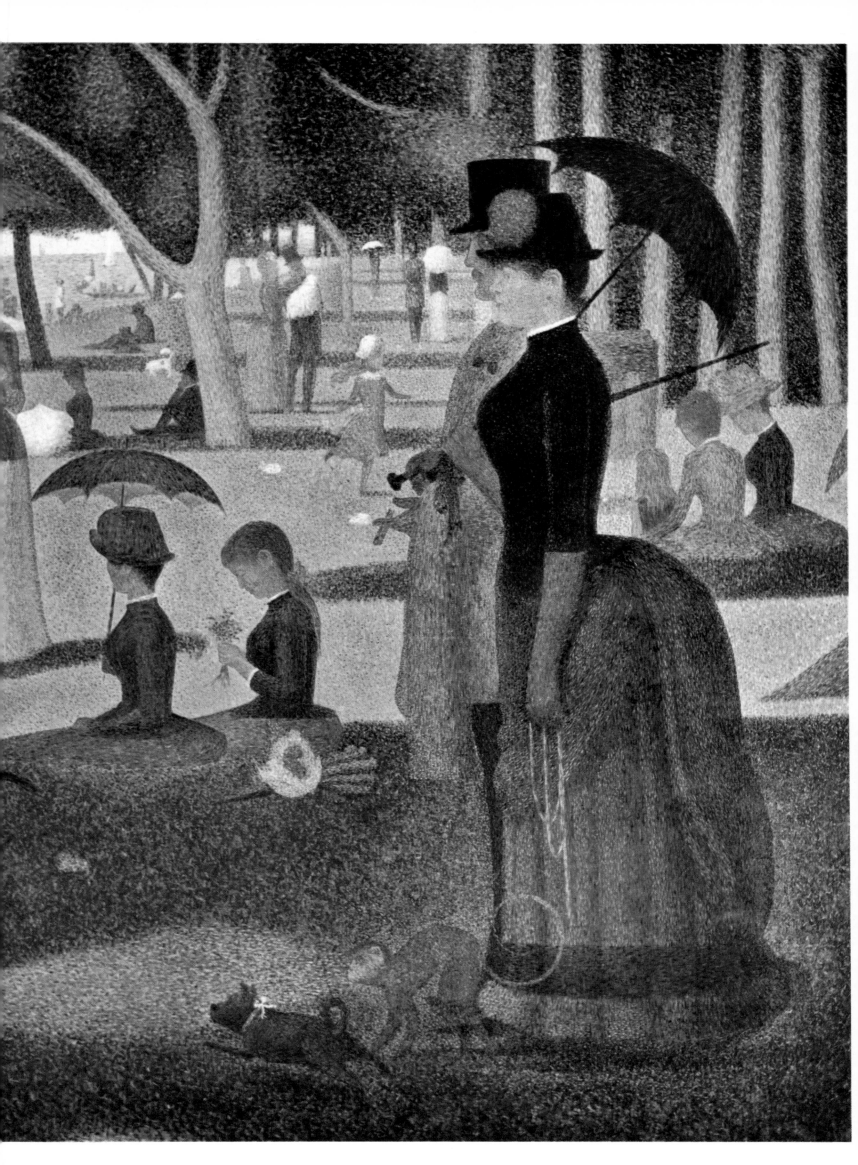

◁ *La Grande Jatte,* 1884-1886
r/206 x 306 cm)
This is the most important of Seurat's large canvases. In this painting, the contrast of light and shade, between the people seated and those standing, are marvelously placed in space.

The "Maria" at Honfleur, 1882
(53 x 63 cm)
In Honfleur, where he painted in 1866, Seurat scattered his brush strokes in a delicate swarm of dots to suggest the atmosphere of the port.

joined the Society (Association) of Independent Artists, who accepted his large canvas without a jury and without compensation.

In the winter of 1885, while he was living at 39 Passage de l'Elysée-des-Beaux-Arts in Pigalle, he completed *A Sunday in Summer on the Island of the Grande-Jatte,* the second of his large compositions. He became interested in music-halls and painted *The Parade.*

On February 19, 1890, Madeleine Knoblock a twenty-year-old Alsation woman who was his mistress, gave birth to a son that Seurat recognized (legally). The painter spent the summer of this year on the rue de l'Esturgeon in Petit-Port-Philippe in the region of Graveline in the North of France. There he worked on a series of landscapes, and started outlining his work for *The Circus. The Circus* was exhibited at the eighth annual Salon des Independents. It was during this exhibition that he caught cold, came down with infectious tonsillitis, and died at the age of thirty-two.

Apart from a certain number of medium-sized canvases, among which the beautifully lit *Bridge at Courbevoie* and the *River Seine at Courbevoie* with a woman walking her dog, Seurat concentrated primarily on large-scale compositions, which had been neglected by the Impressionists, except for Claude Monet's panels and Renoir's assemblages of people. At the very beginning, Seurat was influenced by Puvis de Chavanne, but Seurat's works have nothing of de Chavanne's decorative elements in them. The painter did a series of studies, in the form of designs and sketches on small planks, for each one of his large canvases.

In *The Swimmers at Asnieres,* the artist was able to convey a strong impression of heat and relaxation on the grassy banks of the river with the bridge and rooftops of Asnieres in the distance. *Posing Woman,* the third of his large-scale paintings, portrays the studio model in three successive phases: undressing, posing erect, and dressing.

By all standards, Seurat's masterwork is his *A Sunday in the Summer on the Island of the Grande-Jatte,* where, for the first time, the painter rigorously applies his scientific theory of optical blending through the division of tones. To obtain green, for example, the painter juxtaposes yellow and blue directly on the canvas, instead of mixing them on his palette, thus allowing the colors to retain their freshness and their intensity.

The orderly composition of light and shadow which defines the strollers and the sitting or standing figures in the foreground of the canvas is remarkable. These summer visitors to the island are distributed throughout the canvas, from the foreground back through the trees, in extraordinarily well executed intervals. This vast painting which measures 7 feet by 10 feet (2.25 meters by 3 meters) demands lengthy attention before we can fully appreciate its admirable quality. The *Grande-Jatte,* is the masterpiece of Neo-Impressionism, which is also called Pointillism or Divisionism. Seurat, however, preferred the more scientific appellation of chromoluminarism.

The Circus, 1891
(186 x 153 cm)
This is Seurat's last canvas, never finished. Perhaps sensing the end, Seurat exhibited it in the Salon des Independants in 1891, just the same.

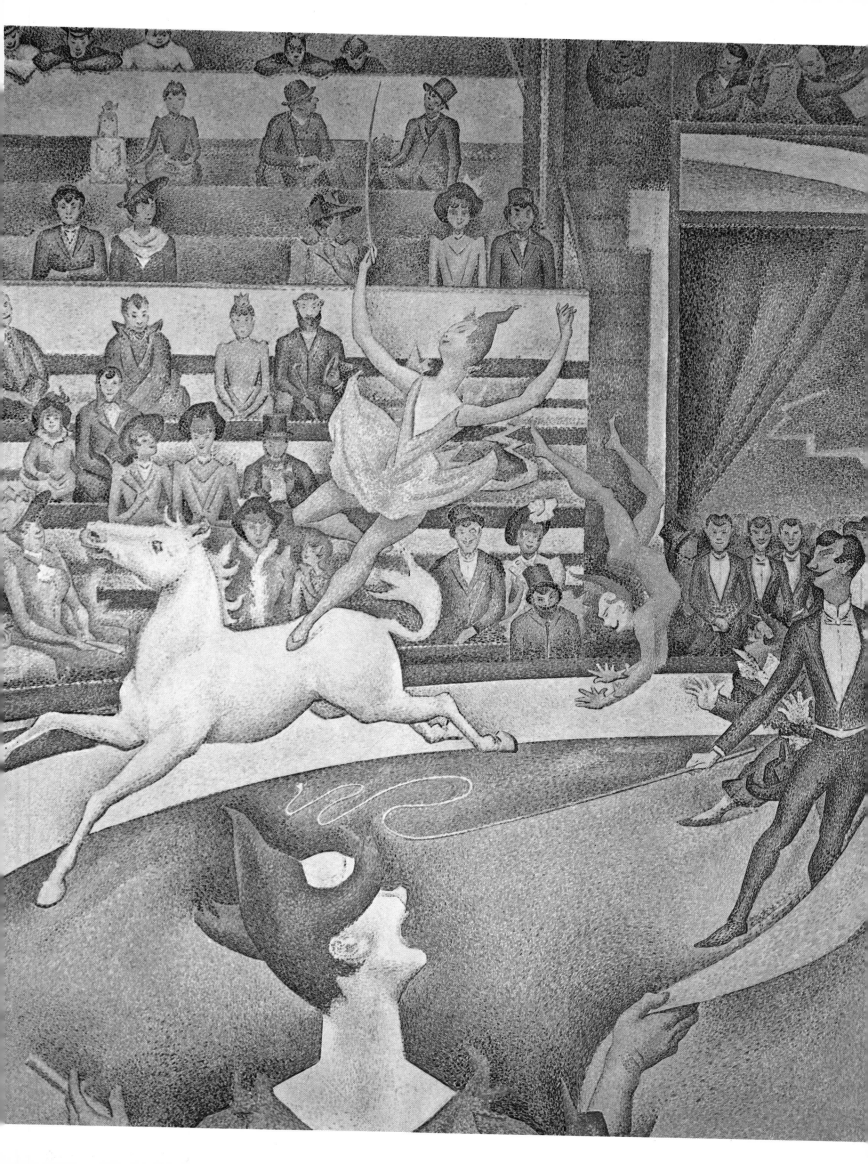

SIGNAC, Paul

Paris, 1863 – Paris, 1935

Signac painted a variety of works, primarily favoring the sea and the ports of Saint-Tropez and Marseille. He enlarged the juxtaposed points of color used by Seurat with his own characteristic rectangular brush strokes. After travelling to Venice and to Constantinople, he painted a large number of aquarelles. In 1899 he published his book, From Eugene Delacroix to Neo-Impressionism.

Signac is the most important of the painters who completely or partially adopted the theory and technique of Seurat, although Luce, Dubois-Pillet, Angrand, Louis Hayet, Hippolyte Petitjean, Henri-Armand Cross, and Theo Van Ryselberghe are significant, as well.

The painter came from a family of harness-makers located on the Passage des Panoramas in Paris. His earliest paintings were influenced by the Impressionists, especially the works of Claude Monet. He studied in the atelier of the Mayor of Montmartre, a recipient of the Prix de Rome. It was there that he met Tanguy, who would later buy paintings from Van Gogh, Monet, Cezanne, Sisley, Pissarro and Gauguin, and pile them up in his ship on the rue Clauzel.

In 1884, Signac met Seurat through his friend Guillaumin, who at that time was painting on the banks of the Seine. He frequented the Symbolist circle of artists and writers, including Felix Feneon and Paul Adam, and adopted their progressive outlook on life and art. He painted at Collioure.

After the death of Seurat, Signac spent a part of each year in Saint-Tropez until 1911. It was during this time that he painted *The Pine*, which is now at the Pushkin Museum. His enlarged rectangular brush strokes and the mosaic quality of the canvas distinguished his work for the canvases of Seurat.

In 1899 Signac saw the paintings of Turner in London. The following year he published *From Eugene Delacroix to Neo-Impressionism*. The book had a strong impact on contemporary painting, and established that the separation of tones had already been announced in Delacroix's *Women of Algiers*. Signac himself followed the theories in Charles Henry's *Chromatic Circle*.

Matisse painted his *Luxe, Calme et Volupte* under the influence of Signac at Saint-Tropez. In 1905 Signac's work was exhibited with the fauves at the salon d'Autumne. In addition to working in oils, he did a large number of aquarelles, some of which were painted in Venice, Corsica, and Istanbul. In 1913, the painter moved to Antibes, where he lived for several years before going to Cotentin, in Britanny, and the to La Rochelle. He died in Paris on the rue de l'Abbaye at the age of seventy-two.

Signac's thinking, akin to that of Felix Feneon, tended towards anarchy. Signac painted Feneon, the astute critic and future editor of *La Revue Blanche*. He's standing and extending a lily over enamel. The background is rhythmic. When Signac suggested doing the portrait, Feneon responded in a letter dated June 25, 1890: "I am a willing accomplice to your idea of painting me, my dear Paul. One of these winters, if my "performance" is up to par, I'd like it to be eternalized on the walls of future picture-galleries where the catalogues will read: Paul Signac (1863-1935): *Portrait of an Unknown Young Man.*"

The Seine at Herblay, 1889
(33 x 55 cm)
Here is the Seine, with its banks reflected in it. For this painting, Signac used smaller brush strokes than he later employed in his series, "Marseille."

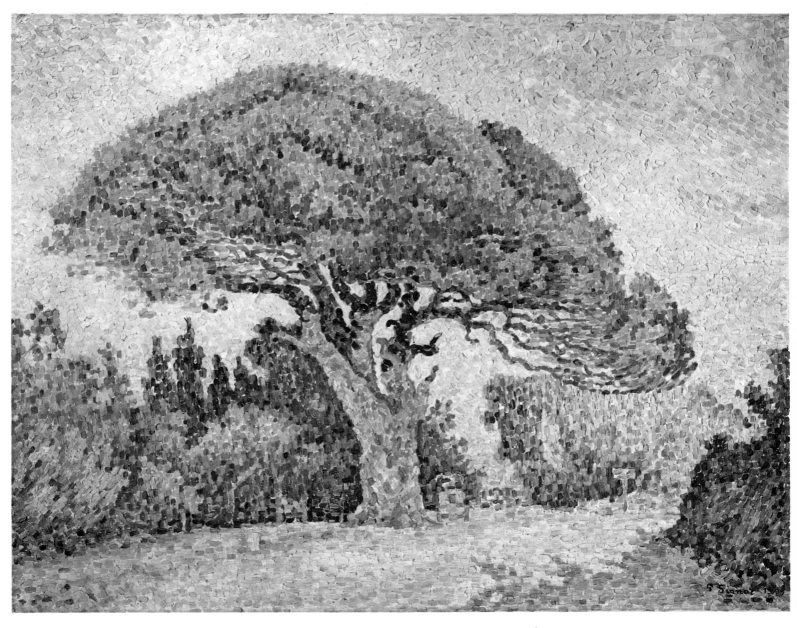

The Pine Tree, Saint-Tropez, 1909
(72 x 92 cm)
This tree, under the brush of Signac with its bold strokes, is an evocation of the Midi, its forceful colors and vibrant light.

The artist's paintings are filled with lively colors that insinuate themselves with a blue luminosity. His very free approach to the aquarelles bears the mark of the same strong personality of his admirable oil paintings of the Port of Marseille.

In the Conte pencil portrait that Seurat did of Signac in 1890, the artist is seen in profile with his top-hat thrown back and his cane drawn up beside him. Meeting him much later in his lodgings at Saint-Germain-de-Pres, I remember him as a gracious man with large, indulgent eyes, and a short salt and pepper beard, who told me with conviction that: "It's necessary to hold yourself together under tension in order to avoid becoming a morose old man."

SISLEY Alfred

Paris, 1839 - Moret, 1899

The Road to Sevres, 1873
(54 x 73 cm)
With the gentle light and general tonality, we see a faint echo of Corot. Our eye is captured by the road.

Snow at Louveciennes, 1878
(61 x 50 cm)
With a stroke of the brush, we have a woman in black lost in the whiteness of the winter landscape and the entire canvas is pulled together.

Sisley was a student of Gleyre, and like the majority of his Impressionist friends, was first influenced by Corot and Daubigny before going on to become the landscape painter of the banks of the Seine and the Loing rivers. He was British by birth but lived in France. Of all the Impressionists his life was the most difficult right up until his death. He experienced financial hardships and made many sacrifices during his life.

There's a fresh, tremulous quality in Sisley's work. His brush strokes have finesse, delicacy and a quivering life. He is the Impressionist painter of reflections on water, of landscapes captured in the pink light of sunrise, of poplar trees with trembling leaves, and of enchanting alleys covered with snow.

When Renoir painted *The Sisley Couple,* Sisley was twenty-nine years old with dark hair, and looked very much in love. There's a photograph of him at age forty-three, standing, with a neatly trimmed beard, looking serious and very determined. This is quite a different portrait from the one we have of him during the last years of his life, in which we see an irritable, neglected man wearing a black toupee, and looking as if he had sacrificed so much that, in the words of Pissarro, he was content just to "drift". The only thing that life had not deprived him of was his joy in painting.

Sisley was born in Paris to British parents who sent him to England to learn the language and prepare for a life in business. Instead, he was attracted to painting. In 1862, he entered Gleyre's atelier, where he studied with Monet, Renoir and Bazille. He followed the example of his friends who all left their Swiss teacher to paint at Chailly and in the forest of Fontainbleau. He then worked in nearby Marlotte with Renoir. Both painters took a sailing trip along the Seine all the way up to Le Havre. In 1866, Sisley exhibited two paintings at the official Salon, only to be refused the following year. He would in turn be accepted and then rejected by the Salon jury, but stubbornly continued to show them his work, saying: "If I'm accepted, I think I'll be able to do business." Theodore Duret was able to find him the rare man who would purchase his paintings. His name was Jourde, the critic and editor of *Siecle.* Although Jourde had had more than his fill of Impressionists, he bought seven canvases from Sisley.

During the War of 1870, Sistely took refuge in England, as did Monet and Pissarro. When he returned to

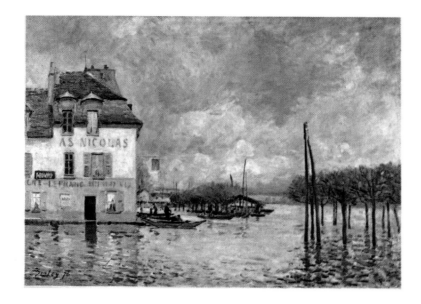

Flood at Port-Marly, 1876
(60 x 81 cm)
Here is one of the most successful compositions of Impressionism: the contrast between the disaster and hopelessness of the subject, and the marvelous harmony of the light and colors.

Village Along the Seine, 1872
(50 x 80.5 cm)
These riverside views of Sisley have a particular poetry. One feels the pleasure of the painter in the sun-dappled trees in the foreground and the clear light on the houses on the other side of the river.

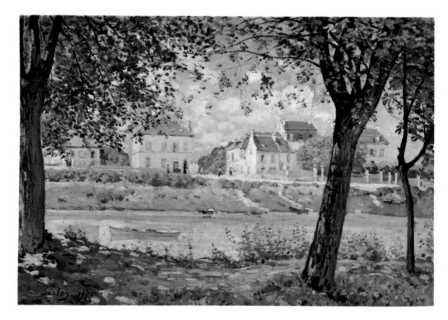

France, he went to Louveciennes with Renoir, and then to Argenteuil, where, in 1872, he painted *The Footbridge and the Square.* From 1873 to 1874 he worked on and off in Louveciennes, in Marly, in Bougival, and in Pontoise. After having sold some canvases to Durand-Ruel, to whom Degas had introduced him, he moved into a large atelier in Montmartre.

Sisley's paintings sold for between 50 and 300 francs during an auction at the Hotel Drouot. At the Impressionist's group show in 1876, he exhibited eight landscape paintings, and the following year exhibited seventeen. He painted in Sevres, in Saint-Cloud, and in Saint-Mammes on the Loing River. Then he worked in Moret, in

Suresnes, and on the Isle of Wight. In 1882, he settled in Moret, where he would die seventeen years later of throat cancer.

Like his friends, Sisley painted scenes along the banks of the Seine and intimate portraits. He often painted his two children, Pierre and Jeanne. He captured the gentle harmonies of his landscapes with green and blue hues painted with a fine-tipped brush. In 1872 he painted *Bougival,* and the quivering poplar tree, his preferred tree. In the winter he painted *The Road to Louveciennes* with its drifts of snow on a pine-tree, and its two delighted children walking on the white-carpeted earth.

When he returned to England in 1874, he painted with

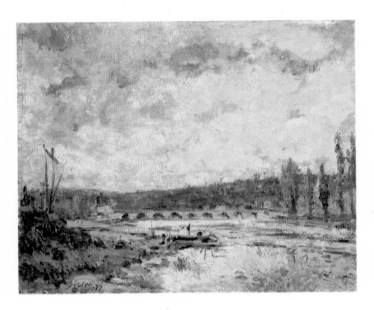

The Bridge at Sevres, 1877
(53 x 63 cm)
Often Sisley painted a sky that was more
important than either the river or the land.

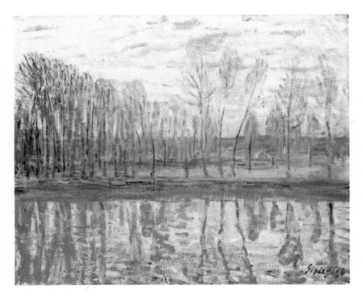

Shore of Loing, 1896
(54 x 65 cm)
It was along the edge of the Loing, a tributary
of the Seine, that Sisley painted a great number
of canvases.

quick, admirably punctuated brush strokes that he seemed to improvise in *View of the River Thames and the Bridge at Charing Cross.*

In 1876 Sisley painted a series of canvases based on the floods at Port-Marly. He transformed the unfortunate event into a joyous evocation, with a mackeral sky, the sunlit facade of a house on which "At Saint-Nicholas" is painted, and the arrival of two men in a boat alongside the house. Trees emerge from the flood waters which are filled with unexpected reflections. This is undoubtedly a

work of major importance. The Seine, and the banks of the Loing at Moret and at Saint Mammes, with its boats and fishermen in the calm of evening, allowed the painter to engage in an endless dialogue with nature.

Sisley painted landscapes at sunset with lightly applied expressive brush strokes that have a certain wandering quality. We are moved by his trails of clouds, his roadways, his mauve reflections and his far-reaching countrysides where the sun has just set. Sisley painted one of his Saint-Mammes landscapes in the trembling light of day with vibrant, sensitive brush strokes on the water and on the figures who are walking along its shores.

Of all the Impressionists Sisley was the least successful during his lifetime. He and his family survived on a few small successes, but Sisley died virtually unknown and underestimated, despite the communicative quality of his work. Eugene Murer, man of letters, pastry chef, and art lover, spoke of Sisley as the "most refined of all the Impressionists."

Murer wrote that "Sisley had a bad stomach, but loved to eat. He'd charm us at dessert with his witty outbursts and his rippling laughter. He had a good French mind, and the manner of a real gentleman. If Claude Monet hadn't been his friend and contemporary, he would have been the most perfect landscape painter of the late 19th century. Sisley knew this, and sometimes let his bitterness show through. . . Nonetheless, he was indeed a great painter whose work is filled wth light and emotion. I will add that, in some ways, he's even superior to Monet. He's more sentimental and more passionate. Nature was Sisley's mistress and he worshipped her. Monet, however, was only a husband to nature, and at times was abusive in his treatment of her. I admire Monet for his incomparable vitruosity, but I love Sisley for his touching enthusiasm. Because he had more heart, he also had more weaknesses, but that's what makes him closer to me."

Sisley is, without a doubt, the closest to Monet of all the Impressionists. Their respective techniques merit comparison: Sisley's *Louveciennes, hauteurs de Marly* (the Louvre) painted in 1873, is an orchestration of colors that are richer and more varied than Monet's canvases of the same period. In Sisley's rendering of a tree, a bush, a roof, a railing, a figure walking along the road, or even the road itself, there's more diversity, abundance and differentiation in his brush strokes. Each stroke is different, as if the painter was discovering the subject matter for the first time. Almost invisible spots of blue, green, and brown are spread through the landscape, creating variety without disrupting the natural harmony of the scene.

In *Regattas At Molesey,* painted on the outskirts of London, (the Louvre), a wide variety of brush strokes is used to suggest the reality of the subject: onlookers are dressed in white, and the oarsmen in their boats are admirably

rendered under the vibrantly-colored flags which unfurl in the foreground. Each and every brush stroke is astonishingly agile, rapid, and mobile. In this type of painting, Sisely is more quintessentially an Impressionist than Monet.

In Monet's landscapes of the same period, there's less precision and diversity. His brush strokes are heavier and lack the mobility we see in Sisely's work. Monet's images are more massive, stronger in design, and much more varied in terms of subject matter. In the *Rocks of Belle-Ile*, and to a lesser degree in his *Antibes* canvases, Monet is more vigorous and authoritative in his designs. At Giverny, however, his *Water-lilies* established his undisputable superiority.

It's interesting to compare Sisley's *Snow at Louveciennes* (1874) with Monet's *Snow at Argenteuil* (around 1875). Sisley's painting is delicately nuanced with muted tonalities to suggest the snowfall, as well as the snow cover. There's more emphasis and density in Monet's painting, with less differentiation in the brush strokes. All of Sisley's paintings of Louveciennes are filled with a lighter, more nuanced touch than Monet's. Nonetheless, it is indeed Monet who reaches an apotheosis in the larger, more varied registers of his painting.

One can speak of Sisley's winters in the same way that one speaks of Bonnard's summers. His snow-filled landscapes are unique. They allow us to see the snow that covers the streets, fences, walls, and roofs, gradually envelop us in white nuances of a fairyland. It's as if we ourselves were walking through the snow with our eyes.

In a letter from Camille Pissarro to his son, Lucien, which is dated Januray 22, 1899, he wrote: "They say that Sisley is gravely ill. He's a beautiful and fine artist. I believe he ranks with the great masters. I've seen paintings of his of a rare and beautiful magnitude, among which is his *Flood at Port-Marly,* a masterpiece."

Sisley tried to obtain French nationality, but was refused. He died leaving his widow and children penniless. Claude Monet came to their aid by organizing an art sale with an important painting of his, and one of Renoir's. Pissarro contributed his *Jardin des Tuileries.*

Immediately after Sisley's death, the art world went mad over his work. The *Flood at Port-Marly,* which Sisley had sold for less than 200 francs, was bought for 40 thousand francs by Count Isaac de Camondo. Today, the painting is at the Jeu de Paume. For Sisley, more so than for any of his friends, his day in the sun came only posthumously.

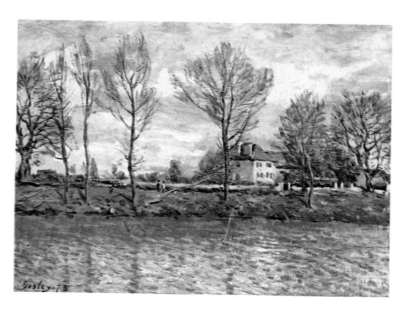

The Island of the Grande Jatte, 1873
(51 x 65 cm)
Here is a corner of the island of the Grande Jatte that Seurat was later to immortalize. The water of the Seine is a sparkling blue-green. Two men are strolling in the open space beneath the trees.

The Countryside at Veneux, 1882
(60 x 81 cm)
Sisley painted the countryside with its many kinds of trees and shrubby fields under a sky full of fine stormy touches.

TOULOUSE-LAUTREC MONFA
Henri de

Albi, 24 novembre 1864 - Chateau de Malrome, 9 septembre 1901

A descendant of the Counts of Toulouse, Henri de Toulouse-Lautrec suffered two leg injuries that deformed him for life. He sought consolation in the music-halls, bars, and prostitutes of Montmartre, and in the shows at the Moulin-Rouge. He was able to make people forget his misfortune with his prestigious talent and his child-like and fraternal humanity.

At the Chateau of Malrome his world was the French aristocracy. His parents were descended from the Counts of Toulouse. His father, Alphonese de Toulouse-Lautrec Monfa, whose main activities in life were geneology and horses, married Adele Zoe Tapie de Celeyran, his mother, on May 9, 1863. They were first cousins. In Montmartre, his world was the Moulin-Rouge, the French cancan, la Goulue, Jane Avril at the Jardin de Paris, and the brothel on the rue des Moulins, where he was welcomed as "Monsieur Henri". Lautrec carried the mind of a genius in the body of a dwarf. One of his friends commented that he was taller sitting down than he was standing up.

Lautrec's arrival at the Moulin-Rouge was always an event. according to his old friend Maurice Joyant: "An Offenbach piece would be playing, and Lautrec would enter with an entourage of exuberant friends and prize-fighters who would clear his path and look out for him.

The Girls,
(60 x 80 cm)
The painter, an intimate of these brothels, shows us a quiet moment in these women's lives.

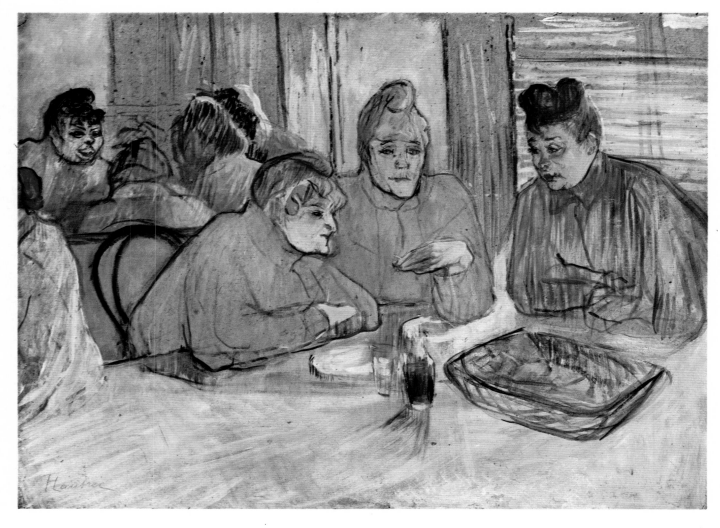

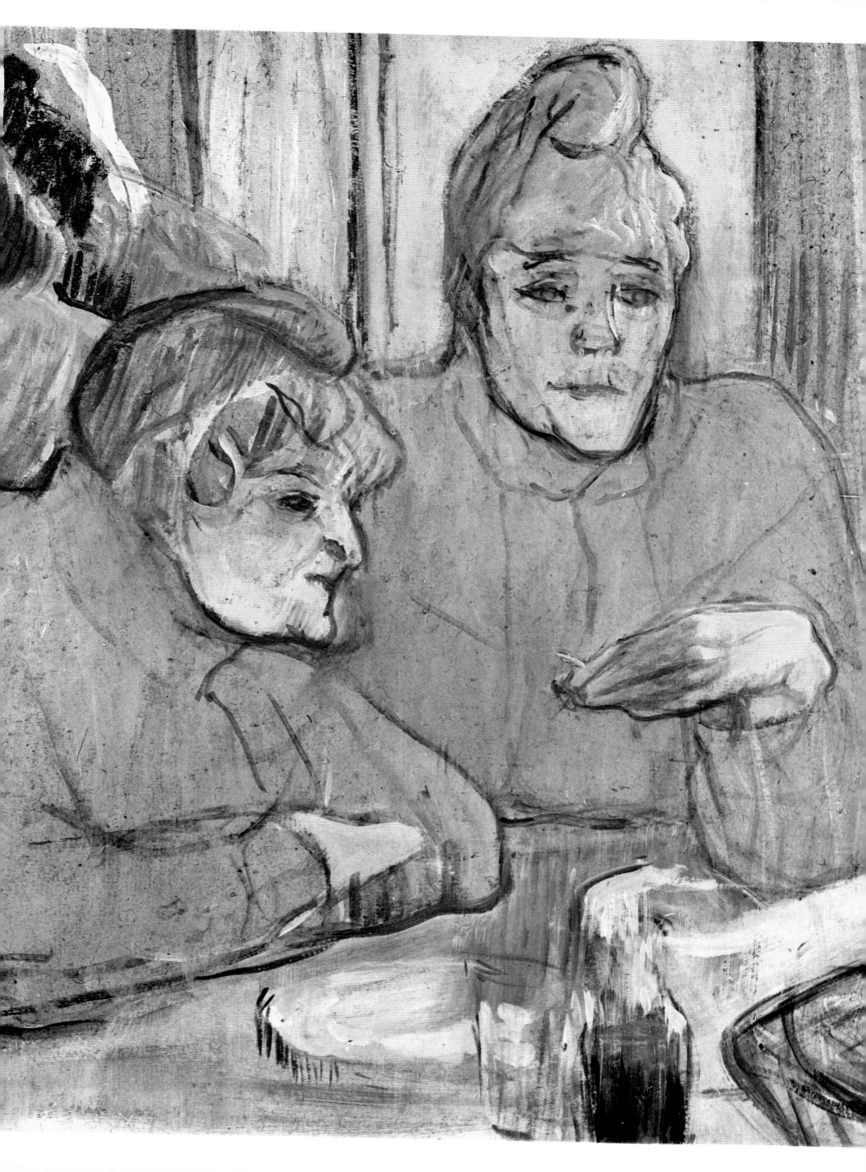

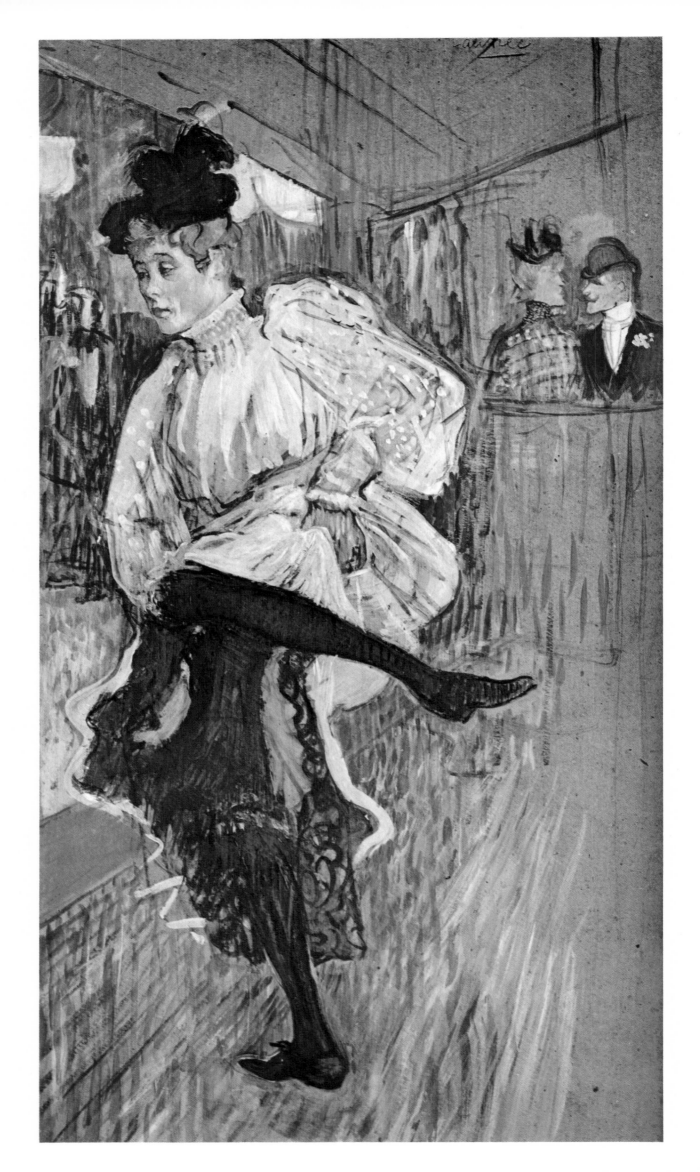

Jane Avril Dancing, 1892
(86 x 45 cm)
He liked La Goulue and her buffoonery, but he
preferred Jane Avril, whom he nicknamed
"Melinite." She is doing side kicks.

All eyes would turn in astonishment as this dwarf with an oversized head and two deformed legs swayed from side to side as he walked. He had cunning eyes, thick lips, a pince-nez on his large nose, and a bush of black hair. He often wore black and white checkered pants and a bowler hat. In winter, he would wear a blue ratteen overcoat with a dark green scarf around his neck. He carried a small cherry-wood walking-stick with a crutch-handle."

The parents of this "little monster", as he would be affectionately called by the actress Yvette Guilbert, moved to Paris when Lautrec was in his early teens, and enrolled him at the Lycee Condorcet, which was then called the Lycee Fontaines. When he was fourteen, he slipped on the parquet floor at the Hotel du Bosc in Albi, his birthplace. he broke his left thigh-bone. The following year, in Barege, he had another accident and broke his right thigh-bone. In order to compensate for his deformity, his parents encouraged him to paint. He started sketching horses under the guidance of his teacher, Princeteau.

In late May, 1882, he entered the Bonnat atelier, and after that went to Cormon's atelier at 35 Rue de Clichy. Cormon was a painter of pre-historic scenes. Lautrec spent five years in Bonnat's atelier, working in the company of Emile Bernard, Van Gogh, and Francois Gauzi. Gauzi said that Lautrec would liven up the atmosphere by singing the songs of Aristede Bruant, but that he was somewhat alone among his fellow painters. Delacroix was his idol, and his lips would tremble when he spoke about him.

In 1886, Bruant set up a permanent exhibition of painting in his cabaret, then called *Mirliton* (the Music Box). Lautrec participated in the exhibition and later made a marvelous poster of Bruant. In 1889, he participated for the first time in the Salon des Independents where he introduced *Au bal du Moulin de la Galette.*

He undertook the painting of portraits in the half-wild garden of old Mr. Forest at the corner of the rue de Caulaincourt and Clichy Boulevard, where he had his models pose beneath the linden-trees and sycamores.

In 1890, he completed his *Dance at the Moulin-Rouge.* The establishment was run by Zidler at the time, for whom Lautrec made his first poster. The Moulin-Rouge painting features Louise Weber, known as "la Goulue" because of her gluttonous appetite, dancing in the center of the canvas. He would paint numerous other canvases of la Goulue, who Jean Lorrain has described as: "Fat, white skin moulded into a small black dress. She would elbow her way through the crowd, and insolently flirt with the

Danse Mauresque, 1895
(285 x 308 cm)

La Goulue and Valentin le Desosse, 1895
(298 x 316 cm)
Here are two panels that Lautrec painted in April 1895 for a booth in the
Trone Fair, where a worn-out Goulue (she was about 25) did a belly dance.
In the first, we see la Goulue dancing in front of Oscar Wilde and Felix
Feneon. In the second, la Goulue is dancing the can-can at the Moulin-
Rouge with Valentin-le-Desosse.

Women With Her Slip Raised, 1894
(68 x 48 cm)
*On cardboard, this is a study for the painting in
the Albi Museum,* The Salon in the rue
des Moulins.

Jane Avril, 1892
(100 x 89 cm)
*Lautrec thought Jane Avril the best of all the
dancers. She knew him well, would go to his
studio and helped him entertain his friends.*

horney men in the room, as if she were a beautiful young woman." Lautrec always postioned la Goulue in the center of his canvases, because she was the lead dancer in the quadrilles and the balls that were the subject of his Moulin-Rouge series.

From 1892 to 1896, Lautrec worked on posters, and then on colored lithographs. He made the album of Yvette Guilbert, who sang at the Divan-Japonais, emphasizing her long black gloves and making her known for wearing them. He also painted his circus and music-hall canvases during this period, capturing the appearances of Marcelle Lender, May Belfort, and the female clown Cha-U-Kao, who performed her buffooneries at the Moulin-Rouge. Lautrec ended this period with the decor he painted for la Goulue's booth at the Trone carnival.

Lautrec regularly frequented the brothels on the Rue d'Amboise and on the Rue des Moulins, where he lingered with the prostitutes, known as "filles de joie". He sketched them, and painted them in pastels and oils, as well. He spent so much time there, including all the times that he ate his meals there, that he was almost considered a boarder. He would often tell his friends: "I'm pitching my tent at the brothel."

In the words of his close friend, Thadee Natanson; "This super-male dwarf was always as ravenous for sex as he was for alcohol, but perhaps preferred the refinements of tenderness most of all . . . He could be found fondling the astonished trollops with incredible gentleness, or wrapping their very soft, round and hanging breasts around his neck, as if they were the softest of mufflers. . . . When Lautrec was drunk, he would come out with the most stupendous words, but when he was sober, it was totally different. For example, I heard him make a running commentary of Balzac the likes of which I had never heard, or for that matter, read anywhere, except perhaps in Proust."

Yvette Guilbert, 1894
(57 x 42 cm)
*It was at Divan-Japonais that he discovered
Yvette Guilbert. He always painted her in her
long black gloves. He admired her style and did
many portraits and lithographs of her, many of
which did not please her: "Little monster!" she
said on seeing one of them, "You made me look
like a horror!"*

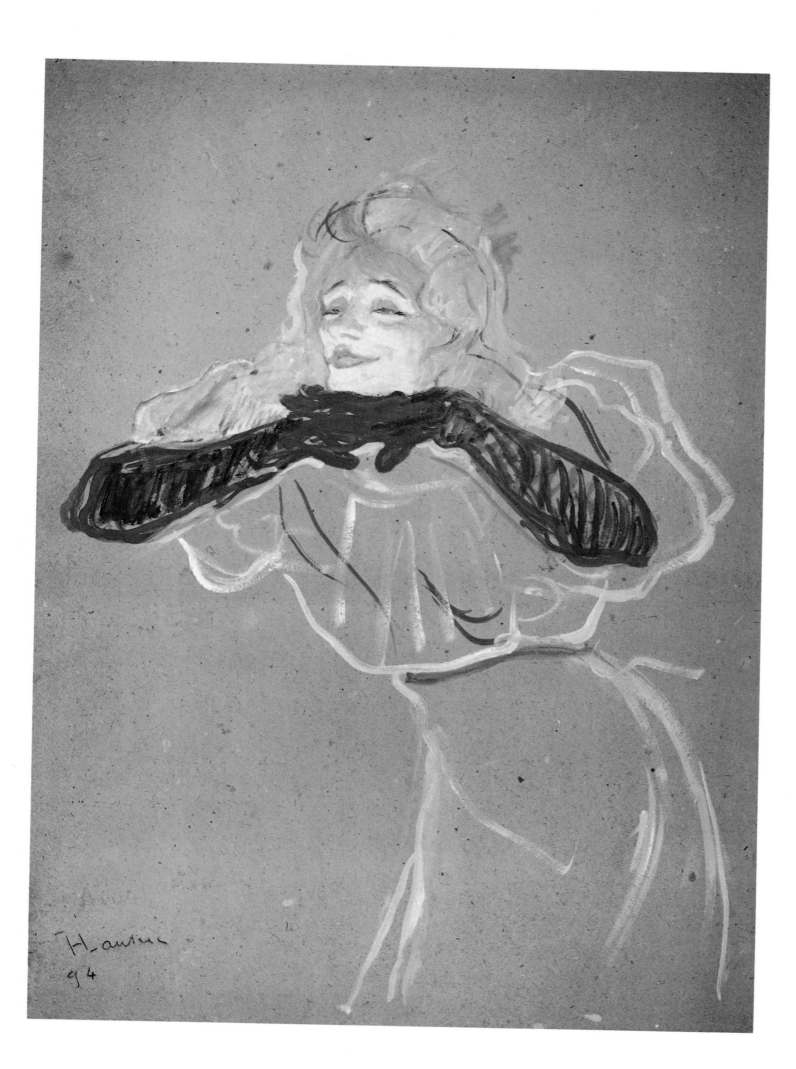

Woman With a Black Boa, 1892
(63 x 41 cm)
This portrait on cardboard gives us a precise idea of Lautrec's drawing. The woman has a slightly savage air, as though she knows well how to use her allure. Her forehead is softened with little curls.

Portrait of Monsieur Fourcade,
(77 x 63 cm)
Hands in pockets, hurried, not noticing anything around him, this gentleman looks only at what interests him.

In 1877 Laturec left his atelier on the Rue Caulaincourt for another atelier on 5 Avenue Frochot, in the same neighborhood of Pigalle. He sketch a cow on cardboard which he sent to his friends, inviting them to join him there for a "cup of milk". He made twenty-two lithographs for the illustration of Jules Rensard's *Histoires Naturelles.* However, his continuous abuse of absinthe and alcohol ultimately took its toll, and between February 1st and May 20th, he had to be hospitalized at the clinic on Avenue de Madrid in Neuilly, treated for detoxification. He was released after his friends made an issue of his confinement in the press. He then moved around from place to place, but his condition worsened. His friend, the sculptor Crabin, told Guazi: "I met him in Montmartre. Alas! He was wiped out, sick, near death. He wasn't even the shadow of the Lautrec we once knew." Lautrec arranged to have himself transported home to his mother at the Chateau de Malrome, where he died.

His physical disability might have been the reason for his attraction to the low-life. His mingling with drinkers, the fast set, and prostitutes, all of whose tired and disillusioned faces he painted, could also have been a protest against the illusory greatness that aristocratic families perpetuated. With sketches as precise as they were biting, but in essence filled with mercy, Lautrec created the atmosphere in which his subjects lived and breathed. Like Degas, he painted his canvases in the Japanese style, often cutting a part of an object or a figure out along the perimeters of the canvas. He was able to emphasize red in an otherwise somber setting, or to illuminate a face, as he did with Marcelle Lender, or to arrange Chao-U-Kao in a yellow collarette and black pants, or introduce Felix Feneon in profile against the painted decor for the booth of la Goulue, who is portrayed entering the Moulin-Rouge between her two female accompanists. Laurtec was a subtle colorist who illuminated his canvases with mauves, unnatural greens, whites, and blacks. Above all, Lautrec's work is alive and incisive, as free-flowing as it is precise. He captured form with agility and a rapidity that heightened, rather than diminished his sensitivity.

No other painter was able to render the make-up the women used to accentuate their lips, and to maximize their looks, as Lautrec did. He aslo had an amazing way of using his background characters, and of dislocating the hips of Valentin le Desosse who is writhing next to la Goulue.

Lautrec admired Degas, and was delighted to hear him comment one day, while looking at one of his paintings: "You are one of us!" Toulouse-Lautrec, however, to an even greater extent than Degas, had the gift of that special penetrating eye that so acutely reflects the soul of Montmartre through the portrayal of its merciful perversity.

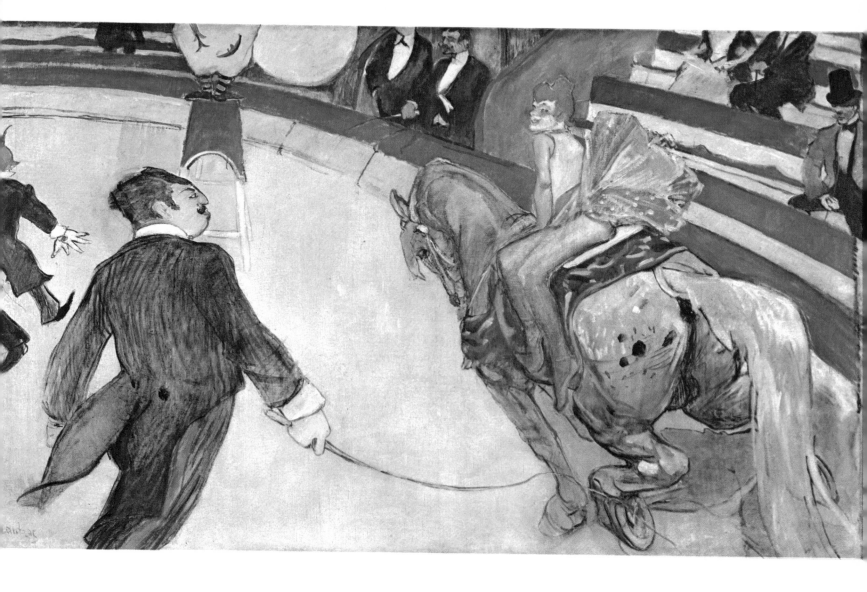

At the Circus Fernando, 1888
(100 x 161 cm)
*Like Degas before him, Lautrec liked to attend
the Circus Fernando. In this design in the
Japanese style, all the corners of the cloth are
cut, and we see, in front, the trainer with a rider
mischievously seated on her horse.*

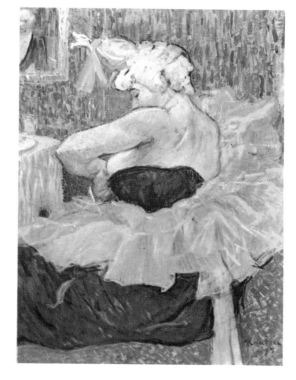

The Clown Cha-U-Kao, 1895
(64 x 49 cm)
*Lautrec painted many pictures of Cha-U-
Kao, a clown at the Moulin Rouge, known for
her buffooneries.*

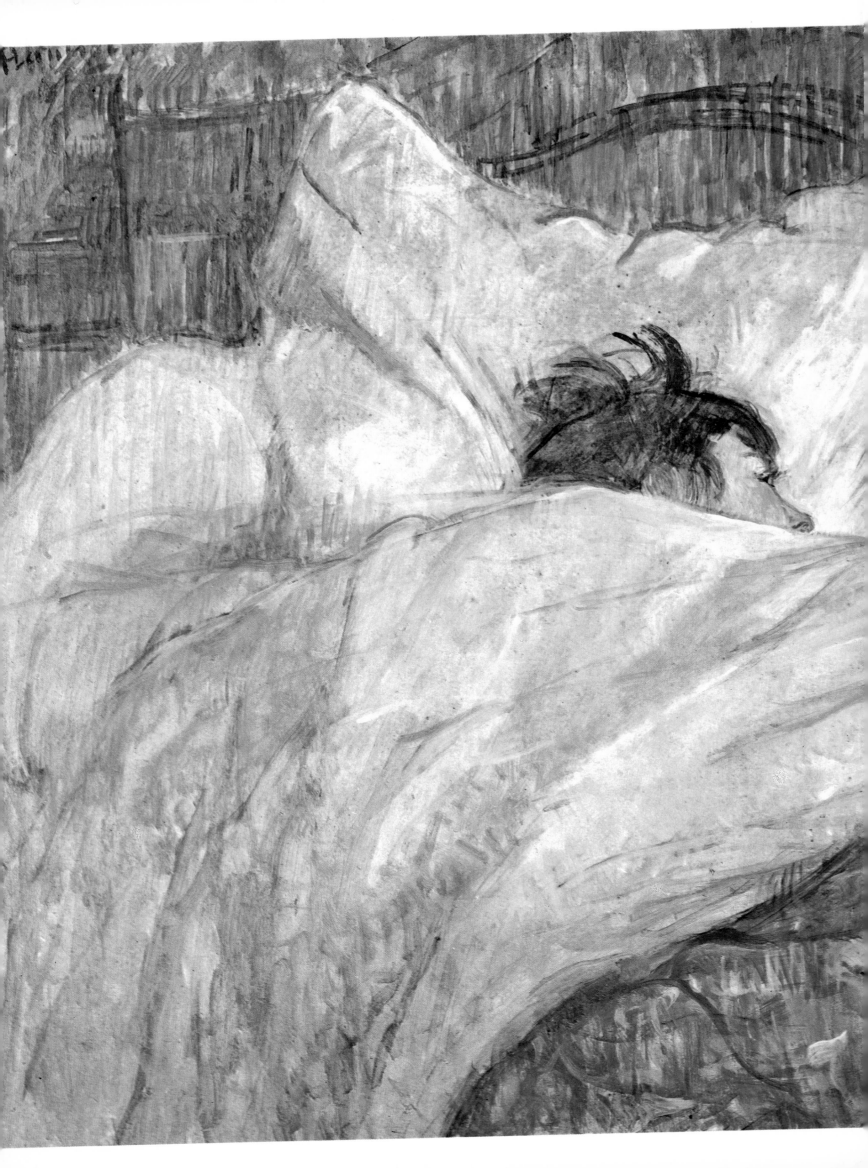

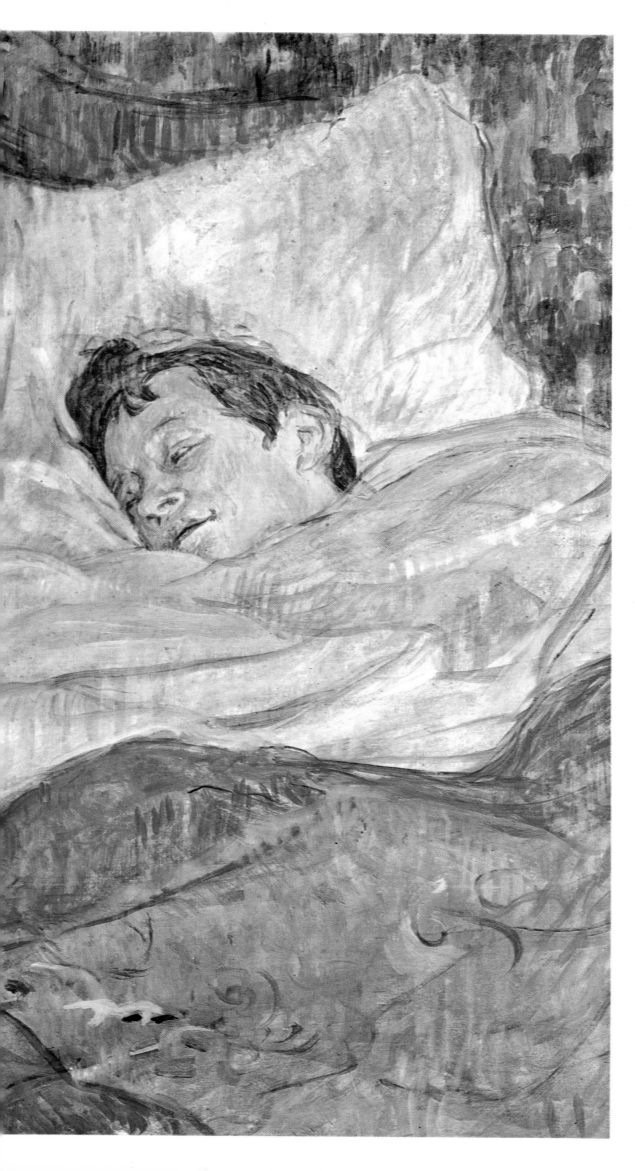

The Bed, 1892
(54 x 70 cm)
*Many times, Lautrec did this
same subject. Two women in
bed, here facing each other, rest-
ing against the white pillows.*

Lautrec's earliest works that were done in the conventional manner of his teacher, Princeteau, were quickly abandoned for his unique style, which he definitively affirms in *The Hangover*, painted in 1888-1889. Suzanne Valadon, who everyone called Marie at the time, is posing as the drunkard. The other painting which represents this affirmation of style is *The Bareback Rider at Fernando's Circus* which is now part of the collection of the Art Institute of Chicago.

Lautrec had his models pose for him time and again. There were many of them: Carmen Gaudin, the gentle worker who was battered by her lover; Lily Grenier with her flamboyant head of hair, who had a taste for burlesque; Mireille, whom he preferred the most of all "his women"; *"Casque d'Or"*, and Rosa the Red, who Bruant wrote a song about:

> "A red-head she was, and dog-faced, too
> When 'ere she passed, they say: There's the Red!"

The nights at the Moulin-Rouge were painted with determined and deliberate brush strokes. They are lightly-drawn portraits filled with extraordinary vivacity, featuring la Goulue with her neckline plunging to her navel, and her vulgar airs, as she lifts her leg to expose a disorderly array of muslin underwear that barely lets us ignore her bleached blond hair.

Lautrec painted men, as well as women, and was equally selective in his choice of models, among whom were Felix Feneon, Tristan Bernard, Oscar Wilde, Alfred la Guigne, and Chocolat, who was portrayed dancing in Achille's bar (1896). It's Lautrec's women, however, that are painted with the greatest detail: Jane Avril, who they called the "Melinite" and who Lautrec portrayed in a tantalizing poster for the Jardin de Paris; his numerous portraits and lithographs of Yvette Guilbert, whose diction he admired; the painting of Marcelle Lender dancing the Bolero in *Chilperic*, the operetta by Herve, which was playing at the Variety Theatre in Paris in 1895. This latter canvas is a masterpiece. The painting is dominated by the rose tones of the actress' underclothing, and the movement of her legs is translated with graceful elegance. Marcelle had the red hair that Lautrec was so sensitive to, as well.

The greatest impact of Toulouse Lautrec's body of work is in its design. It's here that he rejoins the French tradition of Callot. The only attention he drew from the Impressionists consisted of the few paintings he did outdoors, and the effect he achieved with reflected artificial light in his paintings of cabarets, bars, and music-halls.

In his seductive portraits of the women who performed and frequented the cabarets and music-halls of Montmartre, he alone most genuinely represented this typical aspect of Parisian life that was called the "Belle Epoque".

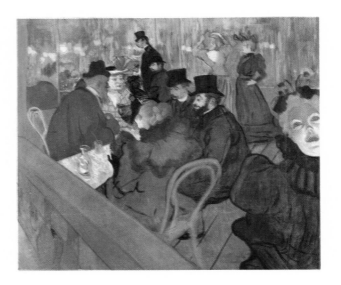

At the Moulin Rouge, 1892
Here at the Moulin Rouge, the regulars are around a table that seems to be on a slight balcony. There is a half view of Celeyran, as well as Toulouse-Lautrec himself. In the detail we see the wonderful face of Nelly C. in the full light of a projector.

Women Dancing at the Moulin Rouge, 1892
(93 x 80 cm)
On the same theme as formerly, he shows here two lesbians dancing at the Moulin Rouge.

TURNER Joseph Mallard William

London, 1775 - London, 1851

Turner was an Impressionist before Impressionism. He was a visionary who transformed reality into light and color in the most entrancing way.

After apprenticing with Thomas Girlin, two years his senior and the force behind the English School of aquarelle painters, Turner followed the example of Claude Lorraine's *Liber Veritatis* and started his own *Liber Studiorum,* a series of studies engraved in *mezzo tintio* (half-tints). The series, which he worked on for over twelve years—it includes sixty plates that were to complete the sketches— also includes memories and notes from his travels along the Rhine, through Italy (where he rejected a poorly taught classicism), through Switzerland (where he sketched in Valais), and Chamonix in the Savoie where he painted the *Mer de Glace.*

Between 1830 and 1837 Turner often stayed at Petworth House in Sussex, the home of his friend and patron with whom he explored the local low-life. It was during these years that Turner's Impressionism was most fully expressed. The Petworth House environment allowed him the freedom to abandon traditional painting. His oils and guaches suggest rather than represent what he imagined. The memory of a drawing-room with a piano or a canopy, and the apparition of a shadowy figure in a doorway or in a mirror were haphazardly brought together beneath a burst of light through which incredibly delicate colors were scattered. He also had a special gift for evoking large vistas of water and sky filled with shades of gold and silver.

Rain, Steam, Speed, at the National Gallery in London, with its locomotive speeding across a viaduct in the fog, is the oil painting that establishes Turner as an Impressionist thirty years prior to the exhibition that gave the movement its name.

Turner affords us a firmer grasp on the possibilities and the limits of French Impressionism: the mysterious fusion of naturalistic reality with the free-flowing fantasy of its expression. In the paintings of Monet and Pissaro, a belfry in Veteuil, a bank along the River Seine at Argenteuil, or a marketplace in Pontoise provide the backdrop for dream, poetry and imagination. Both painters define the

The "Temeraire" Being Hauled Into Dry Dock,
(91 x 122 cm)
He was the magician of the sea, a painter of ships in difficulty. The sky at dusk, the towed ship, all reflected in the water.

The "Temeraire" (detail)
In this detail of the previous painting, one can see the play of the light of the setting sun, with its touches of red that light the twilight colors.

locale and the subject matter in a way that Constable or Courbet would have conceived them. In Turner's work, however, Huysmans commented that: "all the elements melt together in a fantasy flooded with light . . . a total confluence of pink and blue. The pale earth recedes into a lusterous horizon and mingles with it, flowing and reverberating through glistening waters." Another author described Turner's paintings as "filled with translucent madness, torrents of time refracted through milky clouds stained with red fire, and awash with opalescent violets.

Turner had the spirit of a wanderer and loved to envelope himself in mystery. He had wealth, but was somewhat stingey. He couldn't care less about fame, and turned his back on the vain pursuits of this world, thus avoiding their bothersome aspects, as well. He preferred to spend his time at the pubs where he drank with sailors, and told tales of ominous sea adventures in which squadrons were devoured by the waves. His tales were descriptions of his own paintings recounted in a grandiose way, filled with terror and eternity. He would disappear for days on end. One day his housekeeper, Mrs. Damby went out to look for him and found him ill and stranded in a cottage near the bridge of Battersea. The cottage belonged to a Mrs. Booth. Turner was calling himself Mr. Booth, and thought he was a retired sea Captain. He was

brought back to his residence on Queen Anne Street in London to die.

The value of Turner's legacy lies in his paintings, which were unshowable during his lifetime. He surpasses all those before him through his imaginative use of color. It's clear that he had read Goethe's *Farbenlehre*. His biographer, P. G. Hamerton, writes that: "No other artist so painstakingly studied his predecessors in order to go on to show such complete independence in his own work." Ruskin has attempted to give us a better understanding of the painter's work in writing that: "When you follow an object that's receding into the distance, it will gradually lose its intelligibility and its definition. Ultimately it will be totally incomprehensible, except for its gradations of light, which will *never* be lost."

Rain, Steam and Speed (detail), 1839 ▷
Here is a painting that changed the evolution of art. All by itself it gives an impression of space and speed. It is the precarious balance of man in a menacing world, a fear of the infinite. In this great Impressionistic canvas, we see the beginning of Modernism.

VUILLARD Edouard

Cuiseaux (Saone-et-Loire), 1968 - La Baule, 1940

The Two Students, 1894
(214 x 98 cm)

Vuillard, along with Bonnard and Vallotton were at one time part of the intimate group of the Academie Julian known as the Nabis, the self-proclaimed prophets of newness in painting. Vuillard's taste was consumately French, often a bit pretty. Some of his paintings are of outstanding quality.

After the death of his father, a retired army Captain who was a tax-collector in Cuiseaux, Edouard Vuillard gave up the idea of preparing for Saint-Cyr and started to study painting. He moved rapidly from classes with Gerome at the School of Fine Arts, to the Academie Julian. He shared an atelier with his friends Bonnard and Maurice Dennis at 28 rue Pigalle, and met Lugne-Poe who was then opening his Art Theatre. Vuillard showed his paintings at the offices of the Revue Blanche, which was founded and owned by the Natanson brothers. He also did set designs for the Theatre de L'Oeuvre. He lived with his mother, at first on rue Truffaut, and later on the Place Vintimille, which has since become Place Adolphe-Max. He frequently spent extended periods of time at the Natanson home in Cannes, and was exhibited on a regular basis at the gallery of Bernheim-Jeune.

Around 1910, when Bonnard's reputation was already widespread, Vuillard became the portrait painter of the Parisian bourgeoisie. He was also one of the painters who decorated the Theatre de la Comedie on the Champs-Elysees. In 1914 he served as a track-watchman for the government-run railroad, and spent a good deal of time with the Hessel family.

During the time that Vuillard and his mother lived at the Place Vintimille, near Clicy Boulevard, he and Roualt both had ateliers at Vollard's. In 1936, he painted a set for the Theater of Nations in Geneva.

There are two main periods in Vuillard's work: the Nabis period, which also includes Bonnard, Vallotton, Maurice Dennis and Serusier, and the period during which he was the fashionable portrait painter of "proper society". During the period of the Nabis, Vuillard's painting had a certain disjointed quality that distinguishes it from the subtley connected paintings of Bonnard. For the most part, Vuillard's earlier works are far more interesting than his portraits. *In Bed*, painted in 1891, represents the painters effort to synthesize the essential subject matter with a very large format. For his interiors he often worked with blobs of diluted colors on an absorbant mounting. The streets of Paris and the intimate interiors

Interior,
(50 x 71 cm)
The Pointellist painters varied their evocations of the inside of rooms. Contrary to our usual way of looking at pictures from a distance, this painter is more interesting close up.

of Parisian apartments were his preferred landscapes. The Place Vintimille and the home he shared with his mother were the subject matter for numerous interiors and exteriors.

In decorative painting, Vuillard was unequalled in his ability to depict infants playing in the public parks, as their nannies looked on attentively from their wrought-iron chairs. His most important work in this genre are the four panels that Doctor Vaquez commissioned him to paint for his library. *Playing Piano* and *Reading* for example, portray intimate scenes against a background of tiny flowers reminiscent of very old tapestries. The panels evoke an atmosphere of meditation, harmony and music, a pleasant contrast to the hectic noise and activity on the street.

Vuillard's early paintings are filled with nuances of incomparable subtlety. His *Old Mother Looking at her Work* (1893), has an almost tactile quality. The manifestness and granularity of this very moving and intimate scene remind us of Vermeer.

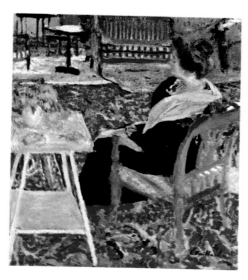

Woman Seated Inside,
(44 x 38 cm)
Incontestably, it is the finesse of the eye, and the freshness of the colors, that make this a truly tasteful picture.

WHISTLER James Mac Neill

Lowell, 1834 - London, 1903

Whistler was Irish in origin. He spent most of his life as an American in Paris and in London. He was the son of a civil engineer. After going to the Military Academy at West Point he worked in the studio of Gleyre, as did Monet, Bazille, Renoir and Sisley. He lived life as an adventure.

Whistler's particular form of Dandyism included a love for controversy and the pleasure of being talked about by others who gathered in small groups and spoke in hushed voices. In this sense, he differed from the prettiness of the Pre-Raphaelites. He brought mirage and enchantment back into painting. He did, however, distrust complete audacity in art and remained separate from his Impressionist friends. He chose to apply his virtuosity to the palette.

Whistler was Mallarme's "uncommon gentleman, prince of something." He would appear in the fashionable circles of London and Paris dressed in a high-collared dress-suit but he would never wear a cravat. Described as a calm and glorious prince of elegance, he would always arrive late at the most select dinner parties where his hoarse and sonorous voice would penetrate the room. "It's Whistler," the guests would calmly say.

He was short, with black hair that had a streak of white running through the center. He looked strange and mysteriously dandified with his monocle attached to a mohair ribbon. There was an aura of the old French regime about him. The mere mention of his name, "Whistler," evoked the wings of a butterfly—a monogram he himself used to

Painter in His Studio, 1864
(63 x 48 cm)
It was a conceit of Whistler's to paint himself in his studio, working hard, palette in hand, with his back turned on the two women (friends, models?).

sign his work. He was boisterous, talkative, and a lover of paradox. He had legal battles with Ruskin, and quarreled with Carlyle and Oscar Wilde. In a nutshell, he was like one of the writer Barbey d'Aurevilly's characters. The poet and art critic Baudelaire admired his etchings. Fantin-Latour was his friend and portrayed him with his monocle and frock-coat as a participant in his *Hommage to Delacroix.*

The influence of the Impressionists is primarily translated through Whistler's ability to conjure forth reveries, such as in *The Old Bridge of Battersea.* The blues and the golds in the evening mist arise from the River Thames with a fluid, melancholy and supernatural quality.

Whistler painted his women in long dresses as a symphony of whites. *Woman in White* at the National Gallery in Washington, D.C. is one of his early paintings. It was done in 1862. It was a veritable revelation when it was exhibited the following year at the Exhibit of Rejected Works, along with Manet's *le Dejeuner sur l'Herbe.* (*The Picnic*). Before Mary Cassatt, Whistler had clearly broken with his predecessors in the American School of painting through the originality of his own artistic conception, which he expressed as: "a hidden divinity of delicate essence." With his subtle scales of shading and the uniqueness of his vision he avoided the mannerism of the Pre-Raphaelites. When Degas stood in front of one of Whistler's "white settings", he remarked that the young woman was "posing in front of infinity and eternity."

In 1865, Whistler spent time in Trouville with Courbet, whose art was at opposite poles to his. He was accompanied by his model and companion, Jo, a beautiful Irish girl whose portrait was painted by Courbet.

Whistler met Pissarro during the Franco-Prussian war of 1870, and later met Monet in London. This was the period of the Thames and Venice paintings and of *Ten O'Clock,* which the poet Mallarme translated and read in the drawing-room of Berthe Morisot.

According to the portrait-painter Jacques-Emile Blanche: "although Whistler professed to detest London, it was the only place he was really at home. He had a soft spot for English women with fruity flesh, and amber-colored hair, which he was more sensitive to than the hair of women from Venice or Seville. The little street urchins so curiously dressed in their crude-toned rags that were highlighted by the misty fog, and the shabby storefronts daubed with color were sources of inspiration for his marvelous 'variations.' It was on the banks of the River Thames that he found not only Venice and Holland, but the confluence of all parts of the world."

The last years of his life were spent mostly in Paris where he lived at 110 Rue du Bac with his wife, the widow of the architect Godwin. The windows of their lodging faced out on the gardens of a convent. Blanche described how their house was decorated and furnished: "The same way as in London . . . with yellow walls, blue and white China porcelain, and a few chairs." Whistler's studio was located closeby on the rue Notre-Dame-des-Champs.

Just before his death, the ailing Whistler returned to London where he died at the age of sixty-nine.

Young Girls Dressed in White, 1861
What is there that is so strange in this girl in white? A certain disquietude, an elegance, a secret expression and an air at once natural and restrained.

Table of Contents

INDEX

PRINTED IN SPAIN